Lost Minnesota

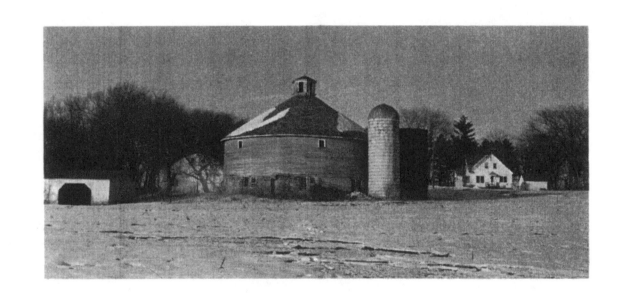

Lost Minnesota

STORIES OF VANISHED PLACES

Jack El-Hai

University of Minnesota Press
Minneapolis • London

Published by the University of Minnesota Press
111 Third Avenue South, Suite 290
Minneapolis, MN 55401-2520
http://www.upress.umn.edu

Library of Congress Cataloging-in-Publication Data

El-Hai, Jack.
 Lost Minnesota : stories of vanished places / Jack El-Hai.
 p. cm.
 ISBN 978-0-8166-3515-3 (PB : alk. paper)
 1. Lost architecture—Minnesota. I. Title.
 NA735.M5 E4 2000
 720'.9776—dc21

 00-008652

Printed in the United States of America on acid-free paper

The University of Minnesota is an equal-opportunity educator and employer.

17 16 15 14 10 9 8 7 6 5

To Ann

Contents

Acknowledgments

SINCE 1990, *ARCHITECTURE MINNESOTA,* the magazine of the Minnesota chapter of the American Institute of Architects, has allowed me to contribute six "Lost Minnesota" columns every year. About forty-five of those columns appear in this book. I wish to thank Adelheid Fischer, who first suggested that I take up the column; Eric Kudalis, who edited most of the columns that are included in this book; Camille LeFevre, who also edited some of the "Lost Minnesota" columns; and AIA publisher Peter Rand. I am also appreciative of the work of Paul Clifford Larson, my predecessor as writer of the column, for setting such high standards.

For their work in gathering and preserving the materials in their National Register of Historic Places files that I used so heavily, I thank the entire staff, past and present, of the State Historic Preservation Office in St. Paul. Susan Roth, John Lauber, and Scott Anfinson offered especially helpful suggestions and assistance.

Many librarians and archivists have helped me over the years as I've researched lost Minnesota properties. I thank all of them. In particular, the following people and groups have given me valuable help and information: the research library staff at the Minnesota Historical Society, St. Paul; the special collections staff, especially Edward Kukla and Audrey Aye, at the Minneapolis Public Library and Information Center; Patricia Maus at the Northeast Minnesota Historical Center in Duluth; and the staff of the Hennepin History Museum.

Any suggestions for properties in a future book?

LOST BUILDINGS WITH UNUSUAL STORIES fill Minnesota's past. I welcome readers' suggestions for properties, along with referrals to sources and photographs, to include in a possible future volume of *Lost Minnesota*. You may reach me by e-mail at el-hai@reporters.net or by postal mail care of the University of Minnesota Press.

Introduction

I DID NOT SET OUT TO BECOME A CHRONICLER of lost Minnesota properties. The opportunity arrived unexpectedly in 1990, when the editor of *Architecture Minnesota* magazine called and asked if I would be interested in taking over its well-established "Lost Minnesota" column. I hesitated. What is the value, I wondered, in trying to grasp the vanished dreams of architects, poking in the rubble of discarded buildings, and resurrecting places that most people had forgotten or never known?

The editor suggested that I start with Rockledge, the house formerly perched on the bluffs of the Mississippi River near Winona and designed by George W. Maher. This house, she said, had a good story. Stories intrigue me, so I said I would try it out. I'm still at it, ten years later.

Lost buildings and properties, like I suppose anything else that people create, repay close examination by offering tantalizing hints on the human condition. A building, after all, is erected only because someone thinks it is needed. It is later discarded because something has changed and it is no longer wanted. If nature has intervened and destroyed the property through fire, tornadoes, or shifting of the earth—all disasters that brought down some properties in the pages of this book—the responses of people to the calamity can also reveal much of human nature.

That is why even though I write my magazine column for an audience of architects, architecture has gradually diminished as a focus of my investigations. I like looking at the design of built properties, but even more I like looking at the lives that flickered inside. I am most interested in trying to understand how a property evolves from something that somebody invests time and money in designing and erecting to an annoyance that another person neglects and pulls down. In between those starting and ending points always lies a tale.

Lost Minnesota includes properties from all corners of the state and from all of its historical periods. In no way, however, is it an inventory of Minnesota's most important or significant vanished structures, by whatever criteria those choices could be made. Instead, I have chosen the properties in this book with other guidelines in mind.

The richness of commercial, agricultural, and social activities that have taken place in Minnesota encouraged me to research properties that reflect that diversity of human interest and endeavor. In these pages you will find farm structures, houses, industrial buildings, bridges, Indian burial

mounds, a water tower, and several other types of built properties. If you do not know much about farming, reading the history of the Titrud Round Barn in Wright County or the Lucius Cutting Barn in Rochester will give you details about the needs and concerns of the people who built and used those buildings. In the same way the many residences included in *Lost Minnesota,* ranging from the grand and short-lived Gates Mansion in Minneapolis to the B-29 bomber house that later sat just a few miles away, shed light on what Minnesotans want and expect from a home.

I also selected properties that tell a story. Sometimes the story has a person at its core, such as architect LeRoy Buffington and his involvement with the second Minnesota State Capitol or Otto and Ethel Johnson's preoccupation with whimsy and fantasy in Mountain Iron. At other times, though, the property itself is a character in a life-and-death drama. The Murray County Courthouse comes through as a prankster who triumphs even in death. The IOOF Lodge Hall in Hubbard Township meets its end sadly and senselessly. On the other hand, if being filled with life is the definition of a happy existence for a building, the American Hotel in Glencoe had it: after a good many years as a lodging house, it ended its days with an even longer stretch as a chicken hatchery.

Finally, I believed that *Lost Minnesota* needed geographic diversity. Several excellent books have already described some of the lost properties in Minneapolis and St. Paul, and my own magazine column has until recently focused on Twin Cities structures. So in my research for new material I concentrated on properties outside the metropolitan area. I found a wealth of information on lost buildings located throughout Minnesota at the State Historic Preservation Office (SHPO), located in the Minnesota History Center in St. Paul. There, in SHPO's documentation of Minnesota's properties in the National Register of Historic Places, I used a group of files describing properties, mostly demolished ones, that had been *removed* from the register. As a result, a large number of the properties outside the Twin Cities in *Lost Minnesota* were once listed on the register.

These once-deemed-historic-but-now-vanished properties point to an important tale that flows beneath the surface of the individual stories in *Lost Minnesota.* This is the progress of historic preservation in Minnesota and the ways in which we have treated historic properties and reacted to their threatened loss. The properties in this book that vanished before the middle of the twentieth century, such as Duluth's Incline Railway and the burial mounds at Indian Mounds Park in St. Paul, aroused little if any preservationist action. Back then, Minnesotans considered themselves the residents of a new land with a wealth of resources, space, creativity, and beauty—but no history to speak of. Properties grew old, not historic. Only later in that century, when large numbers of properties came tumbling down in renewal projects or the clearing of land for new purposes, did historic preservation

gain a following in Minnesota. The razing of the Metropolitan Building in Minneapolis in 1962, while causing the loss of an important early skyscraper, generated the publicity that the region's preservation movement needed in order to gain strength and momentum.

Today several Minnesota communities have preservation boards that review planned demolitions and offer recommendations. The National Register has been in effect for more than three decades. Even so, as any reader of this book will see, historic properties worthy of preservation come down with regularity. Often the preservation boards have only a weak advisory role. And a listing in the National Register in no way guarantees that a property will be preserved.

In fact, a National Register listing does nothing to deter private owners from greatly modifying or destroying their property, as long as the federal government is not involved. (At the same time, private owners of National Register listings receive virtually no governmental assistance in repairing or restoring their property.) When a publicly owned National Register property faces demolition, the governmental owner has to report on the detrimental effect of the property's loss on the community. All too often, officials complete these reports and, regardless of their findings, proceed with demolition. Federal law only requires government officials to go through the process. No law mandates that National Register properties with a high degree of historical significance must be saved.

My point is not that old buildings as a rule should stand forever. Many shouldn't. If some of the properties in *Lost Minnesota* were around today, they would endanger our health and insult our aesthetics. Who in their right mind would prefer the old Kenwood Armory to the Minneapolis Sculpture Garden that currently occupies the site?

Instead, I hope that *Lost Minnesota* will encourage readers to think about what Minnesota would be like if some of these properties were still around for us to use and enjoy. I would love to enter Duluth's Lyceum Theater or the Andreus Thoreson House in Lac qui Parle County, but I cannot. Those lost opportunities force me to pay more attention to the buildings, bridges, and other built properties that make up the world surrounding me and my family. These, too, will vanish someday, and maybe I can play a role in saving the ones that mean the most to me.

Lost Minnesota, then, is for readers who seek inspiration—as well as entertainment and edification—from the past. It's also for people who believe that buildings can tell stories, and for those who want to listen.

Minneapolis
October 1999

MINNEAPOLIS

B-29 Bomber House

Near 1720 East Hennepin Avenue
1946–?

THE NATION WAS IN THE MIDST of a severe housing shortage in 1946 when Roy Rasmussen, a Marine Corps veteran, spotted a section of a B-29 bomber airplane sitting in a scrap metal yard in Omaha, Nebraska. Along with his wife, Evelyn, and two-year-old son, Roy Jr., Rasmussen needed an affordable place to live while he was taking classes at the University of Minnesota, so he bought the 20-foot-long hunk for $130 and towed it up to Minneapolis. Over the next several weeks, Rasmussen fixed up the fuselage—formerly the portion of the airplane that housed the crew and radio section—and installed a cooking range, stove, sink, closet, fold-down tables, and a davenport that doubled as the couple's bed.

"One day I saw this thing coming down the street," recalls Charles Amble, the former owner of a service station at the corner of Eighteenth and East Hennepin Avenue in Minneapolis. "The man pulling it said he was looking for a place to park it. I thought it was kind of a novelty, so I said he could park it next to my station."

For the next year, the Rasmussens lived in the bomber on Amble's property. They used the service station's bathroom, and Roy Jr. played in back of the airplane in a sandbox made from a bubble window of the fuselage. Evelyn Rasmussen does not recall whether the home received much attention from her neighbors. "It was located in the back and under a tree, so I don't think too many people noticed it," she says.

Soon, however, the Rasmussens sold the bomber to another couple, Galen and Elayne Armstrong. Elayne remembers that she and her husband frequently hosted parties there, watched the trains pass on the nearby tracks, and "loved the view of the bubble where the gunner was [and where we] could lay in bed and look at the stars." After about seven years, the Armstrongs sold the home to a Mr. Lewis, who, Elayne believes, moved the bomber to a location near Lake Mille Lacs.

Roy Rasmussen's strange living space had at least temporarily saved the day. "I thought it was wonderful that he thought of it, and there was no place else left to live," says Evelyn Rasmussen.

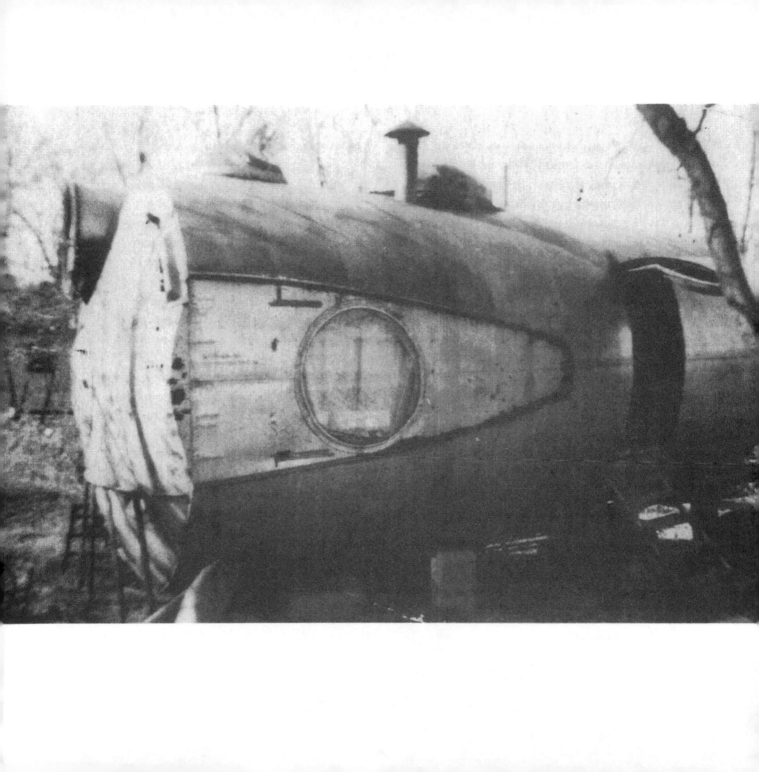

Bohemian Flats

Along the Mississippi River below the Washington Avenue Bridge
1870 to the 1930s

FIRST WERE HICKORY TREES AND SCENIC BLUFFS. Then, around 1870, came a Danish family. Finally there was a flood of Czechs, Slovaks, Germans, Poles, and Irish that wanted to settle in the Bohemian Flats, a crowded neighborhood of small houses, shacks, and shanties huddled in the shadow of the Washington Avenue Bridge in Minneapolis.

Every spring, the Mississippi River greeted this flood of humanity with an overflow of its own. Residents of the lowest (and cheapest) tier of the flats faced an annual ritual of evacuating children, furniture, and livestock to higher ground. (The boys shown here in the boat survived an 1898 flood.) When residents returned, sometimes the whole house had floated away. As if in compensation, however, the river left behind a layer of rich soil that made the cultivation of vegetable gardens a community obsession. Growing food — along with raising chickens, ducks, and rabbits—was a necessity as well because many people in the Bohemian Flats were impoverished. They chose to live far outside the city's main area of settlement where the rents were low or nonexistent.

The Bohemian Flats (pictured here with the Washington Avenue Bridge in 1910) did have a system of social stratification, however, based on distance from the river. Mill Street, the neighborhood thoroughfare farthest from the river, boasted the highest rents, while Cooper Street, somewhat closer to the water, was more modestly priced. Wood Street, closest to the river's edge, commanded the lowest rents.

Eventually, during a peak reached around the turn of the century, about five hundred people lived in Bohemian Flats—a heady mix of nationalities, faiths, languages, and occupations. Residents lacked running water and indoor plumbing, and they mounted a set of wooden stairs to climb the bluffs and reach the rest of Minneapolis. Many worked at a nearby pickle factory or in lumber and flour mills, and some made money (and acquired construction material) from lumber scavenged from the river.

Eventually, city officials formulating plans to clear out the flats joined forces with absentee landlords seeking to evict squatters. A riot broke out in 1923 when police entered the neighborhood to boot out nonpaying residents. Residents wielding yard implements, sticks, and brooms fought back.

Over the next ten years, however, residents lost their battle to stay. In 1932 the city began construction of a barge landing on the site, and only a few residents remained. By the 1940s, all of the houses were gone.

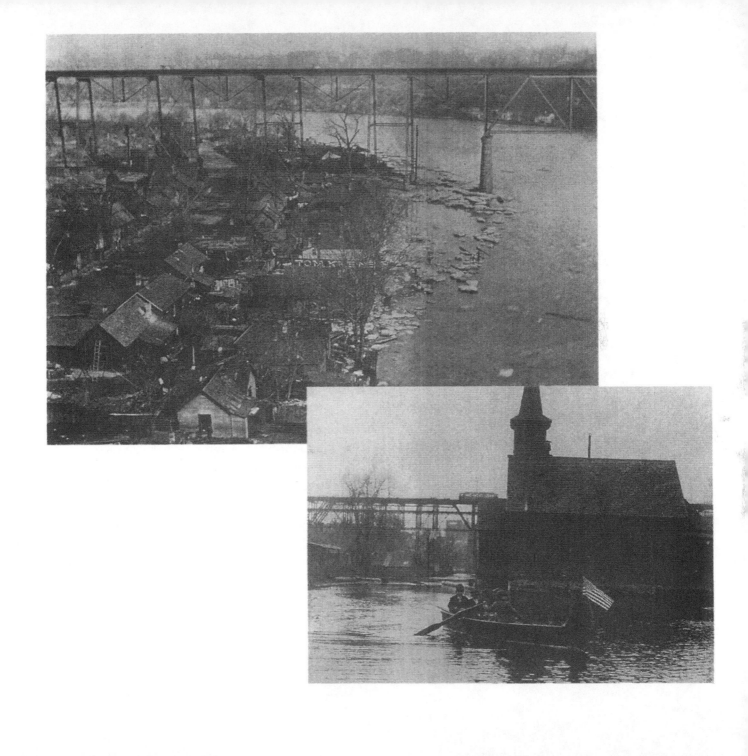

Charles F. Dight's Treehouse

Near Minnehaha Creek
1926–37

CHARLES FREMONT DIGHT DEVOTED HIS LIFE to championing eugenics (the selective breeding of people) and won election to the Minneapolis City Council as an advocate of feeding the city's trash to hogs. Despite these eccentricities, Dight gained the most notoriety for another peculiarity. He was, as any Minneapolitan knew in the 1920s, the man who built and lived in a treehouse.

Dight came to Minnesota in 1889 after teaching at a medical school in Beirut, Syria (now Lebanon). In 1907 he secured a position as lecturer in pharmacology at the University of Minnesota, and he shortly set about scouting sites for the house of his dreams. Dight settled on a lot located close to the murmuring of Minnehaha Creek, but he was not content to dwell near the natural beauty conventionally.

By 1911, Dight had designed and begun constructing perhaps the most singular residence in Minneapolis. Modeling the structure after elevated houses he had seen in Beirut, Dight raised the dwelling on 10-foot steel stilts set in concrete and nestled it within branches of oak trees. "Mr. Dight says he is building his house high for three reasons," the *Minneapolis Tribune* reported. "First, that the ground is low and damp owing to the proximity of the creek; second, that he gets a better view; and third, that he gets more air and sunshine."

The treehouse, constructed of plaster, hollow tile, and wood, had a long gestation. When Dight finally completed it in 1926, it measured 18 feet by 22 feet and had four rooms and a porch. A cupola topped one room, which he set up as a laboratory. Planned as a four-season home, it boasted a do-it-yourself hot-water heating system that proved so inadequate in the winter that Dight was forced to wear overshoes inside.

By the time Dight abandoned residence in the house in the late 1920s, it had become an architectural celebrity. Photos of it appeared in newspapers across the country. It remained unoccupied until Dight's death in 1937 and was razed, in all probability, not long thereafter.

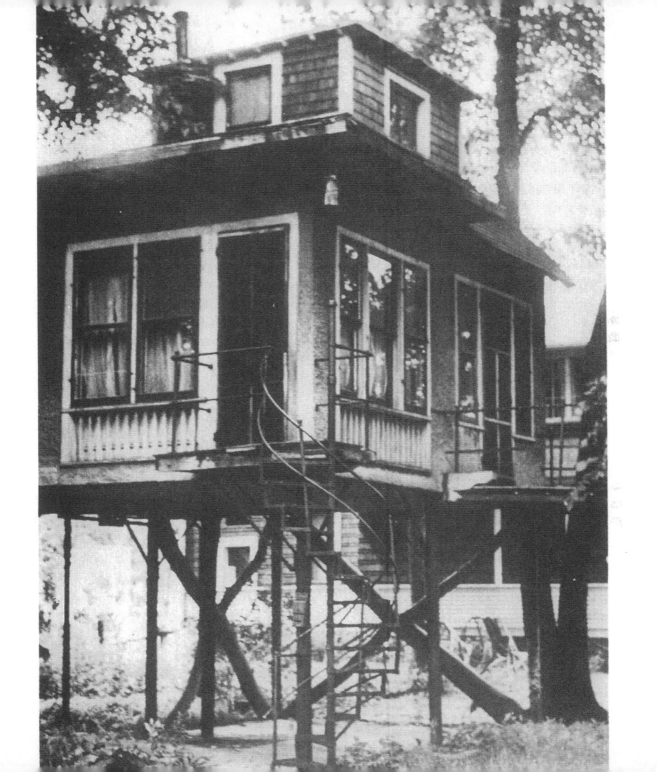

Dyckman Hotel

27 South Sixth Street
1910–79

PUBLIC INTEREST WAS HIGH when the Dyckman Hotel neared its demolition to make way for Minneapolis's City Center complex. Preservation had nothing to do with the interest: this was the city's first demolition by implosion, and onlookers filled the streets on the morning of November 18, 1979, to witness the big bang.

The Dyckman, named by original owner John Andrus after his wife's family, opened on May 3, 1910. Several features made the hotel one of the city's most memorable: a lobby walled with pavonazzo marble and topped by a large mural titled *Roman Triumphal Procession* by Edward Holslag of Chicago; gilded ceilings inlaid with mosaic designs; an elaborately ornamented wrought-iron marquee; and slabs of mahogany, Circassian walnut, and other woods on the walls of the building's public areas. Each of the two hundred guest rooms had a private bathroom, telephone, and "circulating ice water."

There was a seamy side to this luxury. During the 1920s, federal agents repeatedly charged Dyckman employees with Prohibition violations, and room service staff were said to use a tunnel running beneath Sixth Street to procure liquor for guests. Later, the hotel was rumored to be a gambling den for traveling salesmen.

Over the decades, renovations took much of the glamour out of the Dyckman. In 1945–46, for example, the hotel acquired a new facade of granite and Kasota stone (replacing a terra-cotta surface), and the iron marquee was removed for a new glass and stainless steel illuminated sign. In the 1950s, Dyckman management opened perhaps the first French restaurant in Minneapolis, the Chateau de Paris. But by 1975, when hotelier Robert Short bought the building, the Dyckman's high vacancy rates and numerous fire code violations had long erased any lingering memories of luxury. Short sold the Dyckman for a substantial profit to clear land for City Center.

Before the Dyckman came down, Short staged a public open house and a sale of all the hotel's furnishings and decorations. Buyers left with hotel china, escargot tongs, chandeliers, and even the marble paneling of the underground tunnel, which reappeared in the renovation of the Lumber Exchange Building.

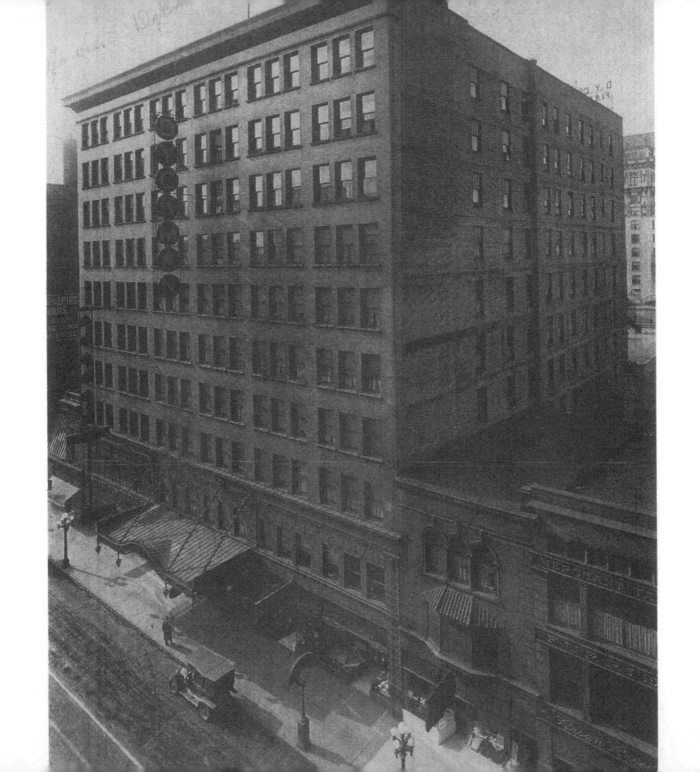

Exposition Building

Main Street at Central Avenue
1886–1940

IT BEGAN AS MINNEAPOLIS'S ANSWER to the Minnesota State Fair and ended fifty-four years later as a lonely, tall tower that bore neon images of pop bottles.

In 1885, a group of Minneapolis business leaders met to counter the state legislature's decision to permanently hold the State Fair in St. Paul. An exposition building seemed a good idea: one that could house an annual display of the best examples of industry, business, and art. Committee members raised $500,000 for the building through a stock offering. The building's planners accepted the proposal of residents of the Mississippi's East Bank, who offered the bluff land occupied by the Winslow House, a building that had served as a hotel, college, and hospital during the previous thirty years. (See the entry for the Winslow House later in this book.)

Minnesota architect Isaac Hodgson designed the original plans, but a building committee altered them after examining similar structures in other cities. Construction began on April 29, 1886, and ended ninety days later. Occupying about 240,000 square feet of land, the exposition building had 8 acres of floor space, a stone-and-brick exterior, and a 275-foot-high tower—topped by a metal weather vane from the Winslow House—that commanded a view of young Minneapolis.

Almost one-half million people passed through the building during the first Minneapolis Exposition of 1886. Revivals of the annual event, lasting until 1894, proved less successful. The building enjoyed a moment of glory in 1892, when it hosted the Republican National Convention (which nominated for president a losing candidate, Benjamin Harrison). Later, the Exposition Building headquartered a food company that went bankrupt.

The First Federal Savings and Loan Association bought the building in 1939 and razed it, leaving only the tower. Eventually, a pop bottler named Tom Moore purchased the site and installed neon Coca-Cola billboards on the tower before leveling it to build a bottling plant. The weather vane, a representation of the angel Gabriel, survives in the collection of the Hennepin History Museum.

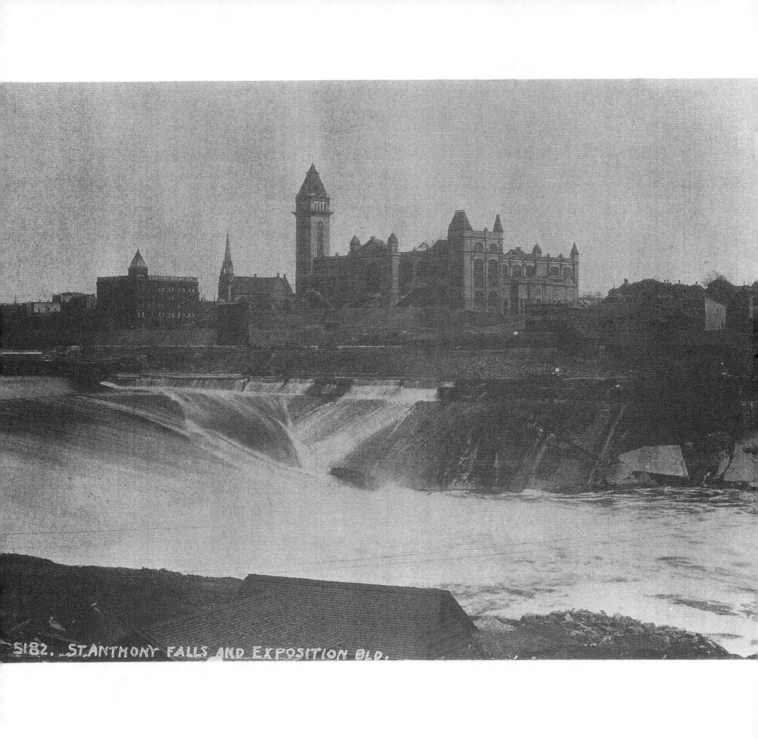

5182. ST. ANTHONY FALLS AND EXPOSITION BLD.

Fairoaks

East Twenty-Fourth Street at Third Avenue South
1884–1924

NEXT TIME YOU ADMIRE THE ROLLING HILLOCKS of Washburn–Fair Oaks Park in Minneapolis's Whittier neighborhood, near the Institute of Arts, thank Frederick Law Olmsted. The noted landscape designer, creator of New York's Central Park, assembled the physical features of the grand estate that used to occupy the site, and many of them remain today.

William Drew Washburn, a Maine-born lawyer who came to Minneapolis to make a fortune in lumber and milling, purchased the block bounded by Twenty-Second and Twenty-Fourth Streets and Stevens and Third Avenues in 1868. At that time only Villa Rosa, the residence of Dorilus Morrison, the city's first mayor, stood anywhere nearby. Washburn waited until 1883 to hire Olmsted and the Milwaukee-based architect E. Townsend Mix (who would later design the Metropolitan Building) to work on his 10–acre estate.

Two hundred and fifty thousand dollars later, Fairoaks rose like a jagged, yellow-stone bump on the bare horizon—a collection of Tudor gables, cast-iron ornaments, oriels, bays, and grouped chimneys arranged in, as one critic has observed, "the closest juxtaposition that the building block would permit." The lavish interior featured frescoes on the ceilings and walls, marble floors, onyx fireplaces, and a library whose walls nearly sagged with oil paintings and heavy tapestries.

But the grounds drew the most attention. Olmsted designed hills, an artificial lake (now a dry depression), and a pond, with a rustic bridge-spanned stream connecting the bodies of water. The house itself, facing Twenty-Second Street, sat on a grassy knoll.

Fairoaks brought Washburn good luck: he ascended to the U.S. Senate in 1889. Renowned New Year's parties and other gatherings made the neighborhood a fashionable area, and other prominent families moved nearby.

When Washburn died in 1912, his widow left Minneapolis. For a couple of years, only a caretaker's family occupied the estate. In 1914, the Minneapolis Park Board took ownership of the property and during World War I ran it as a recreation center for troops. (It is shown here during a spring celebration around 1920.) The house was demolished in 1924 to make way for the park, but sections of the cast-iron fence remained standing for years afterward.

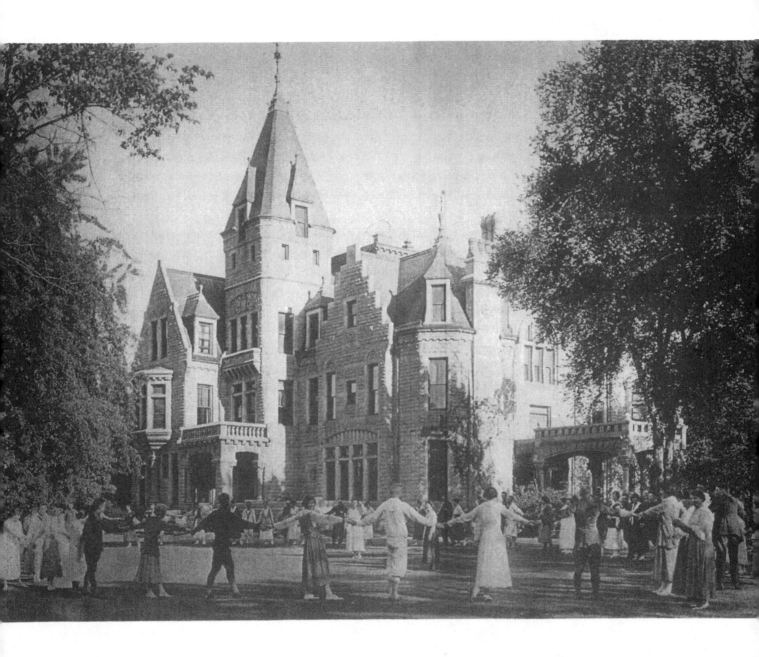

Forum Cafeteria

36–38 South Seventh Street
1930–79

IN 1930, A RESTAURANT OPENED in downtown Minneapolis inside what had long been the Strand Theater, a movie house constructed sixteen years earlier. The Forum Cafeteria, part of a chain headquartered in Kansas City, brought an early version of fast-food eating to the Twin Cities, but it also brought much more. Supervising architect George B. Franklin transformed the theater's dark interior into a streamlined palace of light, mirrors, and chrome—one of the greatest examples of Art Deco design ever built in Minnesota.

An efficient and inexpensive eatery catering to downtown workers, shoppers, and visitors, the Forum did well from the start. The food was fine, but customers seemed to like even better the kaleidoscope of glass that enclosed them. The main, street-level eating area featured vitriolite walls etched with a zig-zag design, glass-tiled surfaces in hues of green, gray, blue, and white, mirrors covered with etchings of forest and lake scenes, and frosted glass chandeliers shaped to resemble pine trees. Fixtures and rails glowed with chromium and onyx. A pair of gorgeous Art Deco lamps marked the start of a stairway that led to a balcony. This elevated seating area included striking examples of Art Deco grillwork—depicting a spider's web surrounding flowers—that covered ventilation shafts. All of the food preparation equipment was built from glass and shining stainless steel.

For more than thirty years, the Forum bustled with light and business, especially during the 1940s and '50s. Around this time, Franklin supervised several alterations to the interior, including an extension of the balcony that straightened its curving contour and the installation of a ceiling of acoustical tile. Despite these changes, the Forum still rivaled the Foshay Tower lobby and the St. Paul City Hall and Ramsey County Courthouse as the best Twin Cities examples of Art Deco—a style not highly appreciated in the mid–twentieth century.

Business had gradually declined by 1974, when the Farmers & Mechanics Bank bought the building but continued leasing it to the Forum. Soon afterward, however, the Forum's management decided that the clientele had shrunk too much to continue. Another restaurant, Scottie's on Seventh, bought the building and opened in the space in 1976. The new owners restored broken glass tiles and rechromed all of the metalwork.

Meanwhile, a huge downtown development called City Center was germinating. The developers

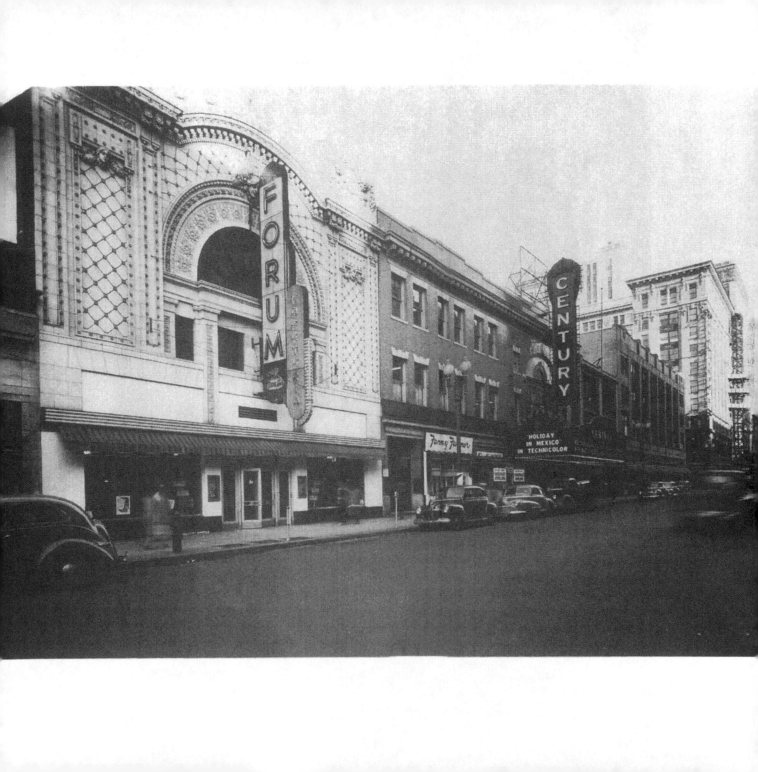

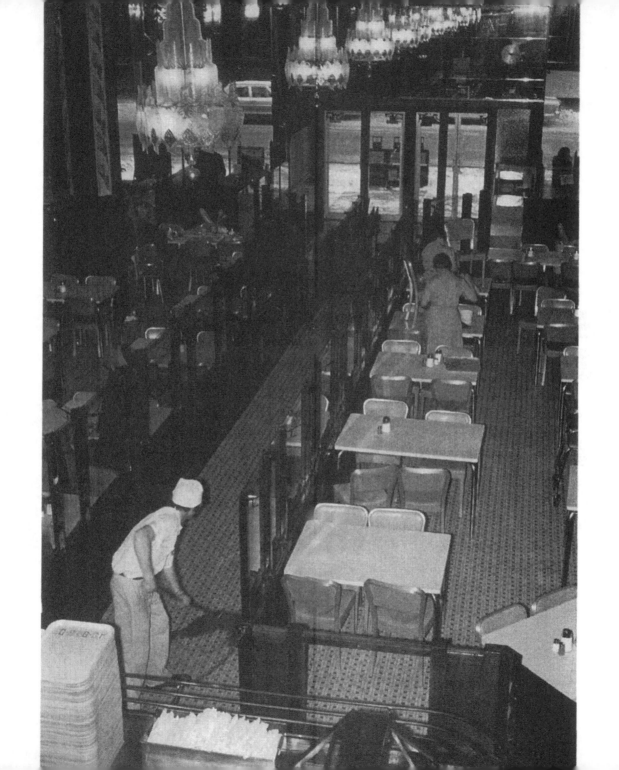

wanted the restaurant's property for new retail space. A bitter preservation battle ensued, which ended in Hennepin County District Judge Allen Oleisky's ruling that the building must be demolished to make room for City Center but that the restaurant's interior must be preserved.

In 1979 a crew of workers began the task of measuring, marking, and removing thousands of pieces of glass and tile from the Forum's old interior. The workers discovered that the amber-tinted chandeliers were really silver chrome soiled by decades of cigarette smoke, that two stained glass windows had long been covered with black paint, and that a floor of ceramic tile lay beneath the carpeting. With breakage held to less than 10 percent of the total, all of the fixtures and furnishings were placed in storage until 1983, when City Center opened with a new Scottie's as a tenant, complete with a re-creation of its original interior.

But the reborn Scottie's lasted only three years. The space sat vacant for several years, and the Minnesota Historical Society briefly entertained the idea of moving the whole Forum interior into its new History Center in St. Paul. Then a new restaurant, Mick's, leased the City Center space and stayed four years. In 1996 the current occupant, Goodfellow's, received permission from the Minneapolis Heritage Preservation Commission to reduce the loud acoustics by covering some of the vitriolite walls with fabric and to create more open space in the balcony by moving some decorative columns.

The Strand Theater is gone, but the Forum, in a sense, lives on.

Gates Mansion

West Twenty-Fifth Street at Lake of the Isles Parkway
1914–33

IN 1932, FRED RAAKE, CARETAKER of the largest residence in Minneapolis, learned that the building was going to be demolished. "Well, if that's true," Raake told a reporter, "it makes me feel rather like a sea captain whose ship is going to the bottom. For the past three years or so, I've felt like a captain without any passengers anyway."

In fact, the Gates Mansion on Lake of the Isles was perhaps Minneapolis's least-lived-in residence. Charles Gates, the spendthrift son of an enormously wealthy speculator, had died during the building's construction, and his widow and children lived in the finished house only a few years before moving to Connecticut. The next owner, a St. Paul lumberman named Dwight F. Brooks, preferred to live in his more modest Summit Avenue abode. For most of its existence, the Gates Mansion housed only its caretakers.

Such was not the original plan when construction began in 1913. Designed by Marshall & Fox of Chicago, the $1 million house was intended as a status symbol of Gates and his family. With Antonio San Gallo's sixteenth-century Palazzo Farnese marble fireplace mantles (including a 9-footer carved from Michelangelo's medium of choice, Carrara marble), a 300-pipe Aeolian organ, and a kitchen that measured 27 feet by 22 feet, the E-shaped house was rumored to contain more cubic space than the White House. And its technological features rivaled its architectural wonders. With an "air-washing" system designed by climate-control pioneer Willis H. Carrier, the mansion was perhaps the first residence in America to boast air conditioning.

After Brooks's death in 1929, his heirs found the maintenance costs too taxing. The family briefly opened the house for public tours before beginning demolition in the spring of 1933. Most of the marble and costly wood was salvaged for reuse in other structures.

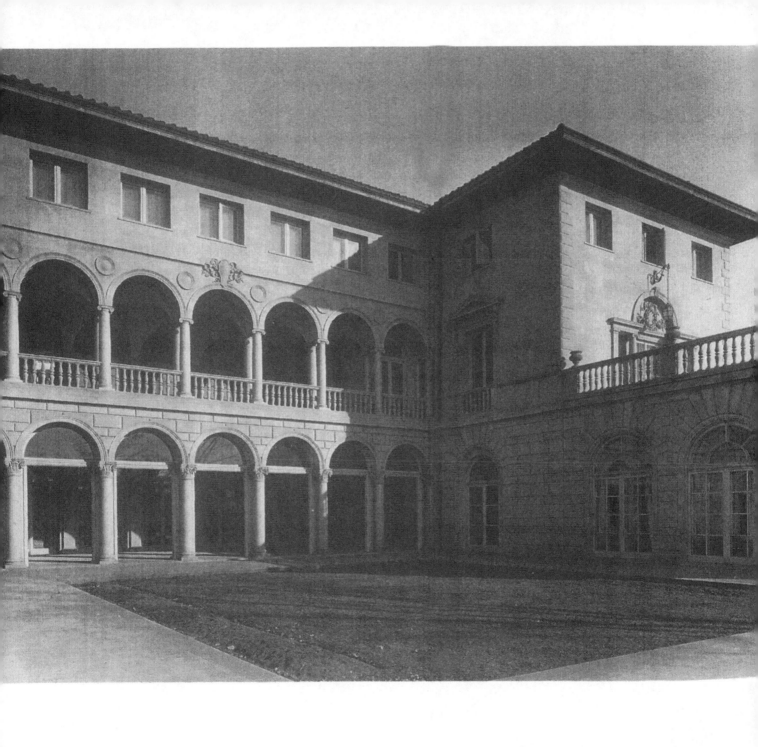

Gateway Park Christmas Tree

Nicollet Avenue at Hennepin Avenue
1925–?

ON DECEMBER 24, 1925, MEMBERS of the Minneapolis Fire Department were hard at work. They weren't putting out a fire, mind you: they were helping to raise a pair of Christmas trees in Gateway Park, at the downtown intersection of Hennepin and Nicollet Avenues.

Minneapolis had never before seen publicly displayed trees like these. They had nearly two thousand light bulbs and a mile and a half of connecting copper wire. The lights required the skills of students of Dunwoody Institute, among the few people in the city who understood the intricacies of wiring, to aid the firefighters in setting up the trees. The Electrical League of Minneapolis also provided assistance. These 50-foot-high trees, in fact, were the first municipally sponsored trees in the city's history to be electrified.

Earlier in the century, Gateway Park had served as the site of several city Christmas trees. The practice had been stopped, however, a dozen years before 1925.

As the afternoon waned, the firefighters and students completed their work. A large crowd gathered in the park, awaiting the stroke of 5 P.M. At that moment President Calvin Coolidge, sitting at his desk in the Oval Office of the White House, would illuminate the trees. Renowned for his reticence to speak, Coolidge would fortunately have to say nothing to bring light to the trees. All he would have to do was push a button. Then, via electrical relay, trees in several cities around the country would flare.

The clock struck five. Silent Cal pushed the button. The Christmas trees blazed with colored lights. Then came a ceremony in which city officials accepted the tree on behalf of residents and a clergyman blessed it. Singers sang holiday carols and a WCCO announcer treated the crowd to a wired-in recitation of Christmas stories. Around the city, five thousand volunteer Santas delivered presents to needy families.

After the holidays, the lights were gathered up and the trees hauled down. But a municipal ceremony at Gateway Park beneath a lit tree at Christmastime remained a Minneapolis tradition for many years to come.

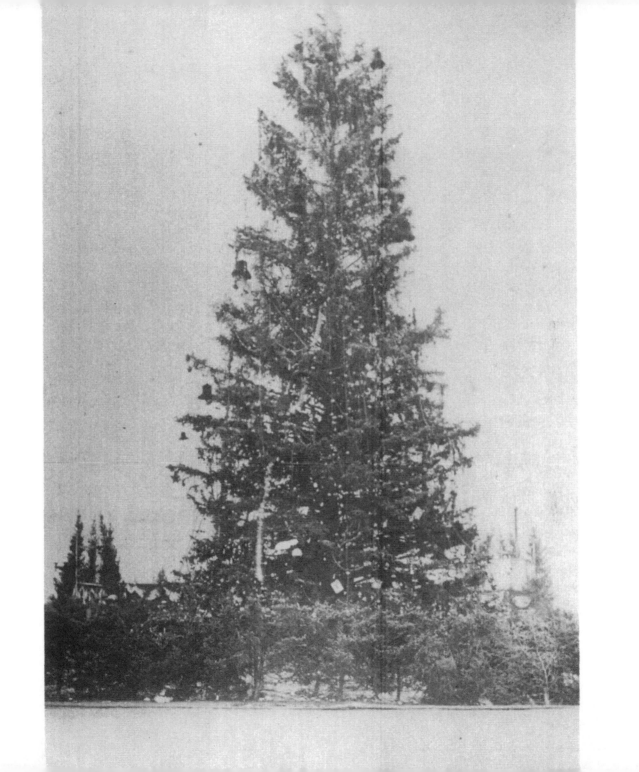

Gateway Pavilion

Nicollet Avenue at Hennepin Avenue
1915–54

LONG BEFORE THE ARRIVAL OF GATEWAY PAVILION, the Minneapolis land near the intersection of Nicollet and Hennepin Avenues had served as a gateway to good fortune. Early settler John Stevens bought the land from the federal government in 1849 to sell as business parcels. The neighborhood boomed and became the home of a bustling municipal market that was notorious for snarled horse-and-wagon traffic. During the last four decades of the nineteenth century, hundreds of thousands of laborers and lumberjacks began their quest for employment by disembarking at nearby Union Depot and seeking the labor contractors who scoured the neighborhood. By the early 1900s, however, the lumber industry slumped and the neighborhood became a last stop for unskilled workers and pensioners. Retailers moved to more southern parts of downtown. With the area in obvious decline, the Minneapolis Park Board purchased the Nicollet-Hennepin site—including the city's original Bridge Square—in 1908 for $635,000. The aim was to save the neighborhood. So the first city hall, several flophouses, two dozen saloons, and a dime museum called the 1,000 Living Sights Zoo were razed. Edward H. Bennett of Chicago suggested the general design for a park to occupy the site. The architectural firm of Edwin Hewitt and Edwin Brown drew up the plans for a Beaux Arts pavilion that would sit at the western edge.

Completed in 1915 at a cost of $114,000, the pavilion had an elegant center structure with a domed roof and high entry arches. Colonnades flanked the building on each side. Inside were marble drinking fountains, a tourist office, and rest rooms.

Critics quickly criticized the pavilion as a potential magnet for the homeless and "a million-dollar toilet." More flophouses, bars, and brothels sprouted in the Gateway area, and when the Great Depression arrived, the critics' fears came true. The unemployed and the unemployable became the main users of the park and pavilion. By 1950, shattered bottles and trampled shrubs frequently surrounded the pavilion.

Bulldozers leveled the park in 1954 as an early part of a massive effort to renew the neighborhood. For a short while Gateway Park remained a barren and fenced wedge. Eventually, commercial buildings and high-rise residences took over the site.

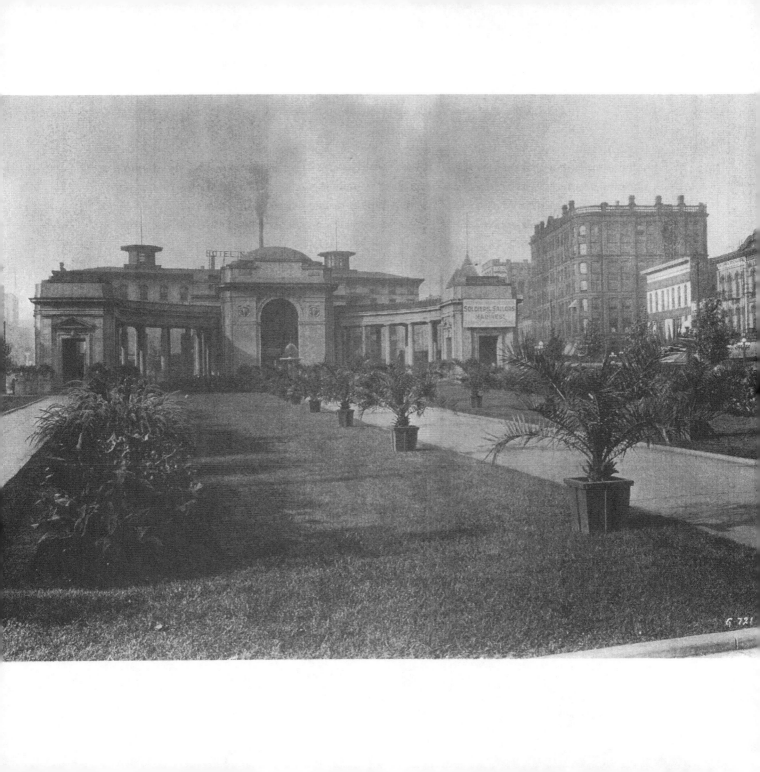

Idea House I

Bryant Avenue South at Groveland Place
1941–62

DURING THE 1930S, AMERICAN MODERN-ART MUSEUMS grew increasingly interested in exhibiting and promoting notable examples of design and architecture. In 1941, the Walker Art Center in Minneapolis made a big splash by becoming the first museum to erect and display its own working house, anticipating by several years the famous Case Study Houses that the journal *Arts and Architecture* commissioned later that decade.

Malcolm Lein of the St. Paul firm Lein, Tudor & Bend designed the dwelling, which cost just under $7,000 to erect and received the name Idea House. Occupying wooded land behind the Walker, the house was intended to provide inspiration for virtually any kind of new home that visitors might be considering.

And visitors came in large numbers—about fifty-six thousand over time—along with newspaper and magazine reporters from around the country. Among the house's first guests after its June 1941 opening was a group of Aquatennial Queen aspirants.

According to Bruce N. Wright, whose article in the summer 1993 issue of *Hennepin History* documented the home and a second experimental house (Idea House II) that the Walker later built nearby, Idea House I contained many innovative features: an open design in which the living and dining spaces flowed into one another, a high-efficiency fan that could replace all the air in just ten minutes, and a striking kitchen with all electric appliances and stainless steel walls and ceiling.

Eventually, Idea House became a residence for Walker staff members. Martin Friedman, then curator and later director of the Walker, lived in it with his wife, Mickey, and family for a time in the late 1950s. "At least by the time we lived there, the practice of people walking through on tours had ceased," Friedman later remembered, although people attending Walker jazz concerts sometimes came in to use the bathroom.

Idea House I survived only a few more years, to 1962, when it was razed to make way for the Guthrie Theater.

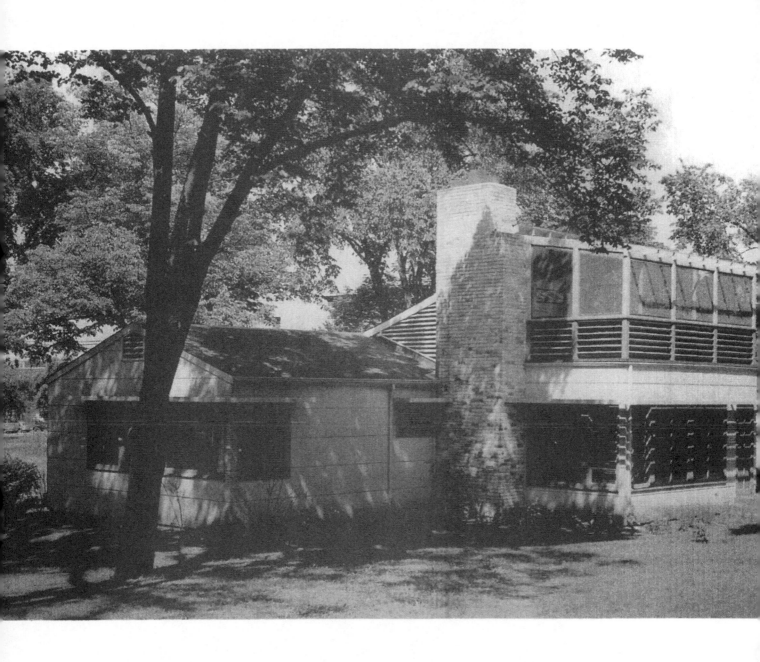

Kenwood Armory

Lyndale Avenue at Vineland Place
1907–34

THE OLD KENWOOD ARMORY SLOUCHED from the beginning. Between 1907 and 1934 it occupied the site of today's Minneapolis Sculpture Garden, land originally a swamp of peat and quicksand. Before the building even opened, Minneapolis officials twice condemned all of its interior concrete work (which had started to crack due to the sinking of the foundation) and dismissed the contractor. On January 8, 1907, for better or worse, the armory was dedicated in a public ceremony.

It replaced the city's first armory building, which stood on Eighth Street between Marquette and Second Avenues. That brick structure, however, had become far too small for the city's burgeoning militia, which numbered four infantry companies, an artillery battery, and a regimental band.

In addition to serious troubles with the swampy soil, another problem briefly hindered construction of the building: protests by the Humane Society, which grieved the entombment of numerous sparrows as the armory rose. Despite the society's dissent, the Kenwood Armory finally opened, and inside the doors of its fortress-like exterior, it contained a 22,000-square-foot drill hall, a gym, a rifle range, and a rehearsal space for the band. The militia, though, did not move into the building until the initial temporary occupants—gawkers attending the city's first automobile show—vacated the premises.

Over the next two decades, only the building's tenuous grip on the limestone base of Lowry Hill prevented a complete collapse. Meanwhile, the armory and its grounds hosted military exercises (few in number because officers feared the unsettling effect of marching), boxing matches, and concerts by such artists as violinist Jascha Heifetz and John Philip Sousa and his band.

The beginning of the end came in 1929, when alarmed military engineers determined that the armory was in immediate danger of falling down. Condemned and vacated that year, it remained empty until 1934, when a crew of workers razed it.

Two years after its demolition, the armory still left a sinking feeling in the hearts of Minneapolis City Council members, who had to dispose of the building's leftover furnishings: two thousand dilapidated folding chairs, 225 kitchen chairs, a lawn mower, and a pair of sink plungers. They bequeathed the items to their Ways and Means Committee.

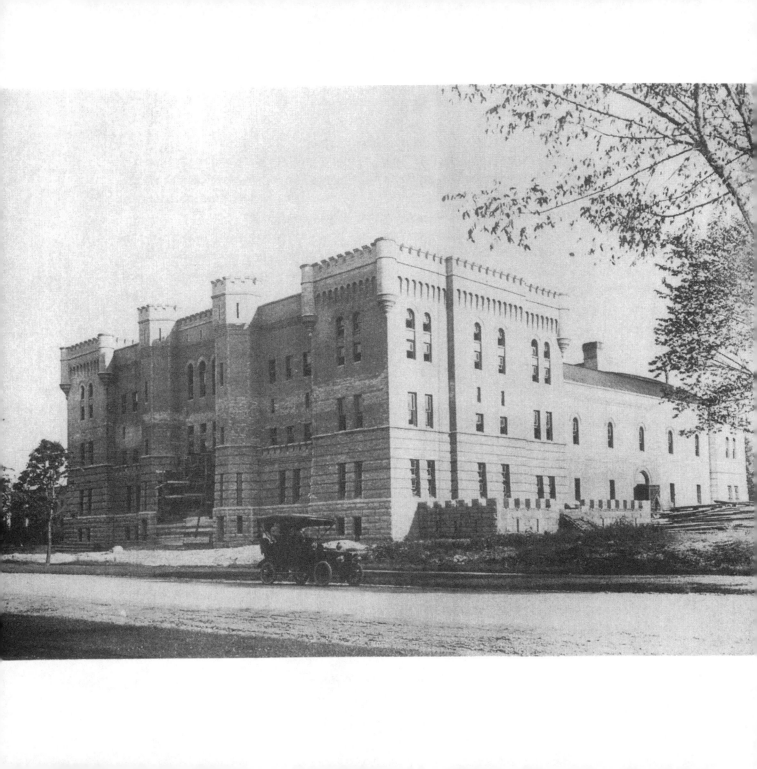

Lutheran Brotherhood/Minnegasco Building

701 Second Avenue South

1956–97

THE PRESERVATIONISTS WHO IN 1997 WATCHED the demolition of the glass- and enamel-faced building at Seventh Street and Second Avenue South in downtown Minneapolis must have felt at least a flicker of satisfaction. Only slowly did the corporate international style structure, former headquarters of both the Lutheran Brotherhood and Minnegasco, yield to the wrecking ball.

The unfortunate saga of this never-adored-but-now-lamented property began in 1954, when the Lutheran Brotherhood bought and cleared the land—which was home to such businesses as Willar's Garage and Lee's Broiler—for its new home. After fifteen months of construction, it unveiled the first major downtown office structure since the 1930s, a round-cornered building (and annex) with a cool-green cantilevered face that mysteriously floated atop recessed walls of native rock set in place by mason Orin Grumbrill of Emily, Minnesota. It was the first curtain-wall high-rise office building in Minnesota. The architects were Perkins & Will of Chicago.

Inside, the six-story building had elevator entrances trimmed with Italian Chiaro marble and garnet, a lobby floor laid with red tiles, an advanced climate-control system that reported the conditions of every zone of the building, a 147-square-foot stained glass library window depicting Martin Luther, four mosaic panels in the executive wing, and two floor-to-ceiling glass walls. These huge windows looked out on a striking below-ground courtyard and terraced garden that won a national landscape award in 1957.

As downtown rose around it, many people came to see the building as short and very '50s-looking, not a good combination for affectionate remembrance. In 1967–68, the Lutheran Brotherhood raised the main building by two stories and the annex by one, but it was not long before the organization needed even larger quarters. It moved out in 1981 (taking the stained glass window with it), and Minnegasco soon became a tenant.

After Minnegasco's departure in 1995, the Minneapolis Heritage Preservation Commission and the city's planning staff recommended the building for historic protection. The city council did not allow this designation, paving the way for demolition. Opus Corporation filled the block with a larger and taller office tower.

MINNEAPOLIS

28

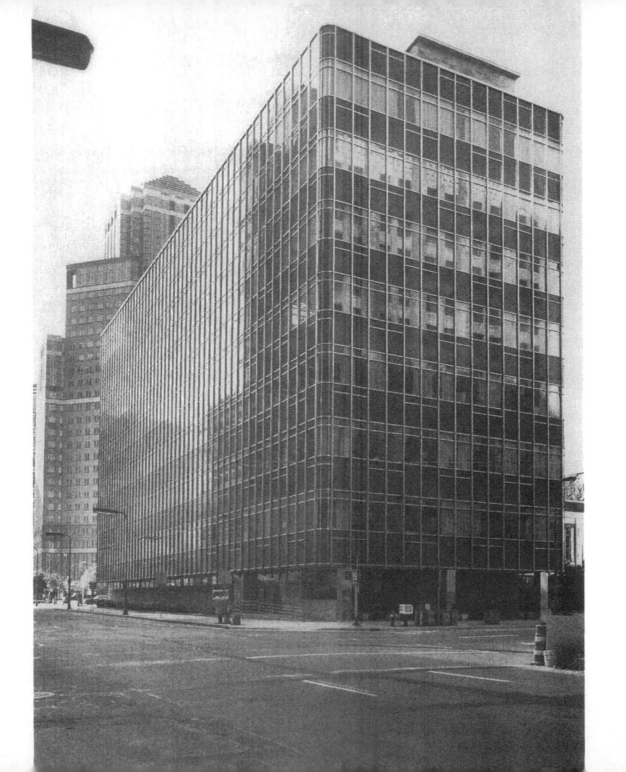

Maple Hill Cemetery

Northeast Minneapolis
Founded 1857

GRAVES DESECRATED, TOMBSTONES VANDALIZED, coffins and human bones exposed to public view: although this may read like events from a bad horror movie, it is part of the story of one of Minnesota's most historic—and now vanished—cemeteries.

Dedicated as a private burial ground in 1857, Maple Hill Cemetery covered 10 acres in the area bounded by East Broadway, Sumner, Polk, and Fillmore Streets in Northeast Minneapolis (then the village of St. Anthony). During the cemetery's first thirty years, about five thousand people found their final resting places there, including some of the earliest white settlers of Minneapolis and Civil War veterans.

Maple Hill's management never ran a tight operation, however, and by 1889 the burial records were a mess and the grounds unkempt. Government officials closed the cemetery to future burials. In 1893, Minneapolis extended Fillmore and Polk Streets through the cemetery grounds and gave families notice to relocate hundreds of bodies. Only two did so, and the city's engineering department moved more than thirteen hundred remains to other cemeteries. One neighbor later recalled that "the caskets were covered with glass, and as the men were digging we'd hear the tinkle of the glass breaking. . . . Just the skeleton would be left."

In 1908 the Minneapolis Park Board took possession of the land. At first it kept the cemetery intact and developed an adjacent 10 acres into Maple Hill Park. But vandalism and wretched maintenance plagued the burial ground. Nearby residents complained in the newspaper that the cemetery was "an eyesore, loaded with rubbish and so neglected that many of the caskets are exposed to view!" Police in 1916 arrested George T. Frost and Frank O. Hammer on suspicion of destroying monuments and throwing them into a ravine, but a jury acquitted them.

Soon after, the park board removed most of the remaining grave markers and enlarged Maple Hill Park to include the cemetery. In 1948, the park was rededicated as Beltrami Park, named after the colorful Italian adventurer Giacomo Beltrami, who explored Minnesota in the nineteenth century. Today, only one remaining grave marker and a monument dedicated to the Civil War veterans hint that the park was ever a home for the dead.

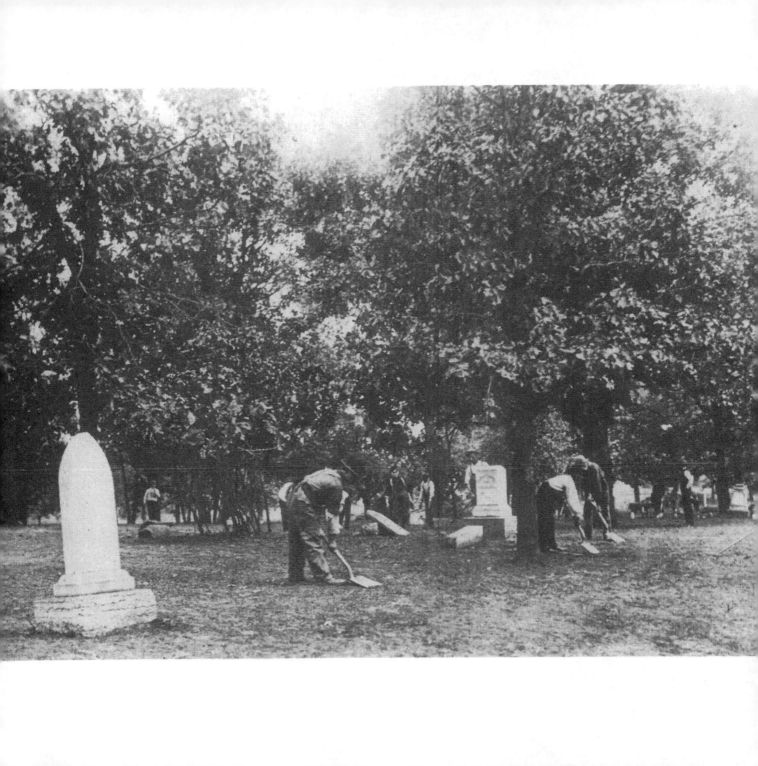

Metropolitan Building
(Northwest Guaranty Loan Company Building)

South Third Street at Second Avenue South

1890–1962

THE RAZING OF THE METROPOLITAN BUILDING—certainly the most famous lost property in Minnesota's history—is often credited as the spark that ignited the historic preservation movement in the state. For several years during the late 1950s and early '60s, as its demolition loomed ever closer, the building symbolized the philosophical differences between preservationists who valued the Metropolitan's beautiful recall of a past era and Gateway District renewers whose vision of a modern Minneapolis did not include poorly utilized skyscraper relics.

The Metropolitan, though, was more than just a symbol. People worked there. One of the building's longer-tenured workers at the end was Wally Marotzke, a janitor who joined the maintenance staff in 1941 and was the last worker to leave the building when it closed down. "I don't mind getting fired or laid off legitimately," Marotzke told a *Minneapolis Tribune* reporter in 1961, "but this is a bad way to lose a job. And those last days were tough. Last thing I did was empty all the pipes in there—every darn one. I hated it. I was getting the Met ready for the ball and hooks crew."

Receiving the ball and hooks was an unkind fate for a building that had opened seventy-two years earlier to recognition as not only the nation's tallest building west of Chicago, but as the skyscraper with the most imaginatively designed interior of any in the country. Louis Menage, chief officer of the Northwestern Guaranty Loan Company, engaged architect E. Townsend Mix to design the building. Mix created a structure affectionately known as the "small red mountain," a 12-story, 100,000-ton building constructed of red sandstone on the upper nine floors and green granite on the lower levels. The street-level entrances were of gargantuan proportions, with doorways 22 feet high and 15 feet wide. An observation tower soared 50 feet above the roof and commanded a legendary view of the city.

Inside, however, Mix really gave the building distinction. A symphony of glass and iron, the inner court rose the full height of the building to a glass roof. Glass-floored balconies on each level were decorated with magnificent ironwork estimated to cost $165,000 (about $3 million in today's dollars). Six elevators glided up more than 220 feet. One elevator operator, Leuie Emond, spent fifty-five years inside the metal cages beginning in 1892. He moved vertically eighteen miles a day and upon his retirement estimated that he had hoisted twenty million passengers visiting the building's four hundred offices.

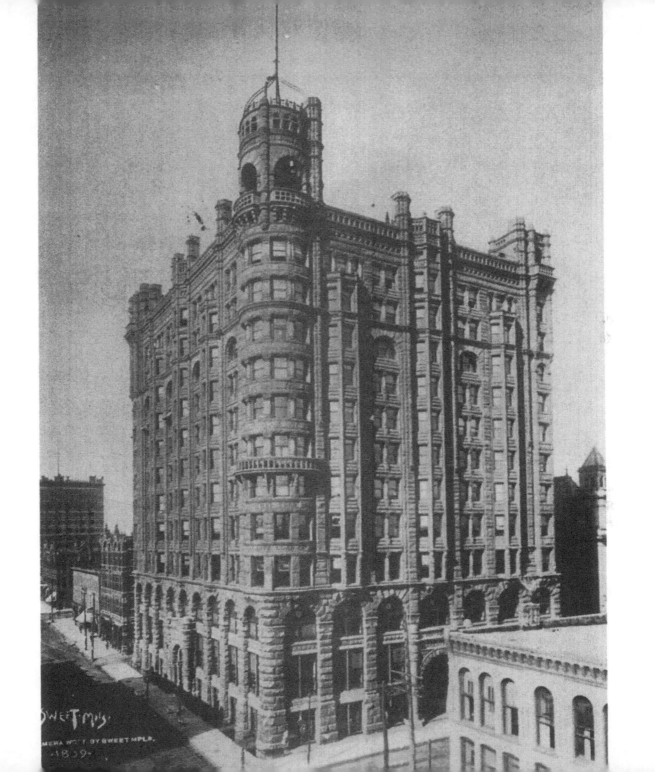

SWEET, MPLS.

CAMERA WORK BY SWEET MPLS.

1899

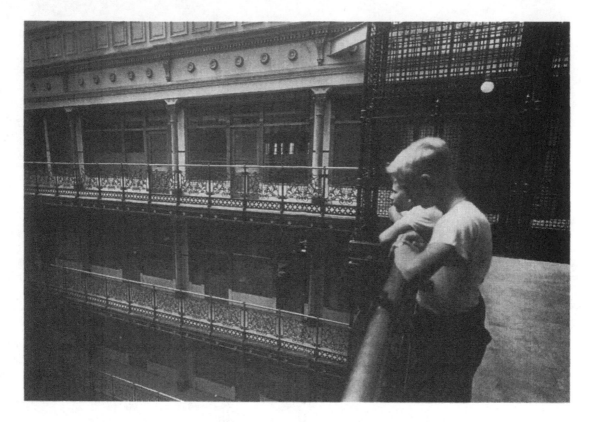

Menage became involved in several notorious real estate scandals during the 1890s and fled to Guatemala. The building's next owner was the Metropolitan Life Insurance Company, which lent its name to the edifice for the remainder of its years. The building changed hands several times in subsequent decades, finally ending up in 1946 in the possession of Henry Michael and Melvin Hansen. These new owners found the Metropolitan in the path of a massive renewal project of the Minneapolis Housing and Redevelopment Authority (MHRA) intended to clean up the Gateway District.

By 1960, while still retaining its architectural and historic distinction, the Metropolitan was no longer the high-grade office space it once was. An insect extermination firm occupied street-level space that once housed more prestigious tenants. The top-floor roof garden, formerly a lushly planted retreat from urban congestion, now held the maze-like offices of the U.S. Army Audit Agency. The MHRA

claimed that the Metropolitan had grown into a good candidate for demolition. It cited the building's numerous maintenance problems, economic undesirability, unfashionable appearance, below-code utilities, inefficient layout, and deteriorating exterior as reasons to level the old building.

After a protracted legal battle, the MHRA defeated the preservationists and the Metropolitan awaited destruction. Hundreds of Minnesotans wanted to purchase sections of the building's celebrated ironwork, and pieces ended up in homes and businesses throughout the region. A Wisconsin construction company picked up 350 feet of railing for use in a Hudson motel.

When the demolition commenced at the end of 1961, wreckers found the Metropolitan difficult to destroy. Exterior stones, some weighing 1,500 pounds, required the force of power winches to remove. The razing was completed the following year. "The future generations are gonna read about this building and they'll see some of the buildings they're putting up here and they'll damn us, they will, for tearing down the Met," janitor Wally Marotzke predicted.

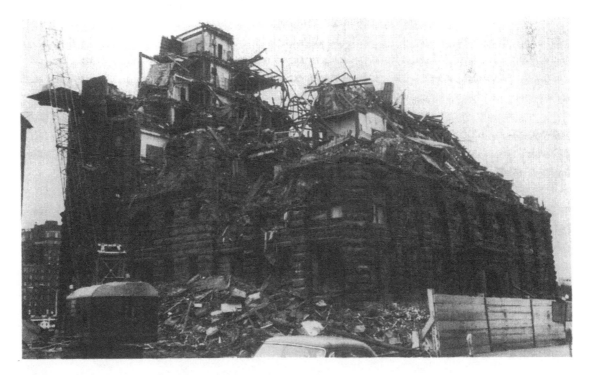

Minneapolis Auditorium and Convention Center

Grant Street at Stevens Avenue
1927–88

A FORMER MINNEAPOLIS MAYOR SUGGESTED placing it at the north end of Loring Park, where, he noted, the nearby lake could allow it "to rival in beauty the famous Taj Mahal." Lumber baron T. B. Walker nominated the juncture at Hennepin and Lyndale Avenues. Other civic-minded brainstormers offered the East Bank of the Mississippi River, Nicollet Island, the Parade Grounds, and the corner of Twelfth Street and LaSalle Avenue as possible locations.

In the end, in 1924, the Minneapolis City Council voted to build a new civic auditorium at Grant Street and Stevens Avenue, just southwest of downtown, where neither congestion nor loss of recreational space was a concern. The city's first civic auditorium, a building at Eleventh and Nicollet designed in 1904 by Bertrand & Chamberlin, had become too small and inflexible.

The city council chose Francis Boerner and Ernest Croft to design the new facility, and by early 1925 some two dozen buildings—including a gas station, garages, and rooming houses—had been cleared from the site. Although the original plans called for the construction of a huge central arena joined by a convention hall to the west and a concert hall to the east, budgetary constraints lopped the convention and concert areas off the design. The central arena that remained was completed in 1927.

Built for $3 million, the auditorium was faced with brick and Indiana limestone. An eye-catching, red-cement tile roof and a stone roof temple crowned the structure. Brown Mankato stone and terrazzo-patterned floors decorated interior lobbies. Above the 42,000-square-foot exhibition hall was a 92-foot-high arena and stage with 10,545 seats.

The auditorium, which served the city over the next six decades, sported the world's second-largest pipe organ, housed countless trade shows and exhibitions, and gained some notoriety when a famed boxing kangaroo got its tail caught in an elevator and developed fatal gangrene. In 1949, a small addition was added on the west end, and twenty-six years later a $15 million convention hall was built on the south side. The auditorium was razed in 1988 to make way for the current convention center.

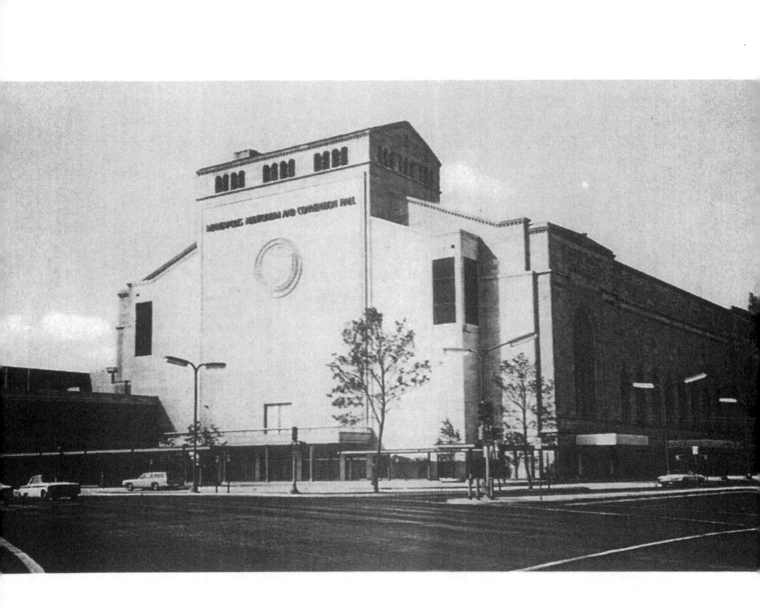

Oak Grove House

Cedar Lake Avenue
1870–92

MINNESOTA ARCHITECTURALLY LAGGED BEHIND the times when Mr. and Mrs. E. D. Scott built the Twin Cities' first eight-sided house in 1870. About fifteen years earlier, hundreds of octagon houses had been raised in the East, inspired by the 1853 publication of a book by Orson S. Fowler, which promoted such homes as healthful.

The Scotts were Philadelphians who had bought 80 acres on the shore of Cedar Lake in Minneapolis. They wanted to build a lodging house that would draw Southerners who came to Minnesota to convalesce from malaria and tuberculosis. The house they eventually constructed closely matched the specifications Fowler had outlined in his book. A porch that may have encircled the building, for example, allowed visitors to sit out in the sun at almost any time of the day. The basement, situated well above ground level, supposedly protected the main living areas above from fluctuations in temperature. The house contained forty guest rooms and boasted a then-unusual concrete and stucco construction.

The Oak Grove House attained some success, at least initially. Guests included U.S. Supreme Court Chief Justice Salmon P. Chase and U.S. Vice President Schuyler Colfax. Over the years, however, the Scotts' religious convictions proved a business liability. They refused to serve liquor on Sundays, and the house became a money loser. They devised a plan to turn the house into an orphanage but could not come up with the necessary financing.

Finally, in the mid-1880s, the Scotts sold the house to Judge Edwin Jones, a Twin Cities philanthropist. By 1888, Jones had rechristened the octagon house the Jones-Harrison Home for elderly women. Within five years, though, poor construction made it unsafe for occupancy. Jones demolished the former Oak Grove House in 1892 and replaced it with a second Jones-Harrison Home at the same site on Cedar Lake Avenue. That building remains today.

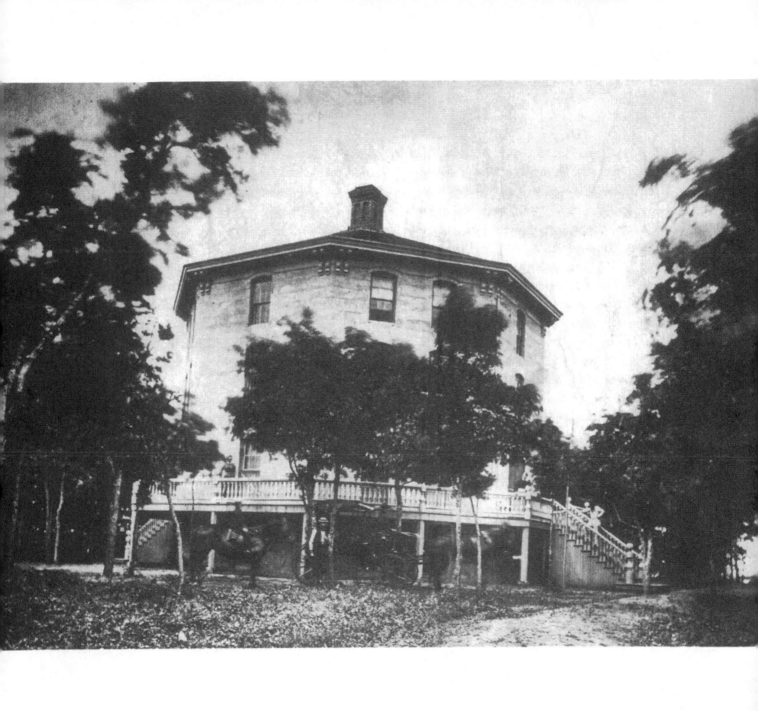

Orpheum Theater

21–27 South Seventh Street
1904–40

ECHOING WORDS THAT HAVE BEEN APPLIED to buildings ranging from City Hall to the Metrodome, the *Minneapolis Journal* trumpeted the 1904 completion of the Seventh Street Orpheum Theater as "the newest and most striking evidence of the fact that Minneapolis is assuming more and more of a metropolitan tone." No one, at any rate, could deny that the city's first home for major-league vaudeville, built for $300,000, was a luxurious eyeful. The 2,000-seat theater had a terra-cotta facade with speckled brick and glass; a brilliant electric sign and illuminated clock; marble and mosaic detailing in its rotunda; a 32-foot-high proscenium arch painted red, green, and gold; and solid bronze drinking fountains that spouted artesian well water.

The Orpheum Theater chain, which operated vaudeville halls in a dozen other American cities, assigned virtually all contracting work to Minnesota firms. It charged Kees & Colburn, which previously designed such city landmarks as the Donaldson Glass Block, the Powers Arcade, and the Northwestern National Bank Building, with the theater's overall design. With 150 to 250 laborers constantly at work, the building rose in less than six months.

Because of fires that destroyed large theaters in other cities, Kees & Colburn placed special emphasis on making the Orpheum fireproof. With twenty-one separate exits, a sparing use of wood in its construction, an asbestos stage curtain, and isolated brick chambers for the dressing rooms, scene shops, and underground electric power plant, the building seemed nonflammable. The theater's promoters were proud of the four 600-step fire escapes, which could hold three thousand people.

When a second Orpheum Theater on Hennepin Avenue opened and vaudeville began its decline in the 1920s, management needed to find other uses for the theater. In 1930, it underwent a $40,000 remodeling to accommodate talking pictures. Eventually, though, the theater became unprofitable, and it was leveled in 1940 to make way for a parking ramp.

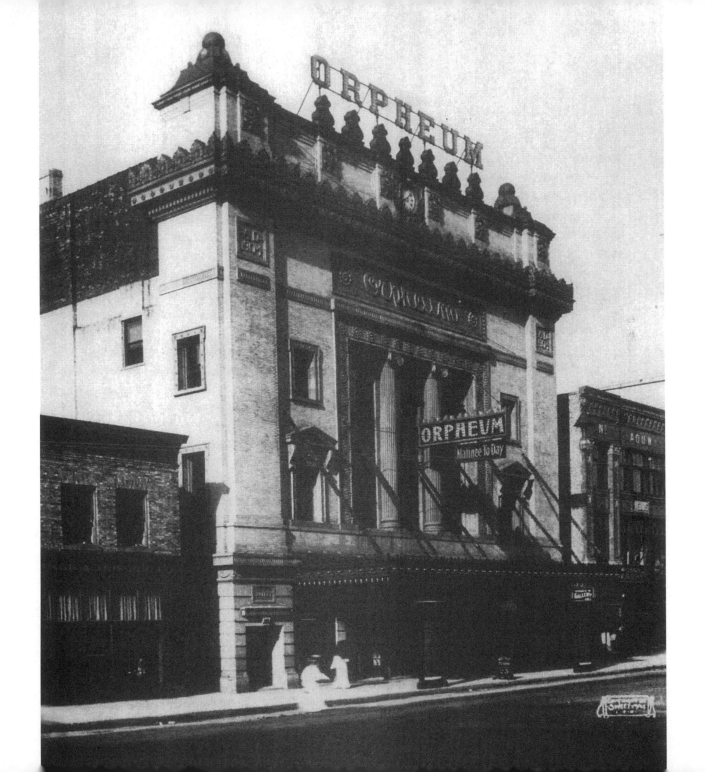

Pioneer Square

First Street at Marquette Avenue
1934–67

PIONEER SQUARE, A SWATH OF OPEN SPACE and greenery created in an early phase of the reclamation of the Gateway District of downtown Minneapolis, itself became the victim of urban renewal after only thirty-three years of existence.

For years, the area bounded by First and Second Streets and Marquette and Second Avenues had been one of the Gateway's worst stretches, full of dilapidated buildings and filthy alleys. In the early 1930s, the federal government demanded that Minneapolis clean up the block as a condition of the opening of a new main post office across the street. The city purchased the block for $320,000, razed all of the buildings, and spent another $80,000 to lay grass, build walks and curbs, set up a sprinkler system, and install benches. This new oasis became Pioneer Square, an elegant entryway to the post office building.

By 1936, work on Pioneer Square was finished. The final addition had been a centerpiece sculpture commissioned from Minneapolis artist John K. Daniels. Titled *Pioneers,* it depicted a pioneer family, sheaves of grain, and the meeting of Father Louis Hennepin with the Indians of the region. Including the foundation, the all-granite work weighed about 500 tons and stood 23 feet high.

From the moment of the statue's dedication, Pioneer Square was regularly coveted for other uses. As early as the 1940s, city planners considered the park as a site for a parking ramp, and in 1951 the director of Minneapolis's federal public buildings administration proposed the construction there of the city's first public atomic bomb shelter. Meanwhile, the city grew so lax in its upkeep of the square that sculptor Daniels, at the age of seventy-four, took it upon himself to clean the statue with ladder, mop, and pail.

By the mid-1960s, broken glass and trash were winning their battle against the grass. When the site came under consideration for urban renewal and an expansion of the Towers Apartments, Pioneer Square had few defenders. It passed into private hands in 1965 and vanished two years later. The *Pioneers* sculpture survived, ending up in a much less prominent spot at Fifth Avenue and Northeast Main Street.

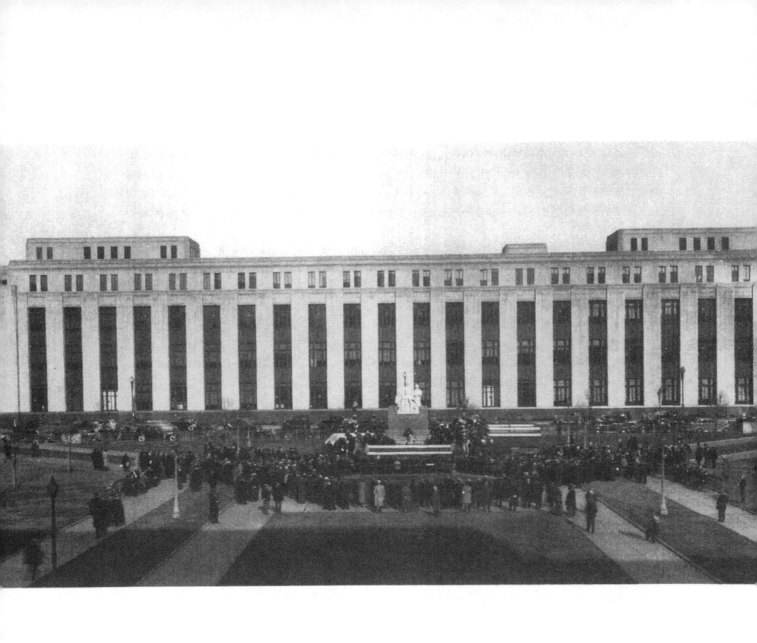

Plaza Hotel

1700 *Hennepin Avenue*
1906–60

FOR YEARS, THE JUNCTURE of Lyndale and Hennepin Avenues at the foot of Lowry Hill in Minneapolis was known simply as "the bottleneck"—a jam-up of autos and streetcars, all moving in non-perpendicular directions. In 1960, in an effort to clean up the traffic problems and permit Interstate 94 to burrow beneath the area, engineers redesigned the streetscape. They also ended the life of a hotel full of character.

That hotel, the Plaza (shown here just after its completion), was built in 1906 by Walter J. Keith. It occupied most of an island in the Hennepin-Lyndale intersection, at Kenwood Parkway. To the east was Loring Park and to the west were the Kenwood Gardens (now the site of the Minneapolis Sculpture Garden).

Sedate on the outside, the 175-room Plaza betrayed through its interior its aspirations of elegance. A dining room with hanging tapestries, a gold-leaf ceiling, and floor-to-ceiling mirrors offered formal meals nightly. The grand assembly room was filled with wicker furniture. For a few years, a roof garden gave splendid views of the park. Italian tenor Enrico Caruso stayed at the Plaza, as did the actress Sarah Bernhardt. The hotel generated its own electricity, operated a genteel speakeasy during Prohibition, and hosted many of Minneapolis's most glittery social events.

The Plaza plodded through the years, its water pressure dropping, its clientele becoming more residential, and its glamour fading. In 1955 a new owner, Fred A. Ossanna Jr., completed a $400,000 renovation that gutted the building, added a new restaurant called the Aztec Room (complete with an "Aztec sun disc"), changed the hotel's name to the Park Plaza, and furnished the guest rooms with formica tables. The Caruso Suite went for $30 a night, and all of the hotel maids received makeup and grooming instruction. Ossanna's plans for further improvements ended when he was convicted of skimming illegal profits from his earlier involvement with the Twin Cities Rapid Transit Company.

The Plaza spent a short time as a residential club for senior citizens, but then Interstate 94 roared into town. With the payment of $695,000 to its owners, demolition began in November 1960. Interstate 94's northern entry into the Lowry Hill tunnel now occupies the site.

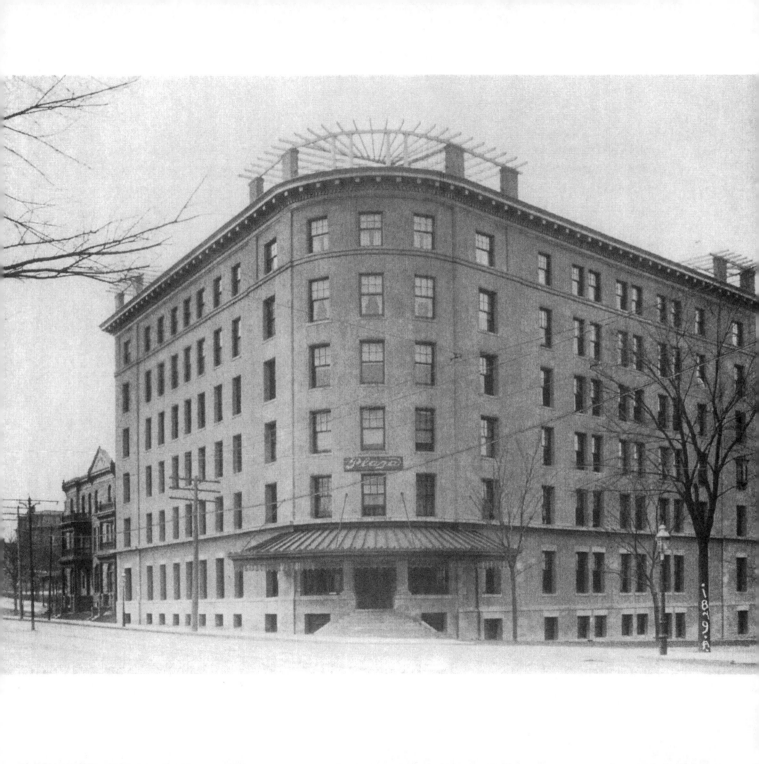

Pond Brothers' Cabin

East Shore of Lake Calhoun
1834–36

THIS CABIN, THE FIRST RESIDENCE BUILT by European American settlers in the lakes area of what is now Minneapolis, belonged to a pair of zealously evangelistic brothers, Gideon and Samuel Pond. Natives of Connecticut, they traveled to Fort Snelling in 1834 in search of opportunities to convert the Dakota Indians to Christianity. The Ponds were poorly prepared for their task—lacking religious ordination, experience as missionaries, and knowledge of the Dakota language—but Chief Cloudman at the Indian village by Lake Calhoun welcomed them.

Cloudman, in fact, selected the site of the Ponds' cabin: a spot atop a glacial moraine on Lake Calhoun's east shore, where the two missionaries could enjoy a view of the lake's plentiful loons. Using poles from the tamarack groves on the lake's west edge, tree bark, split logs, and recycled wooden slabs from an old government mill at the Falls of St. Anthony, the brothers built a cabin that measured 12 feet by 16 feet, with 8-foot ceilings and a cellar.

The cabin did not last long as the Ponds' home. Soon an ordained minister named Jedediah D. Stevens set up his own missionary activities at the northwest shore of Lake Harriet, and the Ponds abandoned their home in 1836 in order to help Stevens with his work. Later that year, when the Dakotas fell into a series of battles against the neighboring Ojibwes, Cloudman's people dismantled the cabin to use its materials to fortify their village.

The site subsequently was home to a diverse series of buildings. In 1877, land developer William S. King built there the Lake Calhoun Pavilion, a large hotel later known as The Lyndale. After a fire destroyed this structure in 1888, the next building to occupy the site was the Forman Mansion, a Classic Revival house built around 1900. The Forman Mansion lent its southern plantation looks to the land until its demolition in 1955. Finally, in 1957, the congregation of St. Mary's Greek Orthodox Church raised a new church on the site, a building designed by Thorshov and Cerny that still stands.

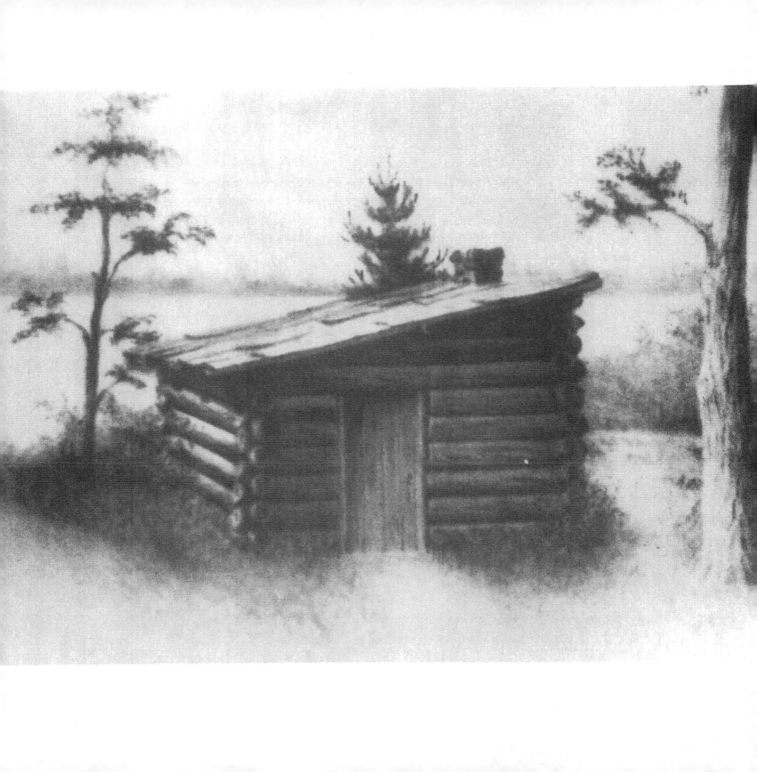

Radisson Hotel

41–43 South Seventh Street
1909–82

WHEN EDNA DICKERSON, THE MANAGER of a court-reporting school in Chicago, arrived in Minneapolis in 1907 to collect a multimillion-dollar inheritance, she probably had no idea how much attention she would receive. George Draper Dayton and other members of the business community wasted no time in telling her about the luxury hotel they believed was needed for the site next to Dayton's five-year-old department store. Dickerson plunked down $1.5 million to start the Radisson Hotel on its way.

The hotel, designed by the firm Long, Lamoreaux & Long of Minneapolis, began to rise in mid-1908. At the time, its 16-story height made it the second-tallest building in the city. The impressive street entrance boasted a 50-foot-long canopy of glass and iron, marble columns, and a glass-enclosed taxicab stand. William Frederick Behrens of New York designed the interior, adopting a French Renaissance style with copies of French period furniture, parquet floors, Circassian walnut walls, and patterned pink-and-gray marble lobby floors.

When the hotel opened on December 15, 1909, it had 425 rooms (prices ranging from $1.50 to $5 a day), a cigar shop with the capacity to store 1 million smokes, a library, a miniature Viking ship created by Edward Caldwell, a 975-foot-deep artesian well for drinking water, an electric revolving door, and a 6,500-square-foot kitchen. Each room had a telephone.

For twenty-five years, Edna Dickerson operated the hotel (pictured here in 1911) with her husband, Simon Kruse. The couple occupied the hotel's thirteenth floor. They opened the famous Flame Room in 1925, grew fruits and vegetables for the hotel on a farm in Anoka County, and established the Radisson as one of the Midwest's finest hotels. In 1934 they ran into financial problems, and a mortgage company acquired the property. Soda bottler Tom Moore, a later owner, began renovating the hotel in 1947. He raised the room total to 565 and eventually refaced the building with a pink-and-white facade. Two decades after Curt Carlson bought the hotel in 1962, he decided he wanted a new hotel on the site.

The Radisson closed in November 1981, and its $1 million demolition took place the following year. Its successor, the Radisson Plaza Hotel Minneapolis, opened in 1987.

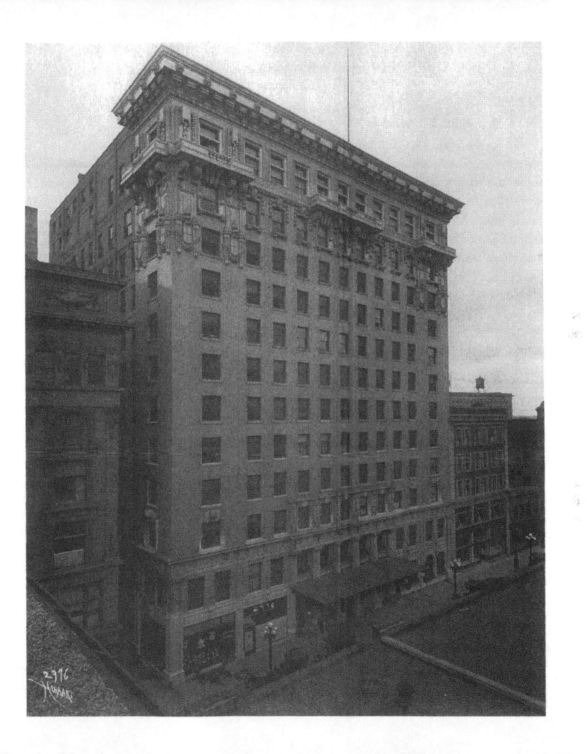

St. Mary's Russian Orthodox Greek Catholic Church

Fifth Street at Seventeenth Avenue Northeast
1888–1904

AT THE END OF THE 1880S, a small church was built in northeast Minneapolis. Because this was a time of many church raisings, probably few Twin Citians noticed. But for its tiny congregation and its builders, the new church held great significance.

Located at the corner of Fifth Street and Seventeenth Avenue Northeast, the church was the first American spiritual home of a band of Central Europeans that had settled in Minneapolis in 1878. The first of these Russian Orthodox immigrants came from the Carpathian Mountain region of Austria-Hungary (now part of Slovakia). Nearly one hundred compatriots followed over the next ten years to Northeast Minneapolis, where they abandoned the practices of the Uniate Church, the state religion of the Austro-Hungarian Empire that they had been forced to follow for decades, to embrace Holy Orthodoxy, the religion of their ancestors.

Two congregants, carpenters Peter Dzubay Jr. and Stephen Reshetar, directed the raising of the building during the winter of 1888. Lacking cupolas or other Byzantine characteristics often found on Russian Orthodox churches, the wood-frame structure had a tiny central entry, above which rose a small bell tower, crowned with the triple-barred Greek cross. Rows of arched windows admitted light into the chapel.

The parishioners christened the church St. Mary's. The meager funds available permitted only simple interior furnishings. A plain altar table occupied the east side of the chapel, facing a belfry on the opposite end. Over the next six years the congregation remodeled the interior, adding a more ornate altar table along with European-imported icons and iconostases (elaborately carved screens that shield the sanctuary from the main body of Eastern Orthodox churches).

By the turn of the century, the congregation had grown to about three hundred people. But tragedy lay ahead. "God tested the faith and love of His parishioners by a misfortune that occurred in 1904," a history of the parish relates. On January 24 of that year, as the temperature plummeted to 30 degrees below zero, a fire erupted in the church. The building was a total loss.

Church members rebuilt on the same site, this time using the Omsk Cathedral in Russia as their model. The new structure completed in 1906—to which Czar Nicholas II pledged more than $1,000—is larger and more resistant to fire. It continues to this day to serve a vital ethnic community as St. Mary's Orthodox Cathedral.

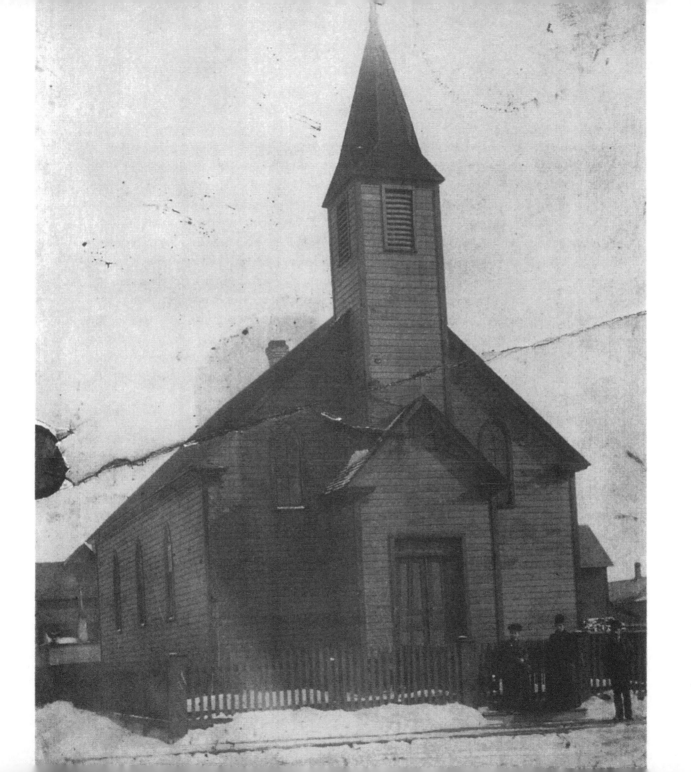

Spirit Island

Mississippi River
Demolished 1960

WHEN THE FRANCISCAN PRIEST Louis Hennepin viewed Spirit Island in 1680, its pyramid peak rose out from the center of the Mississippi River's St. Anthony Falls. One hundred seventy years later, as white settlers began building Minneapolis, the island sat about 1,000 feet downriver of the receding falls. By 1960 Spirit Island had vanished altogether.

Despite its shifting position in relation to the falls, Spirit Island (seen here around 1920) was long a constant presence in the Mississippi, the home of legend. Fredrika Bremer, a Swedish novelist who visited Minnesota in 1850, recorded the oft-told Dakota saga that may well have given the island its name: Ampota Sampa was happy with her Dakota family of husband and two children. One day, however, the husband introduced a second wife into the family. Stricken with grief, Ampota Sampa placed the children into a canoe and piloted it over the edge of St. Anthony Falls. "Their bodies were never seen again," Bremer wrote, "but tradition says that on misty mornings the spirit of the Indian wife with the children folded to her bosom, is seen gliding in the canoe through the rising spray about the Spirit Island, and that the sound of her death-song is heard moaning in the wind and in the roar of the Falls of St. Anthony."

Though Spirit Island—one of a group of Mississippi islands below the falls that also included Meeker, Cataract, and Upton Islands—never had much commercial value, white settlement led to its dismemberment and destruction. In 1854 the federal government deeded the island to George W. Allen, who two years later sold it for $1,000. At this time a rocky isle scattered with hemlock and spruce trees and occupied by a family of eagles, Spirit Island passed through many hands, ending up in the ownership of the St. Anthony Falls Water Power Company (Northern States Power's predecessor) in 1882. Mill-bound logs tumbling over the falls hacked away at the island's edge, and the quarrying of its limestone further reduced its height and length.

Northern States Power returned the island to the federal government in 1957. With the Minneapolis upper harbor project under way in the late 1950s and early '60s, Spirit Island was blocking the approach of boats to the new St. Anthony Falls navigation dock. The Corps of Engineers completely removed the island from the river channel in 1960.

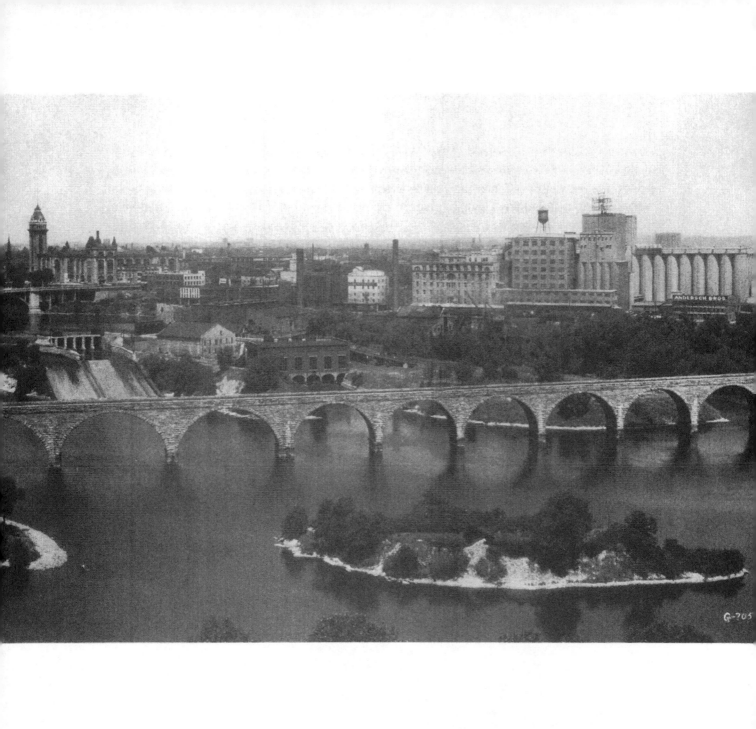

Times Building

Fourth Street at Marquette Avenue
1899–1992

THE VICTORIAN ERA'S VERSION of the shopping mall was the retail arcade, which typically gathered together such merchants as tobacconists, clothiers, and other dry goods retailers on the first floor of an office building. One of the best-known arcades in Minneapolis was housed inside the Times Building at Fourth Street and Marquette Avenue.

Designed by Long & Kees with a Renaissance Revival facade and big arched windows, the 1899 Times Building was originally built for the *Minneapolis Tribune* as part of Minneapolis's impressive Newspaper Row. In 1913 the *Tribune* bought the neighboring Century Building—a five-story structure built in 1890 for the Century Piano Company, complete with a 1,000-seat concert hall—and renamed it the Annex. Then, in 1941, the *Tribune* moved into its current quarters at Fifth and Portland, leaving its former building to the *Minneapolis Times*. At some point, the Times building and the Annex were joined together.

But the *Times* newspaper ceased publication in 1948, forcing the building into a new life as an office structure, with the retail arcade still thriving. That's how things stood until 1978, when the Kerr Companies of Minneapolis bought the property for an ambitious $4 million renovation. Completed the following year, the project moved the main entry from Fourth Street to Marquette, gutted the interior for new office space, removed the arcade, and darkened the exterior.

Over the next twelve years, the renovated structure—now christened the 400 Marquette Building—had a lackluster tenancy rate and changed ownership several times. By 1991, a foreclosure had left it in the hands of Traveler's Insurance, which sold it to a firm intent on razing it for a parking ramp. A brief preservation battle ended with Traveler's convincing the Minneapolis City Council that the changes to the interior had diminished the building's historic value, and it was demolished in 1992— just thirteen years after its expensive renovation.

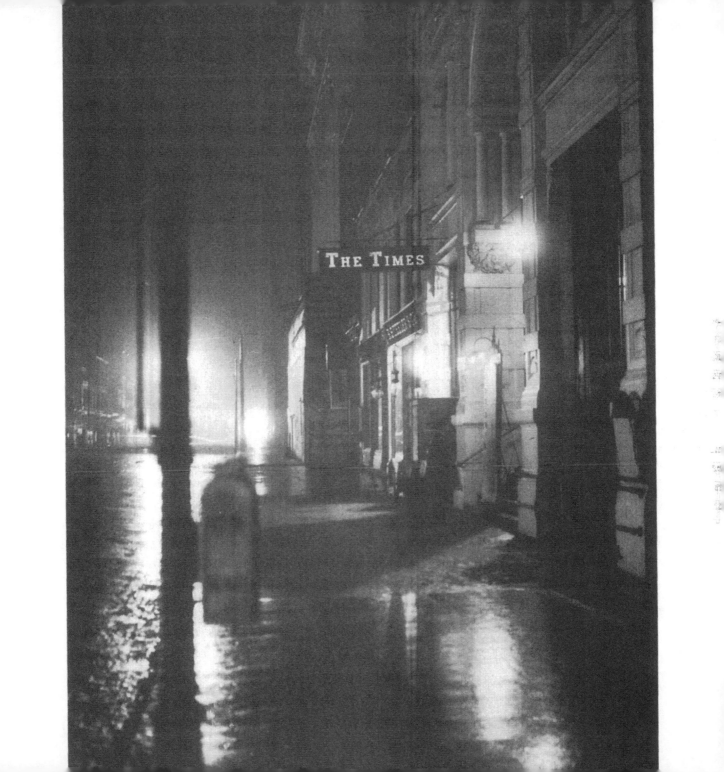

Washburn "A" Mill

Minneapolis Milling District
1874–78

IN 1878, THE WASHBURN "A" MILL on Minneapolis's East Bank of the Mississippi River put the city in the headlines of the nation's newspapers—not because of its advanced machinery or high flour output but because of the spectacular way in which it self-destructed.

The mill was built in 1874 by Cadwallader Washburn, a Minnesota milling magnate who wanted to tap the rushing waters of the Mississippi to power the largest flour-making facility in the country. It enclosed 13,800 square feet of space on the river's bank, and its limestone walls rose seven and a half stories. Washburn placed its water wheels 45 feet below the ground and imported milling equipment from Austria.

For four years, the mill produced flour that was impressive for both its quality and quantity. Then, at 7:10 P.M. on May 2, 1878, an immense blast rocked the building. University of Minnesota scientists later determined that sparks from the grinding stones had ignited particles of flour suspended in the air. The resulting explosions lifted the roof, which weighed hundreds of tons, 500 feet into the air; killed eighteen people; started a fire and other explosions that destroyed or damaged six other mills; hurled hunks of stone eight blocks away; and shattered windows as far away as St. Paul's Summit Avenue.

The next day, a reporter described the scene, where the ruins would smolder for another month: "Scarcely one stone stands upon another, as it was laid, in the big Washburn mill, and the chaotic pile of huge limestone rocks is interwoven with slivered timbers, shafts and broken machinery from which pours forth steam and water."

Cadwallader Washburn responded to the disaster by hiring architect LeRoy Buffington to design an even larger replacement mill, completed two years later. This new mill, Washburn made sure, included dust-removal equipment and ceramic and metal grinding machines that would not cause sparks. It operated until 1965. It still stands, although fires seriously damaged it in 1991 and 1999, and it will soon be incorporated into a Minnesota Historical Society site that tells the history of Minneapolis's riverfront.

West High School

DURING THE NINETEENTH CENTURY, several structures successively sat at the corner of Hennepin Avenue and West Twenty-Eighth Street in Minneapolis. Even before there were named streets, a small shack, built by a land claimant, rose above the prairie. Next came a farmhouse raised by the Russell family. After the city swallowed up the farmland, the Russells built a brick house on the corner. In 1906, the city bought the plot for the construction of a high school.

Minneapolis architect Edward Stebbins, who frequently worked on schools, received the design contract the following year. The construction budget was $250,000.

West High School—a two-wing brick-and-stone structure with arched entries and a thrusting, pedimented front—opened for public tours in September 1908. Visitors admired the seventy-five rooms, up-to-date science labs, metal and wood shops, and 1,500-seat auditorium. Seven hundred students showed up for classes a few days later.

Soon, however, enrollment exceeded the school's capacity. To expand, the city bought more land reaching west to Humboldt Avenue. By 1917 West High had added a second gymnasium, a music room, and a greenhouse. Now it could accommodate sixteen hundred students. Further expansion came during the next decade, when a muddy pond in back of the school was transformed into an athletic field.

Over the years, West High produced more than its share of well-known alumni. Notables include actress Tippi Hedren, journalist Harry Reasoner, household-hint tipster Mary Ellen Pinkham, entrepreneur Curt Carlson, and surgeon C. Walton Lillehei. (Another West High distinction: none of its basketball or football teams ever made it into a state tournament.)

The final addition to the campus—a new gymnasium—came in 1972. The school closed ten years later, the victim of declining enrollment. The new gym retains life as a YWCA branch, but the rest of the school was razed and replaced by the Kenwood-Isles condominiums in 1984. A stone marker at the corner of Twenty-Eighth and Hennepin bears the high school's name.

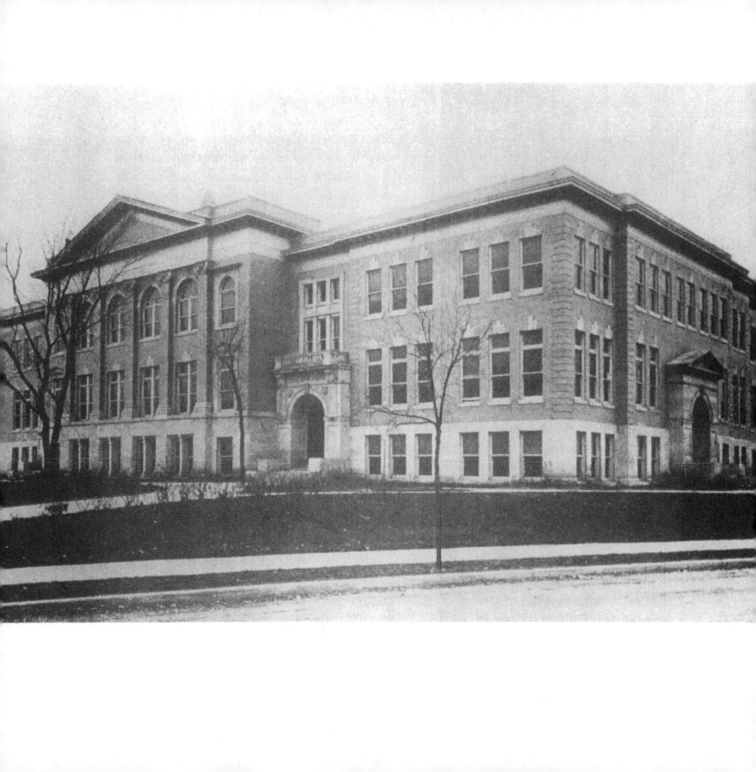

Winslow House

East Bank of the Mississippi River, St. Anthony
1857–87

LAKE MINNETONKA AND WHITE BEAR LAKE were not the Twin Cities' only resort spots in years past. Before those places began attracting tourists, the Falls of St. Anthony and the waters of the Chalybeate Springs had drawn visitors to the Winslow House on the East Bank of the Mississippi River.

When the first suspension bridge spanning the Mississippi was erected in 1855 near the falls and groups of tourists from the South began coming (often with their slaves) to Minnesota for reprieves from the summer heat, hotelier James Winslow decided to build a luxurious hotel for them in the village of St. Anthony (now a part of Minneapolis). He engaged Robert Alden, one of Minnesota's first full-time architects and later the designer of the Academy of Music in Minneapolis, to draw up the plans. Construction of the Winslow House, easily the largest building in town, began in the spring of 1856 and lasted a year.

When it was completed, Winslow had a five-story $110,000 hotel ruggedly built from Nicollet Island limestone. Situated near the east end of today's Third Avenue Bridge, it had more than two hundred rooms, an ornate ballroom and dining room, and $60,000 in furnishings. A distinctive cupola topped the building.

Guests could hear and see the plunge of the waterfall from their windows. Nearby Indian encampments gave Southerners and Easterners the thrill of contact with an unfamiliar culture. And down the steps at the Chalybeate Springs, visitors imbibed glasses of a pungent water supposedly rich in sulfur, iron, and magnesium.

Soon the growing hostility between the northern and southern states greatly reduced the Winslow House's clientele, and the hotel closed in 1861. During its remaining years, the building served as a health spa, home to Baldwin College (now Macalester College), and the Minnesota College Hospital. At one point, land speculators tried to reduce the value of the house by spreading rumors that the building was haunted. Before its razing in 1887—to clear space for the Minneapolis Exposition Building—firefighters saved an Angel Gabriel weather vane that spun atop the cupola, possibly a sample of French ironwork originally intended for the 1854 New York Exposition. It is now on display at the Hennepin History Museum.

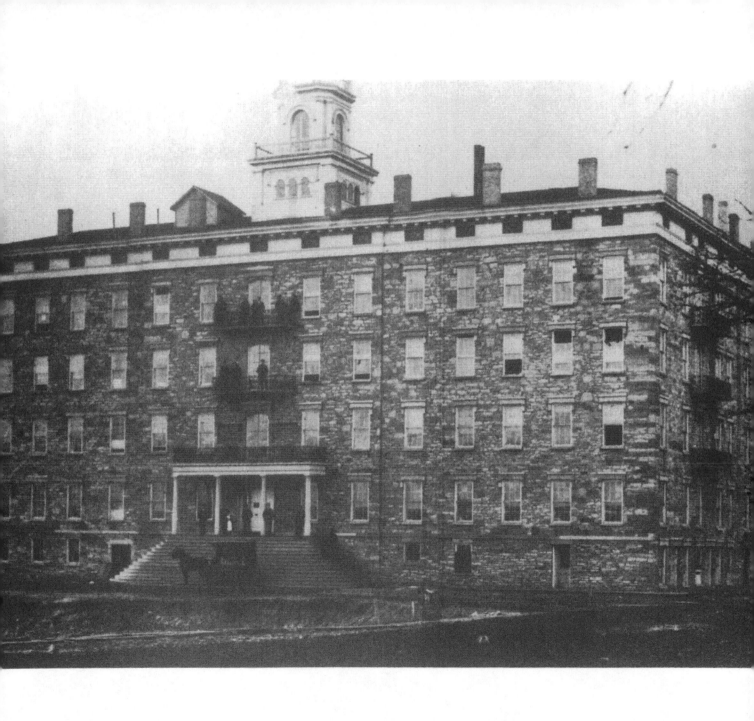

Wonderland Beacon Tower

Lake Street at Thirty-First Avenue South
1905–11

IT WOULD HAVE LOOKED PERFECT atop a California sea cliff or on a speck of a Maine island, but Wonderland's Beacon Tower instead sat in the heart of South Minneapolis. For six years the tower symbolized the electric glamour awaiting Minnesotans at the largest amusement park between Chicago and the West Coast.

Wonderland, built in 1905 by Canadian businessman H. A. Dorsey, occupied land at Lake Street and Thirty-First Avenue South. The designer of the park and its two dozen major structures is unknown, although another of Dorsey's properties, the famed White City amusement park in New Haven, Connecticut, was probably fashioned by the same person.

Fifty thousand visitors poured into Wonderland during its opening day in May 1905, and they strolled, shrieked, and ate amid a peculiar assortment of structures, including an Old Mill whose interior featured artificial stalactites and a replica of the Florida Everglades.

From up to five miles away, however, Twin Citians could see the glow of the Beacon Tower. Outlined by four thousand lightbulbs and standing 120 feet high, it had a powerful marine projector beacon that nightly raked the Minneapolis sky. Its advertising value to the park far exceeded its original cost of about $15,000.

Wonderland's customers could climb the tower's 160 steps for a view of the Mississippi River. Even better, the Beacon Tower hosted on at least one occasion a genuine human-interest drama. On August 5, 1908, Nina Hoke and her groom, A. Krall, stood with a minister on the tiny platform at the top of the tower and took their marriage vows. Down on the ground, as a band struck up the wedding march from *Lohengrin,* a large crowd cheered, and Wonderland's management offered a wedding present of $100 in gold.

Wonderland's honeymoon, though, didn't last long. After an unprofitable season in 1911, Dorsey sold the park to a developer who razed the tower along with the other structures and built houses on the 10-acre site. The beacon had blazed its last.

ST. PAUL

Golden Rule Skyway

Eighth Street near Robert Street

1956–about 1980

MANY MINNESOTANS BELIEVE that two Minneapolis skyways built in 1962 to connect the North-star Center with the old Northwestern National Bank Building and the Roanoke Building were the first such pedestrian walkways in the Twin Cities. But another skyway, this one much more simply designed, had spanned a major street in downtown St. Paul for the previous six years.

The area around Robert and Eighth Streets (now Seventh Place) had long been one of St. Paul's busiest pedestrian stomping grounds. And for good reason: a pair of the city's biggest department stores, the Golden Rule and the Emporium, faced each other here. In the mid-1950s, when the Golden Rule raised a new parking ramp across the street from its building, the retailer decided to make the walk from the ramp to the store a bit easier by proposing an elevated and enclosed pedestrian bridge to connect the two structures.

The proposal to build a structure across a city street was so unusual that the St. Paul City Council had to pass a special resolution enabling its construction. Even so, complex negotiations with officials from the city, state, and labor unions almost derailed several times. In 1956, however, the bridge finally opened.

Today's skyway connoisseurs would have found the Golden Rule skyway (pictured here in 1957) spartan, almost crude. Designed by architect David J. Griswold, it measured only 6 to 8 feet wide, bore standard-shaped trusses (painted green), boasted foggy fiberglass panes in its enclosed window sections, and had a plain concrete floor over its metal deck. It lacked heating and air conditioning. "It was done with extreme economy," Griswold recalls. "We took a cautious, utilitarian approach."

During the next several years, St. Paul's downtown retail scene underwent upheaval. Many of the big department stores closed down, and Donaldson's, which had merged with the Golden Rule in 1961, vacated the Robert Street store in the 1970s. When the old parking ramp grew cracks and faced demolition, the skyway was also removed. Today, another parking ramp and modern skyway have replaced the old.

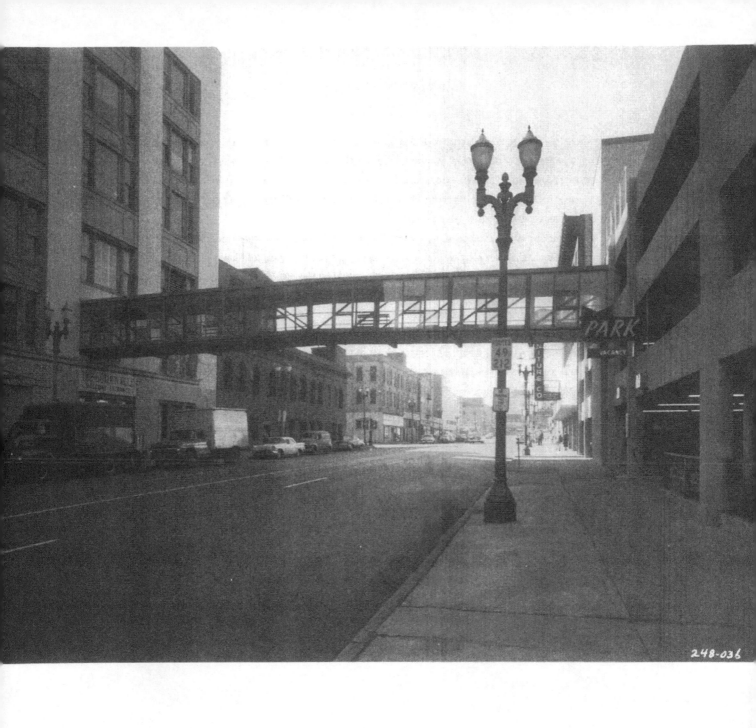

Theodore Hamm House

671 Greenbrier Street
1887–1954

WHEN THEODORE HAMM AND MEMBERS of his family returned to St. Paul in 1887 from an extended trip to Germany, the brewer's eldest son, William, had a little surprise awaiting them. It was a new house for his mother and father, a big red brick pile in the Queen Anne Revival style, with eight fireplaces, nearly twenty rooms, and a view from three sides of the Hamm brewery, whose production would soon reach a million barrels of beer a year.

By all accounts the elder Hamm was pleased. Theodore Hamm had emigrated from Germany thirty-three years before, first working as a butcher, boarding house owner, and saloon keeper. He struggled to earn a living until the mid-1860s, when he acquired the Excelsior Brewery in St. Paul. Within twenty years, Hamm had built that brewing business into Minnesota's second largest. He had a lot of money and enjoyed living comfortably.

To design the new house (shown here around 1900), William Hamm engaged Augustus F. Gauger, a German-born architect who had apprenticed in the office of E. P. Bassfore. Gauger would later design several large houses on Summit Avenue and elsewhere in St. Paul, as well as a few commercial blocks in the city.

Theodore Hamm, a white-bearded man late in life who gave his grandchildren $5 gold pieces for Christmas, spent the rest of his years living in the house. He liked the location: Hamm's children occupied four other houses on the same block, and the Hamm brewery stood just at the bottom of a staircase that began on Greenbrier Street. A nearby barn eventually sheltered the cars of all the Hamm households.

After Hamm died in 1903, William and Marie Hamm moved into the house. A practical man, William ran an underground pipe from the brewery to his home in order to take advantage of the plant's ample supply of steam heat. He died in 1931, followed two years later by his wife, and they were the last Hamms to occupy the residence.

The house steadily fell into disrepair. An attempt to convert the building into a nursing home failed. In 1954, a fourteen-year-old arsonist sealed the house's fate by setting it on fire and damaging beyond repair one of the most impressive homes of the Dayton's Bluff neighborhood. Today, a small plaque notes the former location of the house.

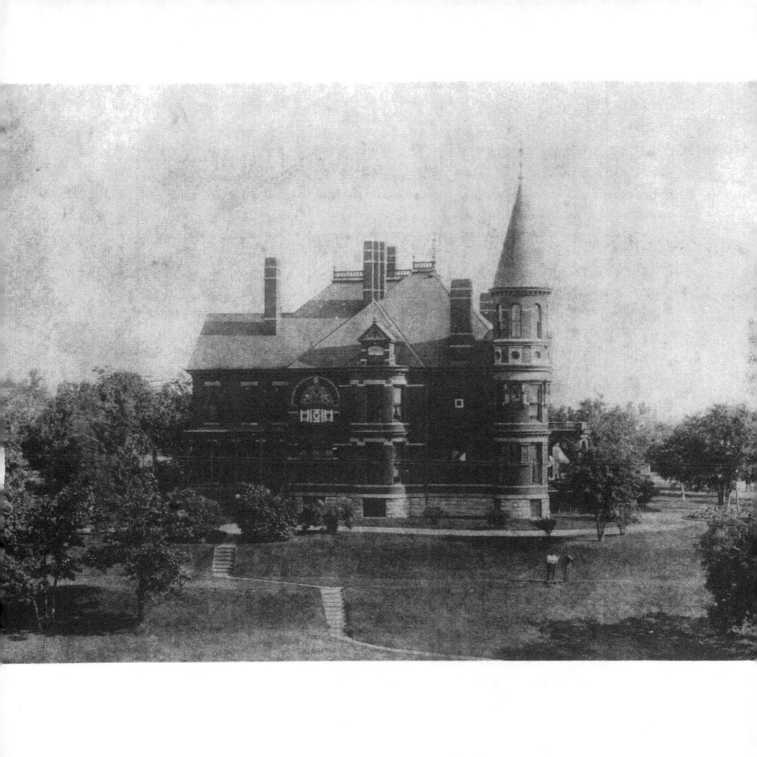

Indian Burial Mounds

Indian Mounds Park
Around 700–1870

THROUGHOUT MINNESOTA'S PREHISTORIC PERIOD, people of several Indian cultures used—and revered—parts of the region as sacred spots for human burial. More than ten thousand burial mounds once existed in different parts of the state. Most have vanished, the victims of disregard, development, and careless archaeological investigation.

One concentration of burial mounds dotted a tract overlooking the Mississippi River and the current site of downtown St. Paul, today called Indian Mounds Park. Beginning in the early centuries of our calendar's first millennium, native groups ceremonially buried their dead there, and later Indian cultures including the Mdewakanton Dakota continued to use the area for interments. Although most of these eighteen mounds appeared similar to the eye, typically rising about 20 feet and measuring 30 feet to 50 feet in circumference, they varied considerably on the inside.

One mound contained a group of eight stone compartments, each constructed of upright hunks of limestone. The compartments held human remains and mussel shells, pieces of metal ore, bear teeth, and other grave offerings. Other mounds rose above log tombs, and one covered a body laid to rest in a pit. Some mounds included bodies placed inside centuries after the mound was first built.

A burial site that nineteenth-century archaeologists labeled Mound No. 3 contained perhaps the most unexpected find: a body whose face had been applied with red clay, producing a death mask.

These mounds rested undisturbed until the 1850s, when amateur archaeologists began exploring the lands that the Dakota had recently ceded. By the 1870s, many of the mounds had been destroyed by property owners and landscapers.

Starting in 1893, the city of St. Paul acquired the land in several separate purchases for the purpose of dedicating a park. The view, not the mounds, attracted the park board. Workers bulldozed several mounds to improve sightlines, the construction of roads erased others, and only six mounds remained by the time the park was in use. Many of the survivors had been rebuilt after relic collectors and others demolished them. Photos of the park from the turn of the twentieth century (as in this photograph from 1904) show roads or walking paths leading up to the top of those mounds that were left.

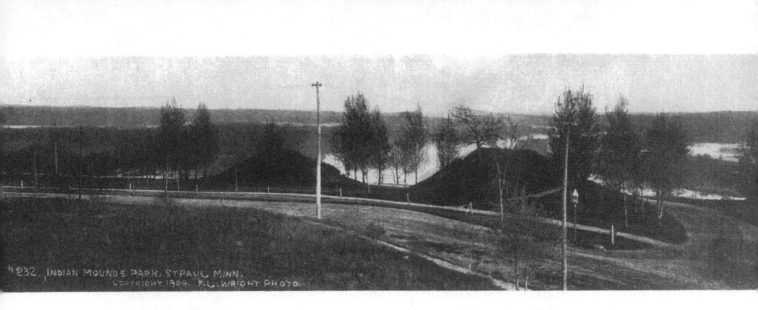

For decades, the surviving mounds of Indian Mounds Park received uncaring treatment. During the 1930s, Northern States Power strung electric lines above them. After hundreds of treasure diggers caused further damage in 1987 when the St. Paul Winter Carnival medallion was hidden in the park, the city erected protective fences around the mounds.

According to a 1981 cultural resources survey of the park, only one mound has emerged unscathed from the past 150 years of neglect. Twelve of the original eighteen have vanished altogether.

Langford Park

Developed 1910

TODAY, LOOK AT LANGFORD PARK, situated in St. Paul's St. Anthony Park neighborhood, and you'll see a well-equipped playground with plentiful trees. What you can't see is a vanished urban landscape. In years past, a sizable lake and a Victorian strolling garden both occupied the site.

Among the earliest speculators to size up the potential of St. Anthony Park were two brothers-in-law, Nathaniel P. Langford and William R. Marshall. In 1873 Marshall, who had served as governor of Minnesota from 1866 to 1870, hired the renowned landscape architect Horace W. S. Cleveland to plan a development for a proposed community. Later the planner of St. Paul's Como Park and the University of Minnesota campus, along with the park system and Lakewood Cemetery in Minneapolis, Cleveland plotted a village in which the designed features followed the natural contours of the land and the lots were large and irregularly shaped. At the center of Cleveland's plan was a park, appropriately named after Langford, who served as the first superintendent of Yellowstone National Park.

Cleveland's plan, never implemented, would have let a pond called Rocky Lake remain in Langford Park. But when the developers had city planners Charles Pratt (seen at the left in this 1885 photo, with planner W. W. Clark, right) and J. Royall McMurran redesign the area in 1885 to suit the tastes and pocketbooks of middle-class home builders, the lake's days were numbered. Around 1890, three years after St. Paul had annexed St. Anthony Park, the community's developers filled the lake "for sanitary reasons," as one historian has recorded.

Not long after the turn of the century, though, Langford Park was in full flower. With rosebushes, manicured lawns, and walking paths suitable for perambulators, it hosted Independence Day celebrations and toboggan runs. The park kept this quaint character until midcentury, when St. Anthony Park Elementary School rose on the east end of the parkland. Rather than a center for social activity, Langford Park gradually became what it is today—a place of ball fields and skating rinks, with the Independence Day celebration remaining a continuing tradition.

Lexington Park

Lexington Avenue near University Avenue
1897–1957

THERE'S STILL OPEN SPACE between Dunlap and Lexington, near University Avenue in St. Paul—that much hasn't changed. But where a parking lot now exists once stood an expanse of grass, dirt, and chalk lines. From 1897 to 1957, the site contained Lexington Park, home of the St. Paul Saints minor-league baseball team. Indeed, space was one of the field's most noteworthy features (shown here around 1925).

As the park was reconfigured in 1916, the center-field wall stood 472 feet from home plate and the right-field foul pole 361 feet, distances that made home runs in those directions no easy matter. But down the left-field line, a ball hit only 315 feet could clear the fence. A long-distance expanse and a short-distance one defined the character of the park: It was tough going for left-handed batters and paradise for righties.

Lexington Park opened its gates on April 30, 1897. Saints owner Charles Comiskey planned the field with home plate on the Lexington Avenue side. Nineteen years later, after the Saints had joined the American Association League, a rebuilding of the park not only moved the plate to the opposite end, but it also permitted the construction of a dance hall, the Coliseum Pavilion, outside the new left-field fence.

The fortunes of the park and the team rose and fell over the following decades. America's entry in World War I canceled the minor-league season in 1918. About fifteen years later, the Saints nearly abandoned Lexington and St. Paul for greener grass in Peoria, Illinois. Electric lights made night play possible in 1937. The Saints brought home an American Association pennant the following year. Attendance hit an all-time peak of more than 350,000 in 1949.

It wasn't long before the construction of Metropolitan Stadium in Bloomington and talk of the relocation of the Washington Senators major-league team to the Twin Cities cast a pall over Lexington Park. The attendance was a puny 2,227 at the final game (a 4–0 Saints victory) in September 1956. And when the Saints recorded their final out, so did Lexington.

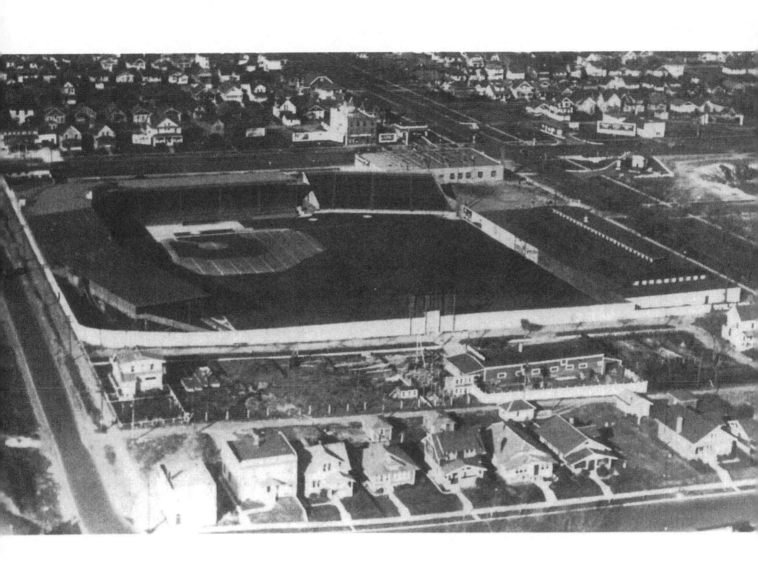

Market House

West Seventh Street at Wabasha Avenue
1881–1915

MARKET HOUSE, BUILT BY THE CITY OF ST. PAUL to spark trade downtown, occupied the block between Wabasha and St. Peter Streets on West Seventh Street. It began its thirty-four-year existence promisingly. Architect Abraham Radcliffe designed the two-story structure with an imposing clock tower, large vaulted windows, and attractive storefronts. And almost immediately after its completion in 1881, Market House filled an important role. That year the Minnesota State Capitol burned, and the legislature adopted Market House as its new home for several months.

Once the legislature got new digs, Market House's fortunes slid. Retailers liked the street-level space, but the upper floors proved hard to rent, probably because the building was considered a firetrap. By the 1890s, the building was a money loser for St. Paul.

But the St. Paul Public Library, which had previously occupied the Ingersoll Block (1883–1890) and the Ramsey County Courthouse (1890–1900), needed a new home. In 1895 the library nearly moved into Market House, but library board president Alexander Ramsey objected to the relocation, noting that a move to Market House "would be from a fire-proof building to a constant risk of fire."

In 1899, the St. Paul City Council bowed to public pressure and gave Market House to the public library. A sum of $98,000 went into a renovation of the building by architect J. Walter Stevens, and the library took over the second floor.

The ultimate demise of Market House—along with most of the library's collection—was short and sweet. On April 26, 1915, a cauldron of candy cooking in the shop of a Market House confectionery store bubbled over and smothered the flame of a gas stove. A terrific gas explosion resulted, producing a fire that engulfed most of the upper floor and destroyed the roof (see photograph). Only 10 percent of the books survived.

Fortunately, the library had already begun construction of a new building at the edge of Rice Park. It moved into the new structure in 1916 and rebuilt its collection.

Minnesota State Capitol (Second Incarnation)

Wabasha Street at Tenth Street
1883–1938

ON A BUSY DAY AT THE MINNESOTA STATE CAPITOL in the winter of 1881, when the legislature was in session, a fire erupted. Faced with imminent death, Minnesota's representatives crawled to safety through a window. Soon after, the roof collapsed and the building burned to its foundation. Government officials quickly reestablished themselves in temporary quarters at the St. Paul Market House. One of their first tasks was to solicit proposals from architects for a new capitol building to be raised on the site of the old one.

Several highly regarded architects submitted plans, but the winning proposal came from LeRoy Buffington, a Cincinnati native who had moved to the Twin Cities ten years earlier. A man of erratic talent and egotistical nature, he had produced some notable buildings such as the Boston Block in Minneapolis, and his firm would later design that city's famous West Hotel as well as Eddy, Pillsbury, and Burton Halls at the Twin Cities campus of the University of Minnesota.

Buffington's capitol design, inspired by New York's then-extant state capitol in Albany and a timeworn proposal he had earlier made for the St. Paul City Hall and Ramsey County Courthouse, laid the four-story building out in cruciform, arranging the government offices in four sections. Upper floors housed the Senate and House chambers as well as the Minnesota Supreme Court. The exterior, whose appearance paid tribute to an amalgamation of Gothic, Romanesque, and French Second Empire influences, was built of brick with sandstone molding. Crowning the effort was a distinctly underwhelming dome set atop a high lookout tower.

The building's cramped spaces and unventilated atmosphere made it unpopular among legislators and their constituents. After just a decade, the legislature acted to give itself a more suitable home. Cass Gilbert would win the competition for the design of that new capitol, to be constructed a quarter-mile away.

How Buffington, a man of undeniable architectural skills, could create such a useless building—and why government officials approved his plans—remains a mystery. But the explanation of Buffington's lapse of inspiration may lie in another project that preoccupied him while he was at work on the capitol. Throughout his life and in his published memoirs, Buffington claimed that in 1881 and 1882, the very time he designed the capitol, he made a series of drawings establishing his invention of the architectural principles of the modern skyscraper. These drawings, which still exist in the University of

Minnesota's Northwest Architectural Archives, show buildings rising twenty-eight, fifty, and a hundred stories, monstrously high by the era's standards, and details of the metal-skeleton construction that could make such skyscrapers possible. Buffington grew obsessed with the idea of patenting his invention and exploiting it for profit. Many architectural historians question the accuracy of Buffington's dating of these drawings, asserting that he actually sketched them several years later when other architects had begun using iron-skeleton construction.

Not long after the capitol was built, Buffington's career began a skid similar to the declining reputation of the building. He never received another major commission in St. Paul, and his busiest period as an architect ended in the 1890s. He lived until 1931, insisting to the end that he was the unrecognized inventor of the skyscraper.

His capitol building, which long served as a storage warehouse, survived Buffington by seven years. It was razed in 1938 to clear space for the St. Paul Arts and Science Center.

Outhouse

2238 Stewart Avenue
1960s

AS RECENTLY AS 1950, there were 50 million outdoor privies in the United States. Today, that number has plunged to less than 4 million—none of them within the city limits of Minneapolis or St. Paul.

At the beginning of the century, however, outdoor privies were common in the Twin Cities. Indoor plumbing did not began appearing in expensive homes until the 1880s. In 1911 the Minnesota State Board of Health estimated that half of the state's population still used privies, including many in cities and towns. By 1930, when St. Paul finally completed its public sewer system, outdoor privy use was banned for local city folk and in virtually every U.S. urban area.

A nostalgia lingers for that preflush era. Those with a keen memory recall the many fanciful names for the outhouse: the *backhouse, dooley, pokey, Johnnie, donnicker, Willie, post office, convenience,* and *back forty* (a term of Canadian origin). Some outhouses had one hole, others had two, and a few boasted two stories. (One of those rare double-deckers is preserved at the Bowler Hillstrom House in Belle Plaine, built in 1870.)

Several decades ago, Gentille Yarusso, who lived in the now-vanished Little Italy district of St. Paul, published a wealth of urban privy lore in his book *The Classics of Swede Hollow*. He recounted the pleasure of a smooth and beveled seat, the route of human waste from Phalen Creek into the Mississippi River, the frequent snow shoveling of the path to the outhouse, and certain distinctive wintertime dangers. "One never knew when using the outdoor bivies whether half his hide was going to be left stuck on the cold wooden plank when he was finished," Yarusso recalled. "In the summer time, however, one lingered a little longer in the old time outhouses, even though he was pestered by mosquitoes, flies, wasps, and other insects. Sitting there, one got to know every nail, crack, hole, and knot in the building."

A few Twin Cities outhouses hung on into the 1960s and maybe even the '70s. Recommended reading for anyone seeking a vivid evocation of the world of privies is Ronald S. Barlow's *The Vanishing American Outhouse* (El Cajon, Calif.: Windmill Publishing, 1992).

St. Joseph's Hospital

69 West Exchange Street
1895–about 1973

LIKE MANY HEALTH-CARE INSTITUTIONS, St. Joseph's Hospital in St. Paul has continuously refurbished, redesigned, and added on to its facilities during its long existence. The hospital that now bears St. Joseph's name—the state's first—has mostly been built during the past thirty years, with little remaining from its early era.

The hospital sprang into being suddenly in 1853 when a cholera epidemic ravaged St. Paul, then a hamlet of barely a thousand people. Four nuns, sisters in the order of St. Joseph of Carondelet, shouldered the burden of helping the sick. They established their first infirmary in a log church built in 1841, near today's intersection of Minnesota Street and Kellogg Boulevard. Within a year, a donation of an open field at Ninth and Exchange Streets, a gift of money from Bishop Joseph Crétin's own family in France, and timber provided by Dakota Indians of the Lake Calhoun band allowed for the construction of a four-story stone hospital at what was then the outskirts of town.

This hospital served the community for forty years. On September 24, 1886, in its small operating room, Dr. Justis Ohage Sr. became the first surgeon in the United States to successfully remove a patient's gall bladder.

Seven years later the building was demolished in preparation for a new St. Joseph's facility, completed in 1895. The new hospital, a four-story structure (seen here in a 1911 photo), boasted four general operating rooms and a top-floor amphitheater for the instruction of medical students. Over the next four decades it added receiving facilities for St. Paul's first ambulance service, an early X-ray machine (in 1902), and a Turkish bath in the basement for the treatment of patients with rheumatism. It was a busy place; between 1922 and 1932 its physicians delivered 6,191 babies and performed 37,750 operations.

Ensuing years brought many alterations and added wings, but eventually the hospital needed a more modern facility. All parts of the 1895 structure were razed to make way for new buildings in the 1970s. But a north wing constructed in 1922 still stands and remains the oldest part of the complex.

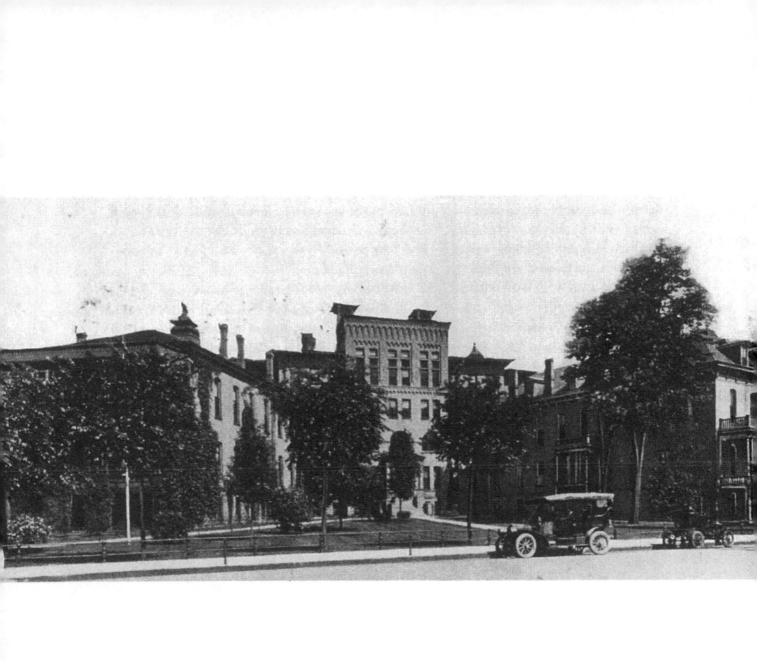

St. Paul Auditorium

Near Franklin between Fourth and Fifth Streets
1907–82

BEFORE CONSTRUCTION BEGAN on the St. Paul Auditorium in 1905, architects Charles Reed and Allen Stem had planned out a building with a multiuse flexibility previously unknown in the United States. The designers hoped to raise a structure able to provide a home for public gatherings, conventions, industry and science exhibitions, horse shows and other sporting events, circuses, grand opera, and legitimate theater shows—combining under one roof all the uses of New York City's Madison Square Garden, Hippodrome, and Metropolitan Opera House.

Replacing a crude exposition hall that had been torn down several years earlier, the St. Paul Auditorium, completed in the modern Italian Renaissance style at a cost of $442,000 in 1907 (pictured here around 1908), proved to be so successful that Reed and Stem patented its design and later replicated it in Denver. In less than an hour, workers could rearrange walls, seats, and floors to create an arena for large entertainments, seating six thousand; a convention space with seating for ten thousand; and a theater with a proscenium stage, seating thirty-two hundred.

The auditorium's theater arrangement seems to have most impressed visitors. The architects claimed, somewhat vaguely, that a whisper delivered from the front of the stage could "almost" be heard in the farthest reaches of the gallery. But in actual use, the theater lived up to the acoustical promises. "I don't know of a building in the country where it is easier to sing," declared Emma Eames of the Conreid Opera Company. Even the world-famous tenor Enrico Caruso, visiting St. Paul to hear an opera performance at the auditorium, pronounced the theater "very fine, surpassing fine."

In its first three years, the auditorium attracted 516 events and 906,000 visitors. Countless performers, actors, conventioneers, and trade-show hawkers traipsed through its halls in subsequent years, and a new and bigger arena was added in 1932. But by the mid-1960s the facility was losing money. It stood, still dignified with its brown brick and terra-cotta exterior but in disrepair inside, until 1982, when it was torn down to clear space for the Ordway Music Theater.

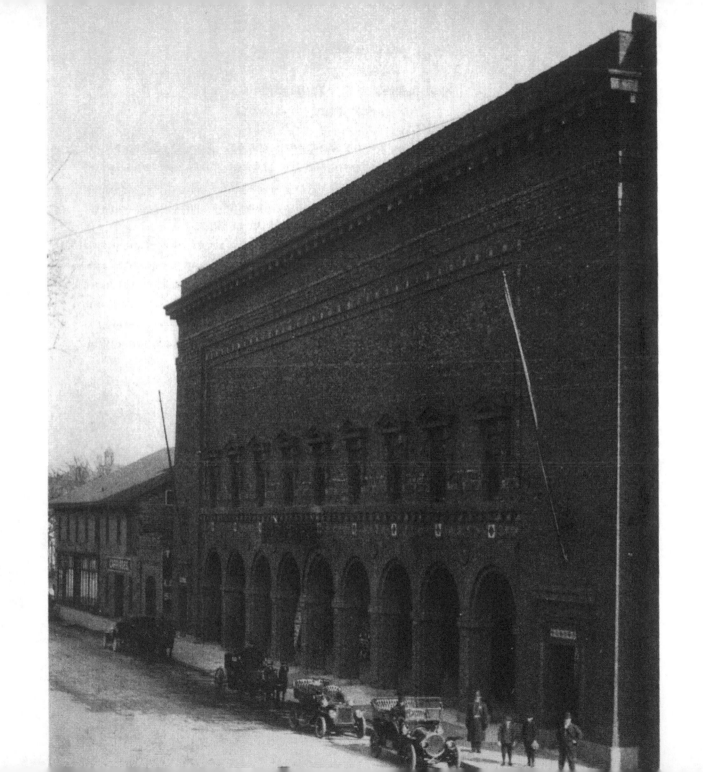

Smith Avenue High Bridge

Smith Avenue over the Mississippi River
1889–1985

IN THE SUMMER OF 1984, as the Smith Avenue High Bridge ended its days, a group of people from St. Paul's West Side and West Seventh Street neighborhoods took positions on the span that had crossed the Mississippi River for ninety-five years. They were mourners, and they carried flowers and wore black armbands. In a ceremony of their own devising, these residents honored the legacy of the oldest surviving river bridge in the Twin Cities—a bridge soon to be demolished.

Few bridges ever receive a funeral, but even fewer could claim a history as colorful and dramatic as the High Bridge. In 1889 (the first two photos depict it around that time) the bridge connected St. Paul's oldest district, which ran along Old Fort Road (now West Seventh Street), with the city's newest residential neighborhood, Cherokee Heights. Formerly an isolated neighborhood whose streets sometimes ended in stairways, Cherokee Heights gained instant access to the jobs, services, and products available in St. Paul's main commercial district. In addition, farmers in southern Ramsey County and areas to the south gained a new passage into Minnesota's capital city.

The High Bridge was designed under the supervision of J. H. Linville, chief engineer of the Keystone Bridge Company of Pittsburgh. It emerged in a great flurry of hoisting and forging as a city of laborers and equipment bustled in its growing shadow. During construction, a reporter for the *St. Paul Pioneer Press* rhapsodized on the talents of one of the bridge's forgers who threw his rivets to workers assembling the bridge above: "He is a sort of expert and if necessary will send his hot rivets like meteors through the air for a distance of 100 feet, always landing them squarely in the keg. His performances are as entertaining as a game of base ball."

When the last of its million pieces had been assembled at a cost of $480,000, the High Bridge ranked as one of America's tallest and longest. Built in the modified wrought-iron Warren truss design, it spanned 2,770 feet. Twenty-nine piers of granite and Mankota limestone supported the massive iron legs that held up the deck. A cedar-block road surface, designed to muffle the sound of horses' hooves, covered the pine-planking road surface. Immediately, the complexly woven silhouette of the bridge became a city landmark. The bridge became a favorite strolling place for St. Paulites as well.

In 1901, inspectors discovered that a center span was slowly dropping off its foundation. Workers secretly repaired the defect. Then, three years later, a disaster variously described as a tornado or windstorm struck. In addition to killing three people and setting a U.S. record for the highest wind velocity

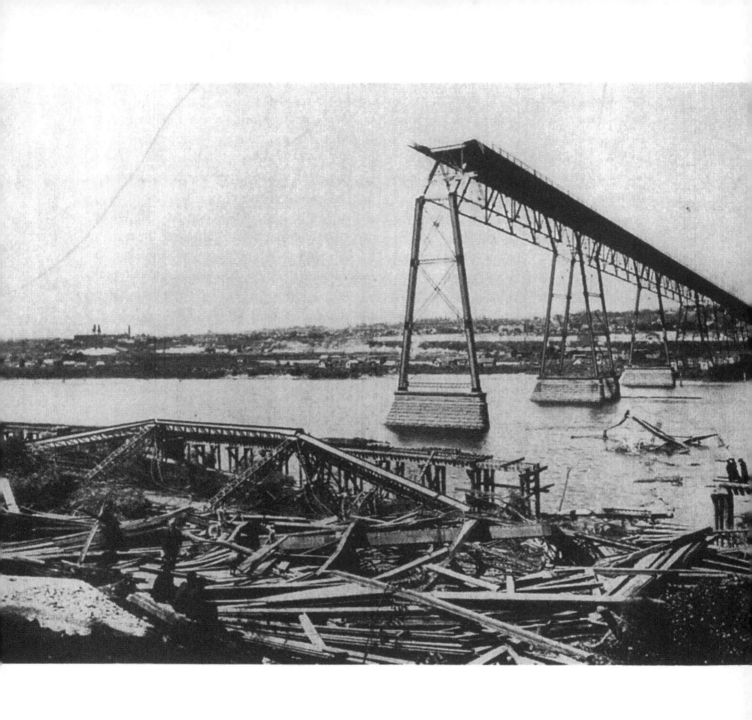

at that time ever recorded—180 miles per hour—the storm turned the southern end of the bridge into a twisted wreck, demolishing one of the supporting towers and strewing debris along the riverbank (see third photo). Restoring the bridge took nearly a year.

In later years, the High Bridge underwent repairs to lay new planking across the road surface (1926), move some piers to make way for railroad traffic (1934), add street lamps (1958), and replace the wood road surface with an asphalt-covered steel grid (1958). Three times, in 1936, 1938, and 1962, autos plunged off the bridge into the water of the Mississippi; only one person died.

Finally, in 1977, an inspection of the bridge uncovered irreparable deterioration. Authorities imposed a weight limit of three tons and began planning for a new bridge. The Minnesota Department of Transportation selected a new design in 1983, and the High Bridge closed the following year.

It took only 76 pounds of explosives to slay the bridge that had been the engineering marvel of its day. In 1985, thirty thousand people lining the banks of the Mississippi and other nearby river crossings watched it come down.

Wabasha Street Bridge

Wabasha Street over the Mississippi River
1890, 1900–1996

IN A METROPOLITAN AREA THAT MUST RANK among the most heavily bridged in the country, the Wabasha Street Bridge over the Mississippi River earned respect for the amount of traffic it carried, its curious method of construction, and, by the end, its age.

An earlier bridge, Joseph B. Sewell's 1858 Wabasha Street span, first linked St. Paul's commercial center with the parts of the city below the river. In just a few decades it proved too narrow for the traffic demands of the growing metropolis. In 1888, city engineer L. W. Rundlett warned that it could collapse. So for $159,000, the city in 1889 began a project to replace the spans, piers, and abutments of the northern half of the bridge with new materials. Rundlett or city bridge engineer A. W. Munster may have designed the replacement bridge, and the Keystone Bridge Company of Pittsburgh, builders of the Smith Avenue High Bridge, manufactured the spans. Planners considered it important to keep the river channel clear for shipping traffic, so they devised an ingenious construction plan. Instead of building falsework to support the construction, engineers used the existing bridge and cranes specially designed to operate on the old structure.

That half of the new Wabasha Street Bridge opened in 1890, after just forty days of work, but it took ten years for a similar operation to begin to replace the southern half. During this second phase of the construction, the city built a temporary crossing 50 feet downriver to handle the traffic. Finally, when the completed Wabasha Avenue Bridge opened in 1900, it had three cantilevered deck spans, a 56-foot-wide roadbed paved with brick, two sidewalks, and a total length of 1,200 feet.

Never considered elegant or beautiful, the bridge carried its load reliably for a century. It gained an access stairway from Navy Island in 1903, new flooring in the 1920s, and a widening of the roadway (and a corresponding narrowing of the sidewalks) in 1955. In 1968 an inspector noted that the bridge "appears to be in good shape" but required painting and the replacement of some structural parts.

During the 1980s, when the sidewalk surfaces of the bridge (pictured here in 1987) began to crack, a study indicated that the rest of the roadway was also in danger of rupturing. In 1987 authorities closed the bridge to bus and truck traffic. Further analysis showed that a new bridge would more reliably carry heavy loads than a repaired and bolstered Wabasha Avenue Bridge.

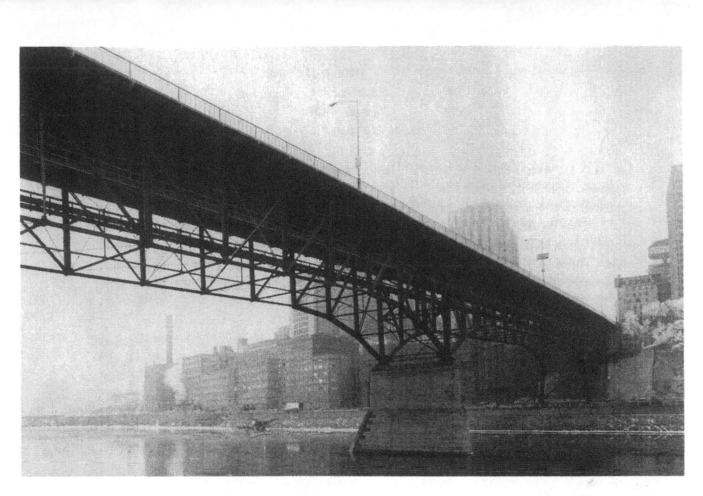

So in 1996 the old bridge began to come down. (The city had offered it for sale, but no takers stepped forward.) Demolishing it with explosives, as had been done with the Smith Avenue High Bridge, would have been the fastest and cheapest way to remove it, but the lead-based paint covering the bridge's surfaces might have scattered and endangered public health. Instead, the Wabasha Avenue Bridge died a piece at a time, lowered by cranes. Its parts ended up in melting vats, salvage yards, and a few artists' studios. The city of St. Paul claimed some of the granite pier fragments for future construction projects.

A new Wabasha Street Bridge designed by sculptor James Carpenter opened in 1998.

Wilder Baths and Pool

319 Eagle Street
1914–92

ON MAY 25, 1914, twenty-three hundred people gathered at a handsome new building in the Seven Corners neighborhood near downtown St. Paul. Most of them needed a bath. For two cents, they received a towel, a cake of soap, and admission to the showers inside.

Over the years, the number of showers and dunks in the pool that St. Paulites enjoyed in this building numbered in the millions. The Wilder Baths and Pool was for decades the only public bathing house in the city, and it was perhaps the nation's only such facility owned and operated by a charity. Thanks to the Amherst H. Wilder Charities, downtown workers, families, and rooming house residents—most of whom did not have bathtubs or showers at home—found cleanliness and relief from hot or cold weather within its walls.

The baths traced its origins to the wishes of Fanny Wilder, wife of the noted businessman and philanthropist Amherst Wilder, who provided in her will for an establishment where anyone could come to swim or bathe. Built of white brick at a cost of $160,000 and distinguished by arched windows and doorways, the building (pictured here around 1914) had a 30-by-70-foot pool, the second largest in the Upper Midwest, and eighty-five shower stalls. The city provided the water at no charge, and the facility generated its own electricity.

For a nickel, swimmers could rent blue tank suits best remembered for their shapelessness. "The one unanimous experience of those who use the suits for the first time is that one cannot tell which is the back or the front until one gets them on," a reporter observed, "and then one knows the back is where the front was thought to be."

After its first year of operation, the bathhouse splurged on a new technical innovation. A St. Paul newspaper writer noted the arrival of "six queer looking machines, which, when unboxed and installed in the women's rest room will prove to be six 'fool proof' electric hair driers." Also that year, patrons began to complain of overcrowding in the locker rooms (pictured here around 1917) and showers. Only twenty-four lockers were available for women. At the same time, African American customers protested the facility's policy of not admitting them.

Others seeking baths and plunges came in large numbers. By the 1930s, the facility had racked

up 5.7 million total admissions, including twenty-one hundred people on a single day during the dust storms of 1934. Bathers and swimmers wore out twenty-four hundred towels each year. As always, Saturday was the busiest day of the week. Gradually, though, the pool replaced the showers as the biggest attraction. More of the urban poor had their own bathrooms than in the past.

In 1950, the Wilder Charities issued a plea for some other organization to take over the bathhouse. The facility was losing $30,000 a year, and the bathing clientele stood at half of what it had been thirty years earlier. No other interested operator stepped forward, so the organization remodeled the building, removing many of the public showers, and reopened it as the Amherst H. Wilder Health Center.

At last, in 1974, the baths and pool closed. The Wilder Foundation sold the building to the St. Paul United Way, which soon transferred it to the St. Paul Rehabilitation Center. In 1992 its final owner, the Seven Corners Hardware Store, demolished it to clear the way for a parking lot.

TWIN CITIES SUBURBS

Beyrer Brewery

597 Stoughton Avenue, Chaska
1866–around 1985

DURING THE FINAL DECADES of the nineteenth century, the biggest businesses in Chaska, then a mostly German settlement, were brick making and brewing. At least three breweries vented the fragrance of hops and barley over the Carver County town at this time—and one beer-making building remained standing longer than the rest. Founded in 1866 by Christian Jung and Peter Iltis, this brewery was located a few blocks from the town's main business district and had several different names and owners through the turn of the century.

In 1906, however, a German immigrant named Fred Beyrer bought the brewery. For two centuries the Beyrers had been brewers, and Fred wished to continue the tradition in this two-story building with deeply recessed windows and walls of Chaska brick. Along with the brewery came an icehouse dating from the 1880s, a single-story rectangular structure also built from local brick.

Twelve years later, Beyrer's son, also named Fred, returned to Chaska after receiving training in a large Stuttgart brewery. He took over the family operation and guided it until Prohibition. Then he closed the brewery and ran a soda pop factory in Northfield. When Prohibition ended in 1933, the younger Beyrer reopened the brewery and was ready for the rising tide of suds during the years after World War II.

He retired from brewing in the early 1950s and closed the business, although he sometimes tinkered with the equipment. The brewery never produced another keg. In 1976, Frieda Beyrer, Fred's sister, inherited the brewery and icehouse, tried to preserve them as a memorial to her family's brewing legacy, and succeeded in having the buildings placed on the National Register of Historic Places.

By that time, though, the structures were in sad shape. In 1978 a surveyor noted that the brewery had a sagging and leaking roof, a displaced top story, and deteriorating walls. But the century-old brewing equipment—including fermenting vats, a boiler, kettles, tanks, and beer kegs—remained in place. He estimated it would cost $500,000 to restore the brewery (pictured here around 1980) to operating condition.

Nobody was willing to invest that much money. Chaska's last remaining brewery was razed after Frieda Beyrer's death in 1981.

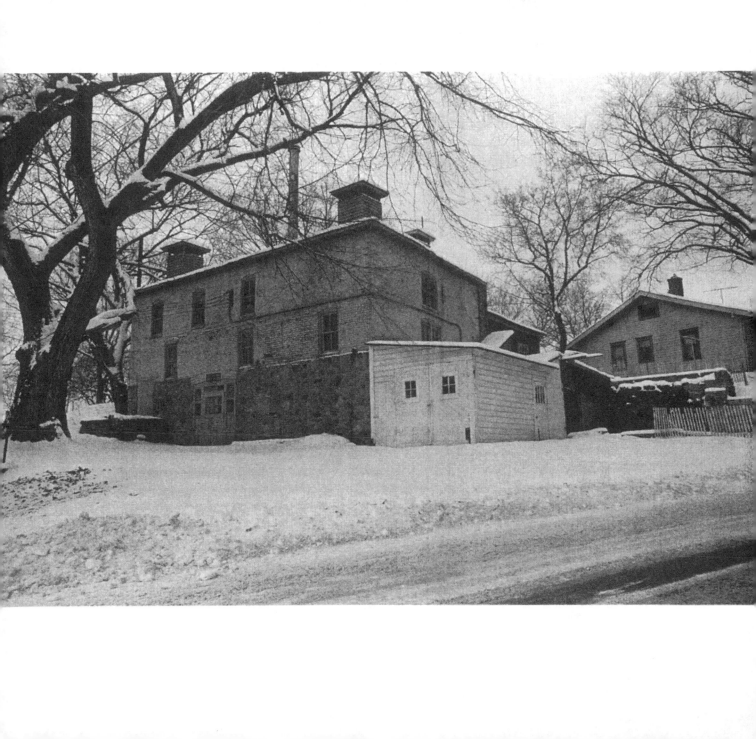

Hotel Lafayette

Lake Minnetonka
1882–97

WE BEST KNOW JAMES J. HILL as the builder of commercial empires, but perhaps his most astounding enterprise was the Hotel Lafayette at Lake Minnetonka. During its fifteen years, the hotel symbolized the ascent and decline of the lake's era as a famous summer resort for the wealthy.

Lake Minnetonka began luring vacationers as early as 1854, when the area's first hotel, the Excelsior House, opened its doors. Several decades passed, however, before big-time hotel operators moved in to snatch up attractive lakeshore lots and mount campaigns promoting the lake as a watering hole without peer in the Midwest. As manager of the St. Paul, Minneapolis, and Manitoba Railroad, Hill was one of the first such entrepreneurs, and in April 1882 he launched the construction of his hotel on a rise between Crystal and Holmes Bays. Within one hundred days, enough time to run railroad tracks practically to the front door, the Hotel Lafayette was ready for business.

The Lafayette had swallowed up 3 million feet of lumber, three carloads of nails, and nearly a mile of shingles. Running 745 feet in length, the olive-green building enclosed three hundred rooms and five acres of floor space. James H. Brodie's design in the Queen Anne style was a mishmash of Elizabethan and Jacobean influences and brought a red roof piled with gables and peaks to the Lake Minnetonka shoreline.

Following the opening in July 1882, the Lafayette had no trouble attracting rich Southerners, adventurous Europeans, and such distinguished personalities as former U.S. President Ulysses Grant and the reigning president, Chester Arthur.

On October 4, 1897, a passerby noticed smoke curling out from the hotel. Despite a record-fast fifty-minute run from Minneapolis, firefighters didn't arrive before the Lafayette had been reduced to smoldering ruins. Hill chose not to rebuild. Perhaps he recognized that the trend toward year-round living at Lake Minnetonka signaled the end of the great resort era. Today, the Lafayette name survives on the private club that occupies the hotel's site.

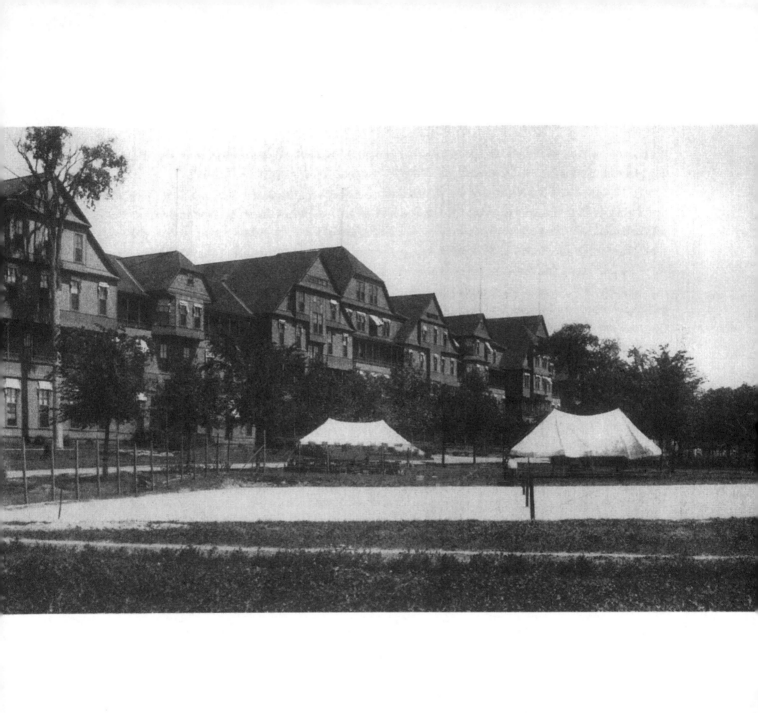

Abraham Lincoln's Funeral Car

Columbia Heights
1864–1911

THE *UNITED STATES,* THE RAILROAD CAR that carried the body of Abraham Lincoln to a final resting place, ended its days in Minnesota, suffering a fate almost as tragic as the president's.

Designed and constructed at the U.S. Military Car Shops in Alexandria, Virginia, in 1863–64, the special car, built to transport a living Lincoln and his cabinet, was one of the most elaborately appointed railroad vehicles ever made in the United States. It had upholstered walls, etched glass windows, sixteen wheels (adaptable to both standard and 5-foot-gauge tracks) to ensure a smooth ride, and rooms for working and lounging. The exterior sides bore a large painted crest of the United States.

Perhaps thinking the *United States* too ostentatious, Lincoln did not use it. After his assassination, however, the car carried Lincoln's body on a two-week, 1,662-mile journey from Washington, D.C. to Springfield, Illinois. The train stopped in many cities on the way—meeting huge crowds along the tracks—and the president's casket was removed each time for display and public mourning.

Later, the military sold the *United States* to the Union Pacific Railroad for $6,850. It lasted eight years as an executive car. For $3,000 it fell into the hands of the Colorado Central Railroad, which stripped the car (leaving only the wall upholstery), installed wooden benches, and put it into service as a day coach and later as a common work car.

Thomas Lowry, president of the Twin City Rapid Transit Company, believed the car was "the most sacred relic in the United States." He bought and restored it in 1905, hoping to donate the *United States* (pictured here in 1908) to a Minnesota organization that would house and preserve it. After his death the car was given to the Minnesota Federation of Women's Clubs.

On March 18, 1911, just months before the federation planned to move the car to permanent quarters in Mendota, a grass fire swept the area of Columbia Heights in which the *United States* was sitting idle. The car burned completely, and the Hennepin County Historical Society salvaged only a coupling link.

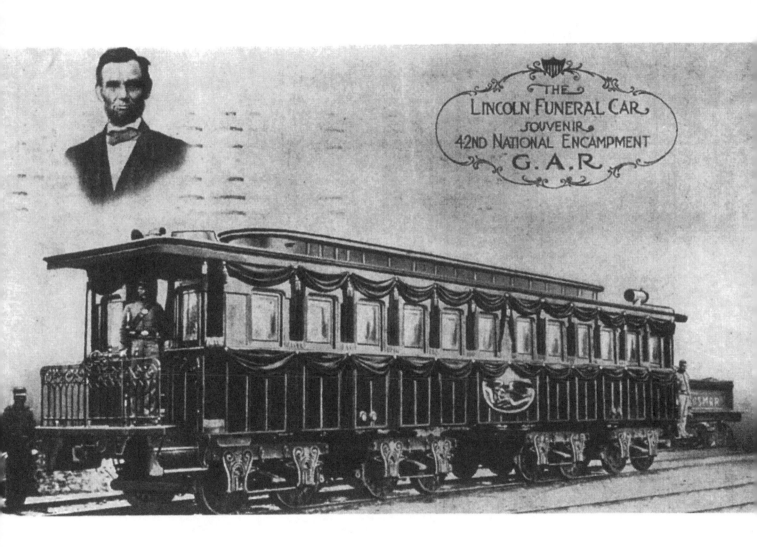

THE
LINCOLN FUNERAL CAR
SOUVENIR
42ND NATIONAL ENCAMPMENT
G.A.R

Merchants Hotel

221 East Second Street, Shakopee
Mid-1860s–1987

LIKE MANY OTHER SMALL NINETEENTH-CENTURY COMMUNITIES in Minnesota, Shakopee grew into a bigger and busier place when the railroad arrived. The stream of rail workers and wayfarers who accompanied the trains created new demands in these towns, including a need for more lodging houses. Just before the tracks became operational in Shakopee in the mid-1860s, the Merchants Hotel was already on the scene to fill that housing void—and it continued to serve in that role for a very long time.

Anna Endres bought the vacant property facing Second Street in 1864, and the hotel rose soon afterward. By the next decade, it was operating under the Merchants Hotel name (the photo shows the hotel in 1875). The two-story building was constructed of buff-colored Chaska brick. It had arched windows, a decorative masonry strip running below the cornice, and a balcony off the second floor. This upper floor contained an opera house and dance hall called Endres Hall.

During the following decades, as Shakopee and its rail traffic grew, the establishment operated under other names, such as the Conter Hotel and the Pelham Hotel. In 1925 the building sprouted a brick addition on its west end, which was three stories but the same height as the original structure. Sometime later the owners built a lean-to section at the rear of the hotel.

The years passed and the railroad became less important to Shakopee's prosperity. The area facing the tracks at the fringe of the town's main commercial district, including the Merchants Hotel property, fell into neglect. By the 1970s, the crumbling cornice of the hotel signaled the building's state of disrepair. A new owner wanted to restore the hotel to its former grace, but those plans never came to fruition.

In 1987 owner Raymond Siebenaler declared that the Merchants Hotel was beyond repair. He had it razed in March of that year.

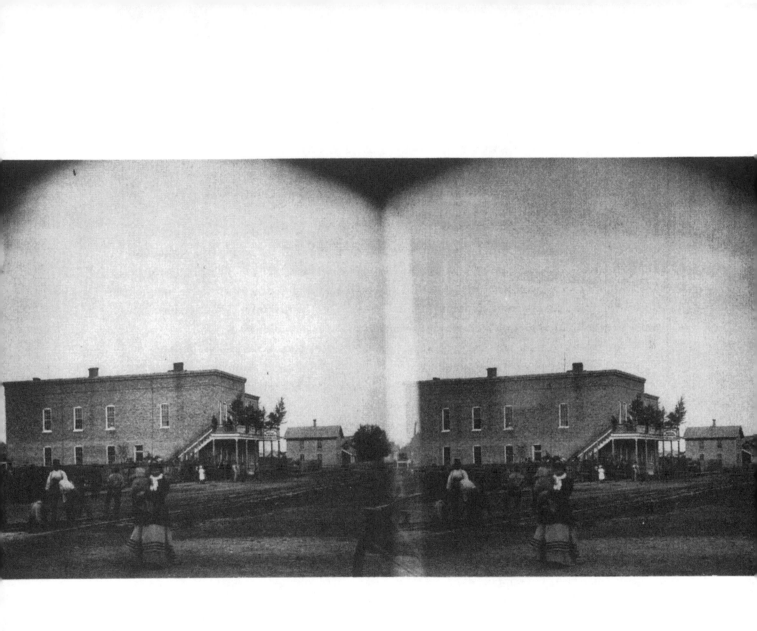

Metropolitan Stadium

Bloomington
1956–85

THE CONSTRUCTION OF METROPOLITAN STADIUM was closely linked to the Twin Cities business community's desire for major-league baseball. Starting in 1953, Gerald Moore, president of the Minneapolis Chamber of Commerce, spearheaded the drive to lure a team to Minneapolis–St. Paul by providing prospective tenants with a modern stadium.

After rejecting several other sites, a stadium committee focused on 160 acres of farmland south of the metro area. Since the turn of the century, this Bloomington land had been fertile ground for raising potatoes, asparagus, onions, and melons. Through bond sales and bank financing, boosters raised $4.5 million to cover the purchase of the land—appraised at about $3,000 per acre—and to pay for construction. (No government money went into the project.) Thorshov & Cerny's architectural plan, which cost $213,000, won approval, and ground breaking began in June 1955.

An explosion at the construction site on February 7, 1956, marred the smooth progress of the project. "Fire began when a portable heater in the basement of the stadium, being used to cure concrete . . . exploded," the *Minneapolis Star* reported. Repairs cost $50,000, and work on one section of the stadium fell three weeks behind schedule.

Still, on April 24, 1956, Met Stadium opened on time to host a minor-league contest between the Minneapolis Millers and the Wichita Braves. (The first photo pictures the stadium in its inaugural year.) Not for another five years would the stadium welcome major-league play. With the arrival of the Washington Senators (now named the Twins), the stadium's 23,500 seats needed supplementation. An increase in capacity to well over forty thousand was again attained without tax support.

After this enlargement, Met Stadium contained 4,300 tons of steel, 2.1 million bricks, 9 miles of pipe rails, 71 turnstiles, 460 doors, and 59,200 light fixtures. A 680-foot well provided drinking water. The grass field, one of baseball's finest, sat 16 feet below the entrance level. (The second photo depicts tailgaters at the stadium in November 1964).

The Hubert H. Humphrey Metrodome in downtown Minneapolis replaced Met Stadium when the Vikings itched for a larger stadium. On a cold, drizzly day in 1981, the stadium hosted its final baseball game, a dispiriting loss to Kansas City. The stadium was demolished in 1985, and the Mall of America rose on the site later in the decade.

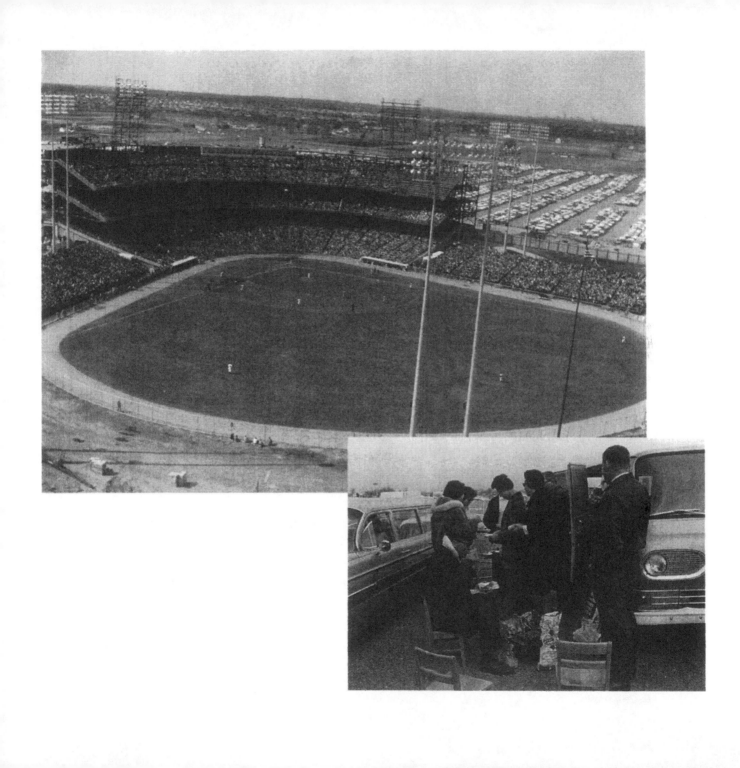

Reis Block

THE REIS BLOCK, A VENERABLE COMMERCIAL BUILDING that long stood at the center of Shakopee's downtown district, was notable for two things: lasting so long into the twentieth century and prominently misspelling on its facade the name of its first owner.

George Reis plunked down $1,000 in 1876 for the undeveloped property at the northeast corner of First and Holmes, and several years later he temporarily located his hardware store at the back end of the lot. On that land, in the early 1880s, Reis raised the masonry building that would imperfectly bear his name. Two stories in height, it used a channel of contrasting yellow brick and decorative arches to set off its many windows. The top of the building had a brick cornice with triangular projections. The first floor provided a home for two retail enterprises, including Reis's own hardware shop, and the second contained an opera house that could seat an audience of 350. The *St. Paul Daily Globe* noted that the opera house had two exterior fire escapes "so that a calamity by fire is impossible," and the newspaper concluded that "[opera] companies can now make this city one of their list of good towns to go to."

The opera house offered recreation to more of Shakopee's citizens than just the opera lovers. Over the years, the theater hosted countless community meetings, amateur shows, and lectures. Commercial blocks with upper-floor performance spaces were important community gathering spaces in the years surrounding the turn from the nineteenth century to the twentieth, and as a rapidly growing town during those years Shakopee relied heavily on the Reis Block. Perhaps that's why no one seemed to care or notice that the permanently marked letters at the top of the building's front spelled *Reiss,* not *Reis.*

During its life the building underwent some changes. Around 1900, a two-story addition appeared at the rear of the structure. Also, at unknown times, the triangular roof projections were removed and stylistically discordant new storefronts replaced the old.

George Reis sold the building to Theodore Weiland in 1890 for $4,000, and from there the Reis Block passed through many hands. By the late 1970s (when this photo was taken), the street level was still in use. The opera house, however, sat vacant, in need of maintenance but largely unaltered from its original appearance and configuration.

In 1986, DeLoris Hay, the final owner of the Reis Block, had the building razed. The building's lack of tenants and "the condition of the structure was such that it was no longer reasonable for me to maintain the building," Hay declared.

NORTHERN MINNESOTA

Duluth Incline Railway

Duluth
1891–1939

DULUTH'S INCLINE RAILWAY CUT A SWATH through the city. Running 2,971 feet from Superior Street at Seventh Avenue West to the 509-foot-high Skyline Drive, the railway served as the most visible and famous piece of Duluth's streetcar system.

Samuel Diescher, a Pittsburgh engineer, created the Incline Railway's original design. Cars weighing 27 tons apiece, pulled by steam-driven steel cables, rode the rails on two tracks. The total cost of the system was $400,000.

Soon after Incline Railway's maiden voyage on December 2, 1891, traveling the tracks became a popular activity in Duluth. The completion of a large pavilion at Skyline Drive in July 1892 further increased the crowds, as people flocked to the elevated spot to enjoy picnics, concerts, and the view of the city.

Tragedy struck, however, when a fire erupted in the railway's powerhouse engine room in 1901. The flames leapt to the pavilion and burned that structure to the ground. Engineers frantically chained the car at the uphill end to the tracks, but the fierce heat snapped the links and melted the cable, sending the blazing coach on a runaway course down the hill to the Superior Street station. The car covered the half mile in ten seconds. It crashed through the station's masonry wall and exploded, shooting flames and debris high into the air and into a nearby rail yard. Amazingly, nobody was injured.

A six-month repair effort put the Incline Railway back in business. Milton Bronsdon's redesign regraded the hill and brought in electric power. Further refinements came in 1911, when the system purchased two new cars and added intermediate stations along the line.

Duluth's citizens and tourists alike continued taking the eight-minute ride up the hill until 1939, when high maintenance costs and the encroachment of public buses on Duluth's streets combined to end the city's streetcar days. At 5:35 P.M. on Labor Day of that year, the Incline Railway chugged its final run. By December, the rails had been ripped up and sold for scrap.

Faith Flour Mill

County Road 40, Faith
1916–89

IN THE MID-1970S, YOU COULD BUY FLOUR from the Faith Mill pretty cheaply: $1.25 for a 5-pound bag of Faith's Best, or just $2.75 for a 25-pound sack of Grandma's Old Fashioned Unbleached Flour. This was no ordinary flour. It came from the last remaining mill in Norman County—and one of two surviving flour mills in Minnesota built to run on water power.

The town of Faith, situated on the bank of the Wild Rice River at the bottom of a group of hills, was first settled in 1872. At its zenith it had fifty residents and a general store, feed mill, lumber mill, and creamery. And because Faith stood in the middle of Minnesota's spring-wheat region, there was also a flour mill, a wood-frame building that burned down in 1915.

In 1916, miller Christ Juhl built a new mill on the same spot, south of town and on a head-and-tail-race that ran parallel to the Wild Rice River's north bank. Local builders erected the building and a wood-crib and stone-rubble dam that powered the mill's turbine, and the Willford Manufacturing Company, based in Minneapolis, designed and installed the milling equipment.

Faith Mill, which was operated continuously until its sudden end in 1989, had three stories, a gable roof, and three sections. The central part housed the milling equipment. At the ends were an elevator head house and a space for the turbine and bagging facilities. A feed shed containing feed processing machinery, a scale shed in which grain was delivered, and a two-story silo also were included in the milling complex.

Inside, the mill boasted a gradual-reduction system originally designed to produce superfine white flour. The grain was cleaned and sent through the fanning mill and grinding equipment. Exiting the machinery on wooden chutes that gleamed with age, the flour was sacked and loaded onto trucks. For at least some of the mill's history, a single person could run the entire operation. After more than fifty years in service, the mill produced the modest output of 700 pounds of grain an hour.

After Juhl, the Faith Mill operated under three different owners. Olaf Shol, who bought the mill in 1945, developed the Faith's Best brand. In 1966, spring flooding on the Wild Rice River destroyed the dam, and the mill had to go on with a 40-horsepower electric motor that made use of the building's original shaft and belt drive system. Eleven years later, the mill fell under the management of a young miller named Alan Buchholz.

Producing a beloved local brand of flour, Faith Mill might have continued operating for a very long time had it not been struck by lightning on August 13, 1989. The resulting fire burned for six hours, ruined several thousand bushels of grain, and left the mill a smoldering heap.

First Methodist Episcopal Church

Third Avenue West and Third Street, Duluth
1892–1969

WHEN THE CHIMES IN THE TOWER of Duluth's First Methodist Episcopal Church rang every Sunday morning, every noon, and on national holidays, the entire city heard them. Forged of Lake Superior copper, they were massive bells: the biggest weighed 1,800 pounds.

The church itself, a red-sandstone Gothic structure with a high steeple that long dominated Duluth's skyline, was massive, too. At a cost of $120,000, it was built in 1892 for a growing congregation that included many of the city's pioneer families. An earlier church located just a block away had been in use since 1869.

The people of Duluth stood in awe of the new building (shown here around 1948). "If there be any virtue in an edifice imposing in appearance, commodious in size, convenient in arrangement, artistic in finish, and comfortable in furnishings," the *Duluth Weekly Herald* observed, "this religious society ought soon to head the procession of the godly at the Head of the Lakes." Most impressive was a steam-heated baptistry that allowed for the immersion of the faithful even when the cold choked Lake Superior with ice. The church also featured windows exclusively made of stained glass, a gallery of paintings inside, and a 1,500-pipe Austin organ (with four manuals) that long ranked as one of the Midwest's finest.

The congregation made several improvements to the church over the decades. In 1925, a Community House for Sunday school, youth, and social service programs rose next to the church, connected to the main building by a bridge corridor. Seven years later, the organ was renovated and electrified.

By the 1960s, the church had become too small for the congregation's needs. A new church, located above the city on Skyline Drive, was built, and the old church hosted its final services in 1966. The Duluth Clinic purchased the property and demolished the church in 1969 to clear land for a parking lot. The Community House still stands.

IOOF Lodge Hall

Hubbard Township
1899–1991

DURING THE 1880S, TWO TOWNS WRESTLED for commercial and cultural predominance in Hubbard County: Park Rapids and the township of Hubbard. To the advantage of Park Rapids was its status as the county seat and its share of newspapers, banks, and businesses. Hubbard, six miles to the south, also had a bustling commercial life, water power, and a sizable grain elevator. In 1888 Hubbard added a cultural distinction to its civic arsenal—its own lodge of the Independent Order of Odd Fellows (IOOF).

A nonsectarian fraternal organization that had opened its first lodge in Baltimore in 1819, the IOOF espoused equality, brotherhood, and good citizenship. It grew rapidly in the Midwest after the Civil War and by the end of the nineteenth century claimed 850,000 members nationally. Hubbard's initial contribution to the cause was a modest eight members, but the membership of the town's IOOF Lodge No. 130 climbed to nearly one hundred in the next decade. In 1899 the lodge built its own meeting hall on a residential street of Hubbard, a two-story wood-framed building with a false front and a lunette window atop the facade. At the time it was the county's largest public hall.

By then, Hubbard had lost the battle of the towns. Several years earlier, the Great Northern Railway had bypassed Hubbard on its branch line to Park Rapids, which soon grew to dwarf Hubbard in population. But Hubbard's IOOF members continued to meet, and Lodge No. 64 of the Rebekahs, an allied women's organization, formed to join them in their good works.

In addition to serving as a meeting place for the IOOF and Rebekahs, the hall hosted wedding receptions, funerals, dances, charity fund-raisers, school programs, and family get-togethers. Eventually, nobody could remember the building not being there, and it was Hubbard's only remaining nineteenth-century structure.

Time took its toll on both the building and Hubbard's IOOF membership. By 1981 only six Odd Fellows remained alive—too few to continue holding regular meetings—and the lodge soon disbanded. The hall, now owned by the township, lacked heat and needed much repair work. (The photo shows the hall around this time.) In 1989 volunteers completely restored the aged building, painting, replacing rotted windows, and repairing the front and rear entrances.

Thus reconditioned, the IOOF Lodge survived only another eighteen months. On Valentine's

Day 1991, a fire destroyed the building. Burglars had broken in and set the hall aflame. "I know I speak for the entire community when I say we are shocked and deeply saddened by this senseless destruction," observed Robert Stevens, chair of the Hubbard Township board, "and can feel only disgust and pity for the person or persons responsible."

Otto and Ethel Johnson House

202 Third Avenue, Mountain Iron
1912–97

FOR NO IMMEDIATELY APPARENT REASON, the streetcar of the Interurban Railway Line, which connects communities along the Iron Range during the early decades of the twentieth century, slows to a crawl. Passengers lean out the windows. Then they see what the conductor wants them to see: a fairytale sight, a whimsical house with decorative half timbering and a molded roof, surrounded by a magical landscape of statues, stone walls, winding paths, and footbridges.

Long a legend of the Iron Range, the Johnson House stood for eighty-five years as the realization of a Minnesota druggist's dreams. Soon after Otto and Ethel Johnson built the house in 1912, Otto began carting rocks into the yard. He worked as a pharmacist in the Kopp & Morris store in Virginia, but in his heart he was an artist. For three decades he used his found stones to create the statues and landscaping that embellished his property. There was a woman leaning backward while holding a hunk of rock (see detail photo), a reptilian creature emerging from a cave, and a lion guarding one side of the house. Johnson also built a pool with a terraced waterfall, a long stone wall, and lengths of paved paths, all set up beneath electric lights for nighttime viewing.

The Johnsons lived in the house until the early 1940s, when they moved to Hastings. It's hard to imagine what it was like for them to leave their property behind. Two later owners tried to care for this strange estate before it fell into the hands of Mr. and Mrs. Gene Cimperman in the 1980s. By then, the statuary needed major restoration and only crumbling walls and weeds remained of Otto Johnson's landscaping.

The Cimpermans wanted to restore the house and gardens to some of their former whimsy, but the expense apparently proved too much. In 1997 the house fell victim to an owner who wanted a more normal home. A new residence now occupies the site.

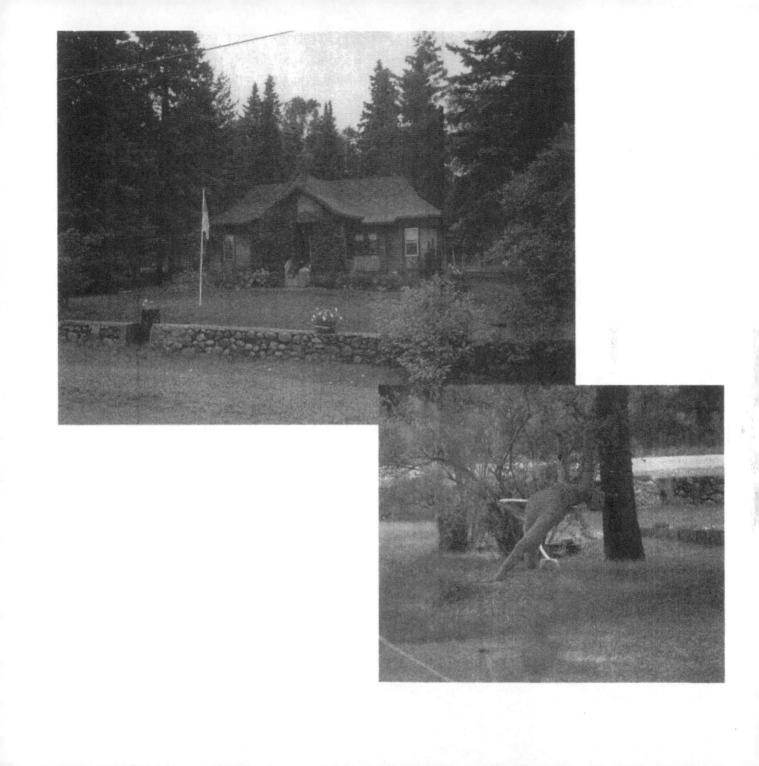

Lyceum Theater

Superior Street at Fifth Avenue West, Duluth
1891–about 1962

WHEN ANDREAS M. MILLER, a rich Duluth lumber baron and railroad magnate, decided in 1890 that his city needed a prestigious theater, he quickly set the project in motion. To design this building, the Lyceum Theater, he hired Duluth's busiest architectural team, Oliver G. Traphagen and Francis W. Fitzpatrick, who would also design such city landmarks as the Fitger Brewery, the First Presbyterian Church, and the Torrey Building.

The Lyceum, situated on Superior Street opposite the Spalding Hotel, became a massive Romanesque structure that was dubbed the "handsomest and costliest building in the Northwest." (It is pictured here around 1900.) Most of the six-story exterior—rising to a seventh at the corner towers— was constructed from brick with sandstone corner quoins. On the lower two levels, however, Traphagen and Fitzpatrick alternated the sandstone and brick, and the triple-arched entrance was decorated with detailed carvings and ornamentation. A pair of stone lions guarded the front steps, and several businesses occupied street-level storefronts.

Inside, the 1,500-seat auditorium contained the largest stage in the Upper Midwest. Frescoes, theater boxes designed to resemble Indian bay windows, and bronze fixtures created "such a sensation in the beholder, as he gazes on the magnificent scene of gold and light, that he instinctively thinks of the glory of Solomon's temple and the story of Aladdin," observed the *Duluth Tribune* upon the opening of the theater on August 3, 1891.

The Lyceum's alleged resistance to fire was highly publicized. Years later, when Fitzpatrick left Duluth to advance his architectural career, he became known as "the father of the fire-prevention movement."

Like many turn-of-the-century theaters, the Lyceum eventually became a movie palace. It also briefly housed Duluth's first radio station, WJAP, in 1922. Duluth's Gateway Urban Renewal Project in the early 1960s spelled the doom of the Lyceum, along with many other buildings in the area. After it was razed, the lions went to the Duluth Zoo.

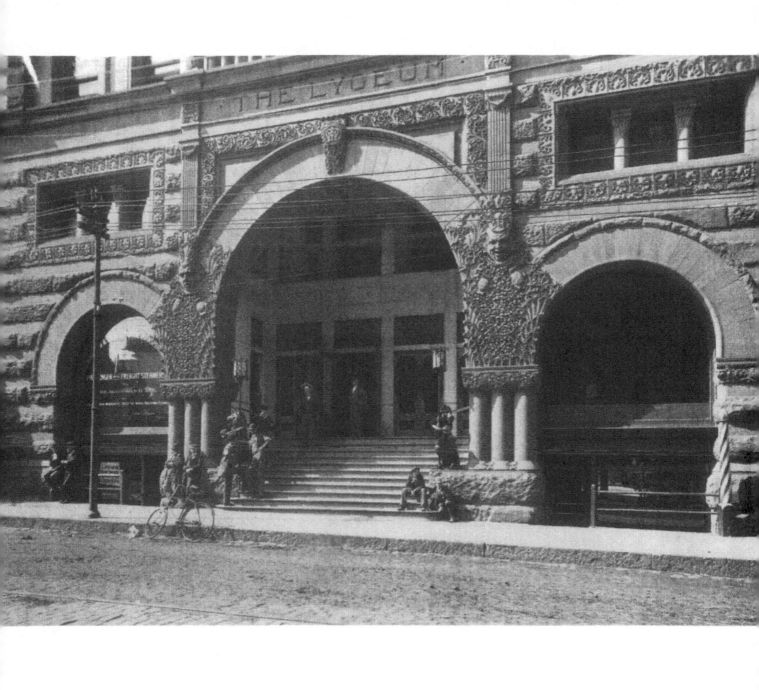

Scenic Hotel

Main at Third Street, Northome
1921–96

THE SCENIC HOTEL AROSE IN NORTHOME at a boom time for the northern Minnesota town. In the early 1920s, the logging industry still employed many workers, and tourism was beginning to bring summer visitors to Koochiching County. Local businessman Julius Ball built the hotel in 1921, hoping to launch a prosperous enterprise in this town that had been platted only eighteen years earlier. Tourists, as well as lumberjacks in search of a home after the nearby logging camps closed every year, needed a decent place to stay.

The building, instantly the most prominent business structure in town, required seven months for construction. Rectangular and three stories high, the wood-frame hotel had a stucco exterior, flat roof, and decorative brackets supporting the projecting cornice. The first floor contained a lobby, pool room, dining room, and kitchen. Forty guest rooms filled the two upper floors, and there was a quaint parlor on each residential floor, complete with French doors.

Just a month before the Scenic's opening, a crate holding the first shipment of plate glass smashed to the ground at the rail station, causing $500 in damage. But owner Ball quickly recovered from this setback. When the hotel opened in October 1921, he threw a big banquet. The Scenic Hotel was on its way.

Ball successfully operated the hotel for twenty-three years. He then sold it to Dorothy and Iver Westling, who converted some guest rooms into apartments and replaced the old coal stoker with an oil-fueled furnace. The Westlings also transformed the first-floor dining room into a cafe decorated with orange booths and acoustical tiles on the ceiling.

Meanwhile, Northome reeled from the death of the logging industry. By the time the next owners, Janice and Ray Parsons, acquired the property around 1980 (this shot shows it shortly after that), the Scenic was almost a ghost: vacant for several years, the hotel had grown weary and sad, with bare lamp cords hanging from the ceilings, stained mattresses in the rooms, and hopelessly outdated bathrooms. The Parsons hoped to renovate the hotel into an apartment building.

That plan fell through, as did plans for other reuses of the hotel. In the end nobody wanted it. The building eventually reverted to county ownership through tax forfeiture. Despite an effort to preserve the Scenic Hotel, led by a Northome woman who had once lived there, the building was razed in 1996.

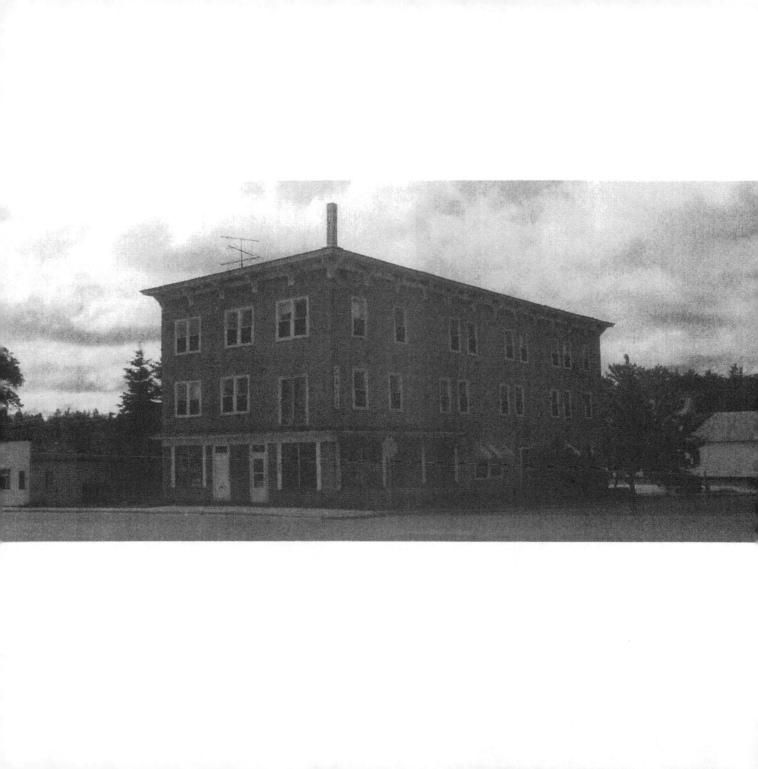

CENTRAL MINNESOTA

American Hotel

Twelfth and Ford Streets, Glencoe
1881–1988

DURING ITS 107 YEARS, Glencoe's American Hotel underwent an evolution in clientele unique among Minnesota lodging houses and probably unparalleled in the history of the United States. It began as a hostelry for railroad patrons and commercial travelers and ended as a residence for chickens.

The American Hotel was built in 1881 by James C. Edson, a New York–born Civil War army colonel who long served the Glencoe area as a lawyer and judge. It replaced an earlier Edson hotel that had been destroyed by fire. Using lumber from Red Wing, workers raised the new hotel in ten weeks just 200 feet north of the town's railroad depot. The completed building had three stories, a gable roof, a wrap-around porch, a balustraded porch on the second floor, and very little ornamental detail.

Inside the hotel was a sample room in which traveling salesmen could display their wares, a dining room, a billiard hall, and offices. Travelers could pay $2 a night and choose from fourteen guest rooms, "all of which are provided with wire spring beds and walnut bedsteads," the Glencoe *Register* noted when the hotel opened.

Edson enlarged the hotel in 1885 and supervised its operation until his death in 1891. Several different owners ran the American until the mid-1920s, when business slackened and the hotel fell vacant. The building was in the process of being dismantled when Charles E. Walker bought it in 1927 and immediately stopped the deconstruction. He had other plans in mind.

Walker, a lifelong resident of McLeod County, wanted to use the hotel as a chicken hatchery. He renamed it Walker Acres, remodeled its interior to accommodate birds, and built his hatchery business into one of Glencoe's most important industrial concerns. At one point, Walker Acres was the birthplace of three hundred thousand chicks per year that were shipped to farms throughout southern Minnesota and nearby states. By the 1970s, Walker's son was using the former hotel as a storage facility for his farm implement business. Its exterior remained unchanged from its heyday as Glencoe's largest hotel.

By the 1980s, the building was one of the region's few surviving frame structures from the nineteenth century. It had grown superfluous in its owner's business plans, however, and it was razed in 1988.

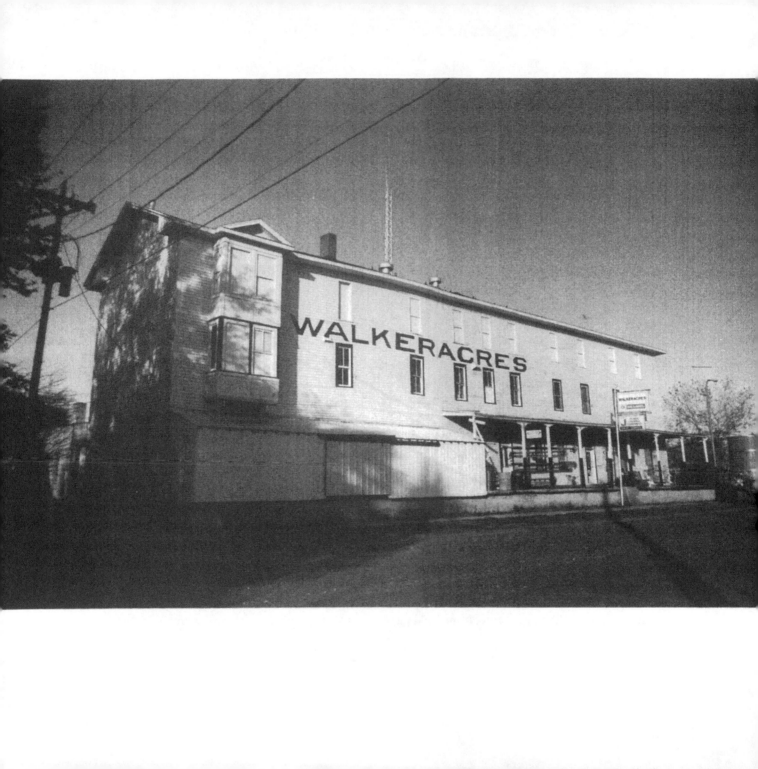

Ansgar College

Hutchinson

1902–80

INSPIRED BY THE SUCCESSES of Carleton, Macalester, Gustavus Adolphus, and the many other private liberal-arts colleges of Minnesota, America's Danish community established Ansgar College in Hutchinson in 1902. John W. Hutchinson, a founder of the town, donated the land. Saint Ansgarius, who introduced Christianity to Denmark in the ninth century, provided the school's name. At Ansgar's opening ceremonies, the benediction was in Danish and the orators spoke as if the college would last for centuries.

The college, alas, didn't even last two years, but its building survived long into the twentieth century. Originally a two-and-a-half story brick structure with a mix of features from the French Second Empire, Gothic, and Queen Anne styles, the building was the work of Minneapolis architect Edward S. Stebbins. A bell tower capped the school, which had walls of solid brick, sixty-eight dormitory and class rooms, and a 500-seat chapel. Stebbins's plan had called for symmetrical wings to flank the central pavilion, but cost constraints permitted the fledgling college to build only an east wing.

Within four months of the college's opening, more than two hundred students enrolled to study under the thirteen-member faculty. But in February 1903, a fire began in the attic above the chapel and spread throughout the building. Townspeople rushed to the scene and succeeded in saving most of the furnishings, but the building's distance from Hutchinson's water mains left the fire department helpless in battling the flames. The interior was gutted and the roof destroyed. "The conflagration was viewed by hundreds, and a sorrowful crowd it was," the *Hutchinson Leader* observed. "When a portion of the building would fall or some chemicals or a radiator exploded, a shiver passed through and a tearful 'Oh' sent up from the crowd."

Ansgar never recovered from this catastrophe, although the school did rebuild its home while classes went on in temporary quarters. The building finally got its west wing and received a third story. By the winter of 1904, however, the college had gone bust and its owner by default, the Connecticut Fire Insurance Company, was eager to dispose of the facilities.

Into these dire circumstances stepped G. M. Langum, president of Minneapolis Metropolitan Commercial College, who bought the building in 1905 in order to start a commercial school in

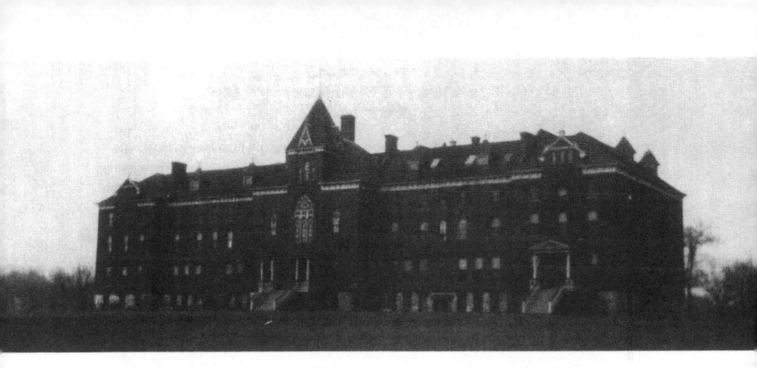

Hutchinson. For four years Metropolitan College, later called Hutchinson College, headquartered in the handsome building. It closed in 1909.

The building's next owners, the Minnesota Conference of the Seventh Day Adventist Church, opened a theological seminary in 1910. For the next eighteen years, religious students from around the world came to Hutchinson to learn in the brick building. (The photo, taken in 1927, dates from this period.) In 1928, Maplewood Academy, a Seventh Day Adventist school then located in Maple Plain, needed a new home. It merged with the theological seminary and relocated to Hutchinson.

During the next half-century as Maplewood Academy, the building continued to host educational services in Hutchinson. By 1977 the school had added five other buildings on its grounds, and the old college structure desperately needed repairs of its leaking roof and crumbling walls. But a comprehensive renovation would cost more than a new building, and the church decided against restoration.

The building met the wrecking ball in February 1980. "A groan went up from the crowd as [the] first strike was made," the *Hutchinson Leader* observed. Echoing the scene at the great fire seventy-seven years earlier, a crowd had gathered to watch the building's demise.

O. A. Churchill Store

55 Bay Street (originally First Street and Broadway), Little Falls
1855–1988

THE O. A. CHURCHILL STORE OCCUPIED the northeast corner of First and Broadway in Little Falls for more than thirty-five years, during which the town grew from a wisp of a settlement at the meeting of stage roads to a community with a lively mix of commercial and industrial activities. Later, however, the wood-frame structure was moved to a new location where for nearly a century it witnessed Little Falls' evolution into a modern town—one in which buildings like the O. A. Churchill Store, the oldest standing commercial building in central Minnesota, were no longer needed.

Not much is known about O. A. Churchill except that he established his store in 1855 on the first floor of a building located practically in open country near a recently built dam on the Mississippi River. The building, an L-shaped Greek Revival structure, had a hotel or rooming house on the second floor. As Little Falls grew up around the store, the corner the building occupied became increasingly valuable as the commercial center of town. In 1891, a new and larger building—the Butler Block, home of the First National Bank—claimed the lot, and the Churchill building was shunted off a few blocks away to a spot on Bay Street.

There the building underwent a series of changes: a one-story addition on the inside corner of the L, a two-story metal-clad growth at the rear from about 1911, and a single-story add-on behind that made of concrete blocks. The building lost a balcony above the storefront window and most of the sleeping-room partitions on the second floor. Parts of the building received a masonry veneer, done with the bricks laid on their sides so that their stamp, M. Scott (the name of a prominent Little Falls brickmaker), filled the walls (see detail shot).

These changes reflected the building's new uses. Soon after the move to Bay Street, it reopened as the Webster Hotel. The hotel closed around 1908 and the building sat idle for about three years until the Muske Implement Company, one of Morrison County's biggest agricultural supply houses, took possession (see first photo, taken in 1984). This company, which occupied the building until the 1970s or '80s, made most of the structural additions.

By the mid-1980s, though, the building was again unoccupied. It stood starkly in a block of parking lots and other open spaces. Plans for its rehabilitation as an office or retail space didn't pan out, and in 1988 the Little Falls City Council approved the building's demolition. It came down in August of that year.

Aaron Diffenbacher Farmhouse

Rusheba Township, Chisago County
About 1868–1985

IN THE EARLIEST YEARS OF FARMING in Chisago County, most of the first houses that settlers raised on their land were temporary structures built from logs or other inexpensive materials. After some years passed, bigger frame homes replaced the early houses. Aaron Diffenbacher's farmhouse, one such replacement home built around 1868, was one of the few to survive so far into the twentieth century.

Diffenbacher arrived in Rusheba Township in 1866. Little is known about him and his family. He apparently brought with him, though, a New England architectural sensibility that shined through in the style of the house he built on his property lying about three miles east of Rush City, a mile west of the St. Croix River, and at the edge of today's Chengwatana State Forest. The two-story house had simple lines, a plain gable roof with two chimneys, and a transomed entry that hinted at the Greek Revival style so popular among New Englanders arriving in eastern Minnesota.

In later years, property owners added a pair of rooms at the rear, both finished harmoniously with the look of the house. A barn, garage, granary, and shed also stood on the Diffenbacher land.

The house sat quietly, attracting little attention, until 1980, when it won placement on the National Register of Historic Places for its connection with Chisago County's early agricultural development. At that time, the house was in an excellent state of preservation. (It is pictured here in 1979.)

The condition of the Diffenbacher Farmhouse took a disastrous turn for the worse on April 3, 1985, when a crew of workers arrived to replace the roof shingles. During the crew's lunch break, a fire started. Someone reported the blaze at 12:45, but the rural property was many miles away from any fire station. The fire destroyed the house and nearly all of its contents. A new house now occupies the site.

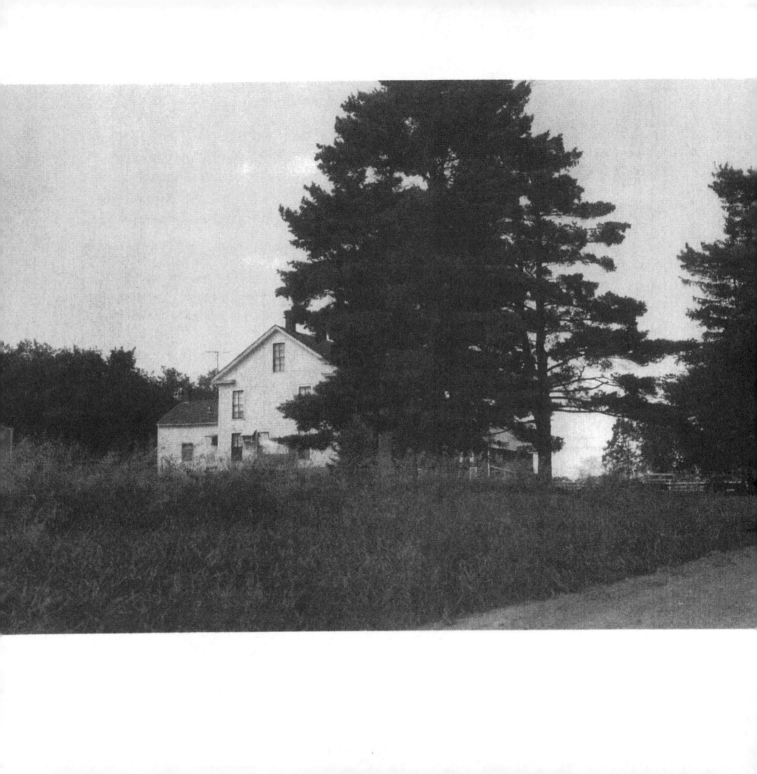

Heath Summer Residence

Arcola Trail Northwest, Stillwater
1911–86

BEFORE THE NATIONAL PARK SERVICE acquired it around 1980, only two families, the Heaths and the Fosters, had ever owned this 2,424-square-foot, T-shaped house on Titcomb's Landing along the St. Croix Scenic Riverway and four miles north of Stillwater. With five bedrooms, a two-story screened porch, and maid's quarters in the attic, it was one of the earliest and biggest summer homes built along the river.

The first family to spend summers there, the Heaths, were from St. Paul. Interested in recreational activities of all sorts, they once canoed from the house to the Mississippi River, and then south to St. Louis. On their land in the shadow of the Arcola Soo Line High Bridge, they built a clay tennis court, a set of three interconnected trout ponds filled by springs on the property, and fish breeding tanks beneath the porch of the house.

The Heaths spent sixteen summers on Arcola Trail before resettling in Europe in 1927. Elmer and Dorothy Foster of Minneapolis bought the house and half of the wooded lot. Fifty years later, the Foster family still owned the property, but the trout pond was dry and the tennis court abandoned to the weeds. (Here it's pictured in 1976.)

In a few years the National Park Service stepped in, hoping to restore the house. By this time, the siding had decayed and a rock retaining wall on the property needed stabilization. But government ownership did not prove beneficial for the residence. Vandals frequently tore up the unoccupied house. Two intentionally set fires in 1984 and 1986 wrecked the interior and charred the front porch. Despite the Park Service's attempts to secure the house, trespassers kept entering and damaging.

Finally, on the morning of July 20, 1986, two hikers noticed a plume of smoke rising from the house. Neighbors heard a pair of motorcycles racing away from the Heath Summer Residence property. By the time firefighters could reach the scene, only a single wall of the wood-frame building remained standing. A fuel-oil tank in the basement of the rubble continued to smoke angrily for days.

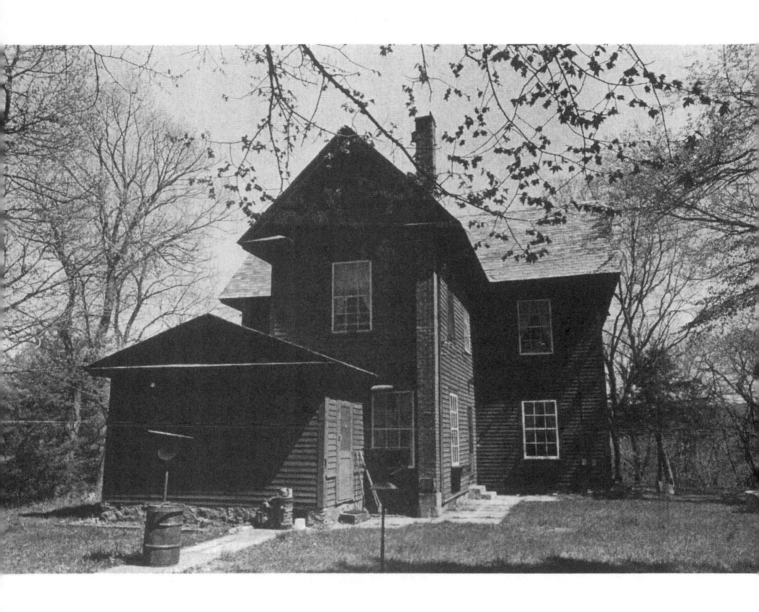

Johnson Block

IN MANY WAYS, THE LIFE OF S. C. JOHNSON offers the classic small-town success story. Born in 1851 in Sweden, he emigrated to the United States at the age of sixteen. Four years later Johnson settled in Rush City, a town destined to become one of Chisago County's most prosperous settlements along Minnesota's growing network of railroads. He went into business as a druggist, later adding to his retail offerings a selection of dry goods, farm implements, and groceries. By the end of the nineteenth century, Johnson was one of Rush City's most important and prosperous businessmen.

The town honored his accomplishments in the form of the Johnson Block, a building erected in the center of the business district by the State Bank of Rush City at a cost of $15,000. Romanesque in design and built of red brick, the imposing two-story structure was unusual in town for its scale and dignified design. It had large arched exterior doorways, matching arched window openings, and a metal cornice peaking the Fourth Street exterior. Several businesses shared the Johnson Block during its early years: the bank, Johnson's own drugstore, lawyers' offices, and the electric light company.

A fire gutted the building just five years after it was built, but the Johnson Block's owners quickly moved to restore it. Already, it was a landmark building in Rush City's commercial district.

As the years flew by and the building passed through the hands of many owners, the Johnson Block's fate mirrored the economic fortunes of Rush City. M. J. Moses bought it in bankruptcy proceedings during the Great Depression, and his son Harry Moses took possession in 1960. The younger Moses tried to make the building more profitable by building nine apartments on the second floor. The passage of time changed the exterior very little, however; only one of the storefronts was remodeled and a few windows filled in.

By 1980, the Johnson Block was hanging on as a viable commercial building, with three first-floor business tenants, including a laundry and a variety store, and several residents upstairs. But on a Tuesday morning in the fall of 1981, flames once again closed the Johnson Block—this time permanently. A fire, its cause never ascertained, began in the basement. Despite the dousing of the building with 45,000 gallons of water from Rush Creek, firefighters from Rush City, Pine City, and North Branch were unable to halt the destruction of the Johnson Block. One of the region's best-preserved relics of the commercial prosperity of the nineteenth century was gone.

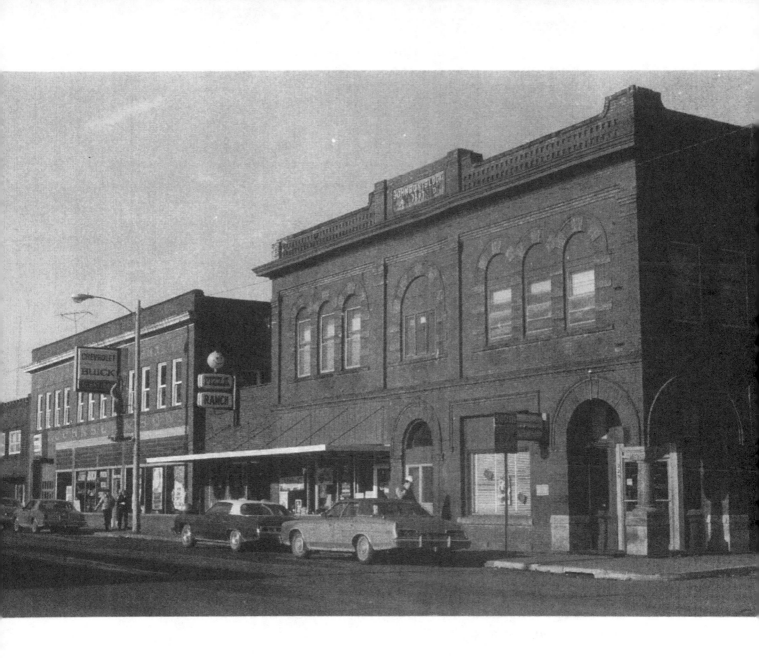

Mount Tom Lookout Shelter

Sibley State Park
1938–92

IN 1938 MEMBERS of the Civilian Conservation Corps (CCC), a federal program organized to put people to work during the Great Depression, set up camp in Sibley State Park to raise an unusual structure. Working at the summit of Mount Tom, the highest point for 50 miles around, the CCCers—mostly veterans of World War I—laid a 525-square-foot pavement of granite slabs from which rose a huge stone pylon that had four arms projecting in a cruciform configuration. The arms reached up more than 7 feet to support a hip roof. According to the original construction drawings, the pylon was to be assembled from "granite boulders native to Mount Tom set deep and at random."

When completed, this structure served admirably as a nonintrusive shelter unique in Minnesota for its rustic-style construction and sensitivity to its environment. For more than a half-century, the Mount Tom Lookout Shelter gave park visitors a grand vista of the surrounding woods. Its designer was Edward W. Barber, who worked for the Minnesota Central Design Office of the National Park Service, and he so much liked this shelter that he retained a drawing of it in his personal collection.

First set aside as a game reserve in 1917, Sibley State Park in Kandiyohi County fell under state control in 1935. The view from Mount Tom in 1938 was spectacular. But as the years passed, the growth of trees obscured the view while the grounds around the shelter eroded. (It is pictured here in 1987.)

In the early 1990s, the Minnesota Department of Natural Resources (DNR) began investigating what to do about the situation atop Mount Tom. The DNR proposed altering the shelter by elevating the roof and adding a second story with a deck and twenty-four-riser staircase. In addition, the DNR wanted to change the contour of the stone base and relandscape the surrounding grounds.

The State Historic Preservation Office (SHPO) vehemently protested the DNR's plan, which it called incompatible with the aesthetic, design, and purpose of the original shelter. "Proposed alterations are UNACCEPTABLE and essentially destroy the historic resource," wrote one SHPO official. "I would rather suggest a new observation shelter elsewhere on the site!"

Despite these protests, the DNR went ahead with its changes. Once an unobtrusive and enclosed shelter, it grew into a vertical shaft that conveyed feelings of exposure and openness as it improved the view of the surrounding land.

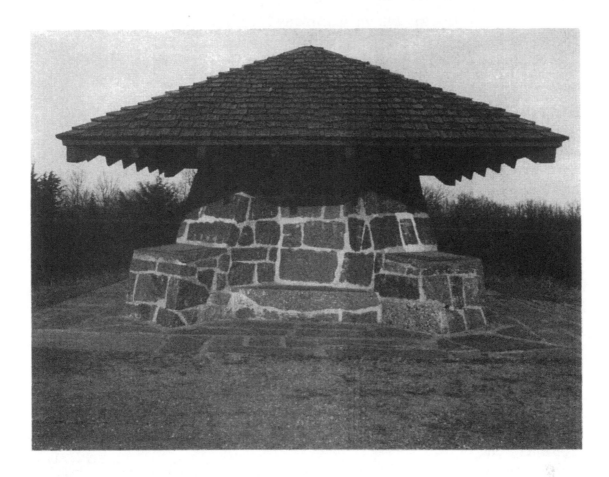

The alterations were completed in 1992. Although DNR commissioner Rodney Sando asserted that "the historic nature of the structure was carefully considered during the renovation, and the project actually enhanced the existing structure," SHPO had the shelter removed from the National Register of Historic Places.

Osakis Milling Company Mill and Elevator

Lake Street at Central Avenue, Osakis
1887–1990

IT WASN'T JUST ABUNDANT GRAIN that made Minnesota one of the world's flour capitals in the 1890s. The state's three hundred flour mills—about 275 of them operating outside the Twin Cities—accomplished the task of transforming grain into commercial products. Few of these mills survived into the final decades of the twentieth century, but the Osakis Milling Company's facility in west central Minnesota was one that did.

Located on Lake Osakis's south shore and conveniently close to the Great Northern Railroad tracks that served the town, the Osakis mill was built in 1887 at a cost of about $50,000 by business partners named Schay (sometimes spelled Shei) and Chalfont. Constructed of beige brick and rising three stories, it housed some of the era's most advanced grain milling technology: porcelain and steel rollers, not the traditional millstones, processed the grain, and a coal-powered steam engine ran the operation. In its earliest years, the mill could produce 150 barrels of flour a day.

The mill quickly grew into the most important industry in town, and when a fire in 1894 severely damaged it, Osakis citizens donated $2,500 to the rebuilding effort. The fire gave the mill's owners the opportunity to take advantage of the latest milling advances, and they bought new machinery and rebuilt at a cost of $30,000.

The new equipment greatly increased the mill's production capacity, and its flour output reached 400 bushels a day by 1909 (see photo from this era, 1910). A few years later, the facility added a grain elevator to its complex. "Oh-Sa-Kis" Flour, packed in sacks showing a young couple kissing, was regionally well known.

By the 1920s, though, Minnesota's flour milling industry began a steep decline. Many mills closed down. In 1926 the Osakis mill converted to an operation that mixed feed for farm animals. Gas-powered equipment replaced the old steam-generating machinery in the late 1930s, and within a couple of years all of the original flour milling equipment was scrapped.

Now one of only two surviving nineteenth-century mills in its region, the facility was commonly known as Pollard's Mill. It continued mixing animal feeds until 1987, when the Minnesota Department of Natural Resources acquired the property with the intention of razing it to improve recreational access to Lake Osakis. The demolition, begun in the summer of 1990, took only two weeks.

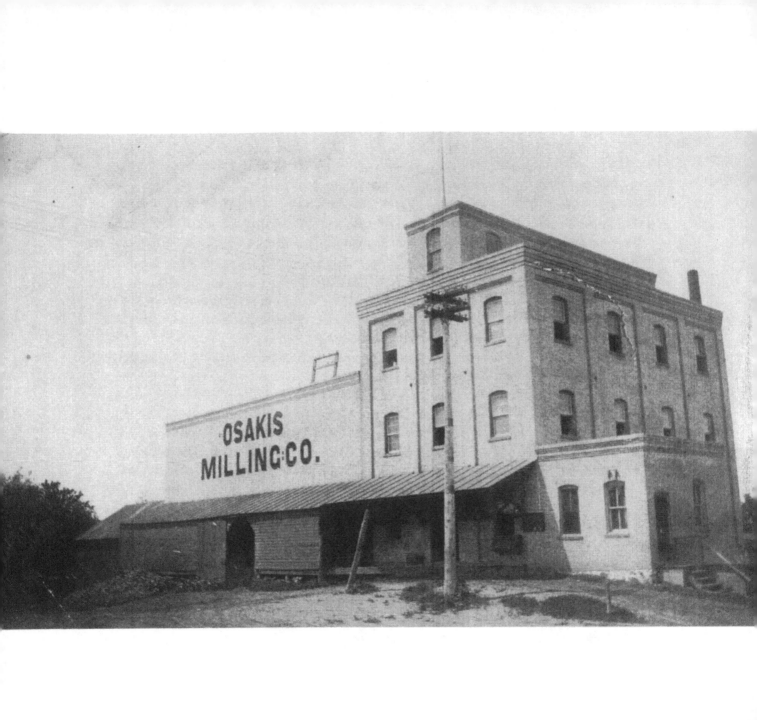

St. Cloud Post Office and City Hall

314 Saint Germain Street, St. Cloud
1902–86

PERHAPS THE PEOPLE OF ST. CLOUD realized something important was afoot when workers began laying four sets of railroad tracks down the middle of Saint Germain Street, one of the city's principal thoroughfares. Or maybe it was when crews cut all the phone and electric lines above the street and shored up the basements of the shops along the road. For a few residents, maybe it didn't sink in that one of America's most amazing engineering feats was imminent until the day in 1938 when the old St. Cloud Post Office building was actually raised off its foundation and drawn by horses, ever so slowly, along the tracks from one side of town to another as crowds watched.

Despite all of its historical importance as St. Cloud's first post office and later as its city hall, the formidable gray granite building that once served both functions is most notable as the structure that played a starring role in this move, a monumental achievement of the era. Toward the end of the Great Depression, the building closed as a postal facility and was purchased by the city of St. Cloud for use as a new city hall. A new federal building was to be built on the same site, so for $6,965 the city hired the F. W. Laplante Company of Sioux Falls to move the building four blocks to its final resting place. The relocation came off without a hitch.

After the move, the building sat near the banks of the Mississippi River. In its new surroundings it looked much the same as it had when first built in 1902 in the Renaissance Revival style. Built at a cost of $50,000 from granite quarried in the area, it had two stories and forcefully arched windows and entryways. Copper flashed from the cornice and the cap of the granite chimney. Originally, the post office occupied the first floor and a U.S. Land Office took the second.

As the postal operations grew, however, even the whole building could not offer sufficient space for a post office. That's why the building was up for sale in 1938.

The building changed little over the years. By the 1970s, it still had its original flooring, mill work, hardware, and windows. (This photo was taken during that decade.) But after the city government moved to a new city hall in 1983, the building constituted a solid granite obstacle to yet another construction project. This time there were plans for a new convention center along the Mississippi, and the building that once picked up and moved four blocks suddenly had nowhere to go.

Preservationists tried to block the destruction of the old post office/city hall, and they urged the

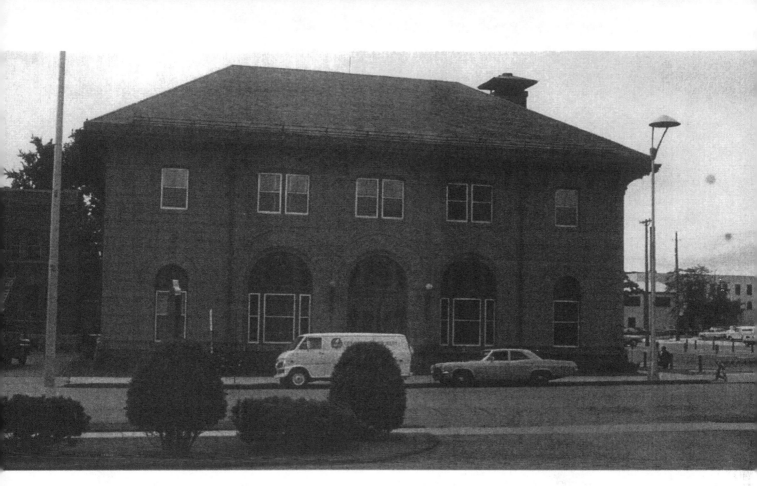

city to incorporate the building into the convention center design. Ultimately, they lacked the money to stop the city's plans. In November 1986, front-end loaders attacked the building's 2-foot-thick walls. Rumors persist that the city illegally disposed of the granite rubble in a landfill.

Sherburne County Courthouse

326 Lowell Street, Elk River
1877–1995

THE CASE OF THE OLD SHERBURNE COUNTY COURTHOUSE is a study of longevity: the perseverance of the building itself and the endurance of the preservationists who fought to save it.

Four years after Elk River became the seat of Sherburne County in 1872, the county commissioners engaged W. C. Warner to design the area's first building solely devoted to county business. The owner of a local sawmill built the structure for $2,400 on land provided by early Elk River settler John Quincy Adams Nickerson. It was a modest two-story building in the Italianate style with a square tower and a cupola over the entrance. The offices and courtrooms inside had pressed metal ceilings.

In most other Minnesota counties, stone or brick courthouses replaced the initial wood-frame government buildings around the turn of the century, and modern buildings often followed later in the twentieth century. Sherburne County broke this pattern. Instead, it altered its first courthouse countless times during the next century to accommodate the growing county government. The building witnessed everything from a hanging to the administration of routine county business.

The first change to the courthouse appeared in 1887, a two-story addition at the rear. Then came the construction of two concrete vaults around 1895, another rear addition in about 1900, the enlargement of the vaults about ten years later, and yet another addition to the vaults and the redesign of the heating system in 1925. The year 1939 saw the shortening of the tower and the construction of a new gable roof. Office additions and a new two-story vault came in 1949. And at some point the building acquired a stuccoed exterior.

Throughout this period, the interior of the original part of the courthouse remained remarkably unchanged. Only the second-floor courtroom received new carpeting and wall paneling in 1975. By 1980, when Sherburne County at last moved most of its offices to a new government building at the edge of town, the old courthouse was one of the last of its kind in the state. (This photograph was taken in 1981.)

At one point in the mid-1980s the building—now looking like an overgrown house—contained only an office for the county veterans' service officer and a karate studio in the former courtroom. The Sherburne County Board wished to demolish it, sell the land it sat on, and use the funds for an addition to the new county government building. Local preservationists, joined by the Preservation Alliance of Minnesota, opposed this idea. At first these activists thought they had the county in a bind, because

Nickerson's original sale of the land required that the property be used for a government building. It was later discovered, however, that his requirement was nullified in 1904 when he signed a quit-claim deed on the land. Without success, the preservationists promoted the reuse of the building as a museum or its relocation. But the funders and buyers were lacking.

At last, after a decade of wrangling, time ran out for the former courthouse. In 1995 the county forked over $38,000 to raze it. "The destruction left a musty smell in the downtown area of the old courthouse, which has not housed county functions for more than a decade," the *St. Cloud Times* noted. The building was leveled in a single morning.

Andreus Thoreson House

Lac qui Parle Township, Lac qui Parle County
1899–1989

IN MOST RESPECTS, THE STORY OF Andreus Thoreson and his family closely resembles the story of many Minnesota immigrants of the nineteenth century. Born in Norway in 1832, Thoreson arrived in Lac qui Parle County in 1865 on a covered wagon along with his wife, first child, and a pig. The Thoresons bought a bit of farmland, lived for a time in a sod-roofed dugout, and later replaced that home with a larger, 225-square-foot dugout. As their farm prospered, the Thoresons added to their land. By the 1880s they owned several sections of fine acreage.

The Thoreson immigrant story deviates from the norm in the scale and craftsmanship of the house the family erected on their farm in 1899. After years of living in very modest quarters, the family needed to spread out. Thoreson hired Claus Hoff, who would eventually design a half-dozen sizable homes in the area, to build a new house—a large one. Offering to pay their passage from Scandinavia as payment for their work, Thoreson brought in highly skilled craftsmen to beautify the house. When all the work was done, the Thoresons had a house that few if any others in the county could rival.

Called *Praii Gaard* (Norwegian for *Prairie Farm*), the Queen Anne–style mansion rose two and a half stories above the gardens, orchards, and grassy ocean of the farm. The house was nearly overwhelmed by carved detail: railings and spindles on the verandas, corner pilasters, gable ornaments, intricately carved brackets in the eaves, and a solemn cornerstone that read, "A. Thoreson—1899." Within its doors was a profusion of wall stenciling by Scandinavian immigrant artists, mock marble wainscoting, and painted wall panels. There were no visible joints in the oak floorboards. An unusual octagonal kitchen, affixed to the back of the house, enabled the cooks to prepare enough food to satisfy a large summer threshing crew. The very hinges on kitchen cupboards were decorated, and decorative brickwork surrounded a built-in preserve cabinet in the basement. Long before other residences in the county had electricity, a generator on the premises illuminated electric lamps in the fifteen rooms of the house. There was no plumbing anywhere inside, however.

Probably no house was lived in more enthusiastically. The Thoresons hosted political gatherings, dinner parties, and church potlucks. Meanwhile, as many as twenty guests could, and did, camp out on the second floor. People far and wide knew of the Thoreson mansion.

Andreus Thoreson, who never learned English, died in 1914. (This family shot was taken at his August funeral.) One of his sons, Tostein, a bachelor, lived in the house parsimoniously, saving heat by

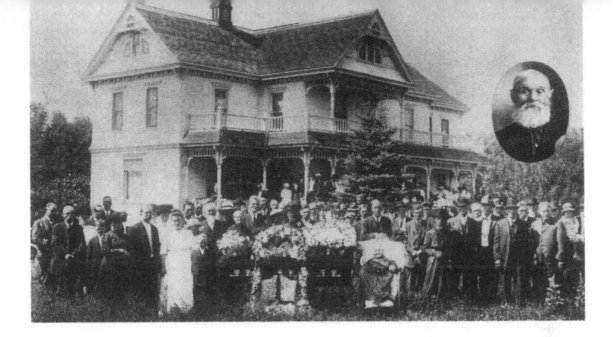

closing off everything above the first floor. Tostein sold the land bit by bit, and his father's cottonwood and ash trees were replaced by rows of corn.

After Tostein's death in 1963, no one lived in the house for six years. The paint peeled and black-berry plants sprang up along the foundation. The next owner, Harold Kvaal, did not appreciate the house. "It'd make somebody a nice garage," he said. "The barn was so much trouble to tear down I haven't started on the house. For a hundred bucks I'd let somebody haul off the house for lumber, providing they'd bulldoze the land flat for corn."

But nobody ever tore down the house. It fell into the hands of owners who tried to restore it. Throughout the late 1960s and '70s, they painted the house, kept the vandals away, and furnished it with antiques.

By 1984, after the death of her husband, Donna Lind, the restoration-minded owner, had run out of steam. The house again sat vacant and in need of paint. Lind sold the house in 1988 to the Hedtke family, which made the mansion livable and set up housekeeping.

The Thoreson House met its end tragically just a year later, when ashes from a coal-burning stove set a stretch of grass on fire. As the Hedtkes watched, the blaze spread throughout the house, leaving only the octagonal kitchen standing. "This isn't just the loss of a home," Donna Lind lamented, "it's a national tragedy. It was an irreplaceable part of our heritage."

Titrud Round Barn

County Road 30, Stockholm Township, Wright County
1908–92

THE UNUSUAL ROUND BARN that long distinguished the Wright County farm of Olof and Karen Titrud and their descendants began its existence in a whirlwind of creative inspiration and came to its violent end in a whirlwind of nature.

Immigrants from Norway, the Titruds (originally the Titteruds) settled in Wright County in 1868 after a traumatic oxcart trip in which a wagon wheel ran over their infant daughter. The girl survived, and the family moved onto land purchased for $9 an acre from the St. Paul and Pacific Railroad Company. The Titruds built a log house, began farming, raised a granary, and increased their family.

In 1908 their son O. L. Titrud, who had studied at the agriculture school of the University of Minnesota, created an experimental design for a new kind of barn. This barn would shelter livestock, their feed, and farming equipment—just like a normal barn—but it used a novel engineering design to convey fodder to the cattle it housed. At the center of the barn was a concrete silo that dispensed feed to the cattle arranged around it in stanchions radiating from the center. The younger Titrud believed that a centralized feeding system would prove more efficient than the traditional arrangement in parallel rows of stanchions.

This striking barn arose as planned. Sleds from Kingston, Minnesota, hauled in the giant granite stones for the foundation, and precut lumber arrived by rail. When completed, the two-level barn stood 67 feet in diameter and had an octagonal cupola that capped an oculus formed by the intersection of wood rafters and sheathing boards. Over time, Wright County farmers built several other round and octagonal barns, so the feeding experiment may have been a success.

Olof Titrud died in 1899, before the barn was built. His original log house lasted until 1951, the granary made it to 1975, and the farm remained in the family. A historical site surveyor who visited the farm around 1980 judged the barn in poor condition, with visible settling of the foundation and bulging of the walls. (This shot dates to shortly before that time.)

The Titrud Round Barn was no match, then, for a tornado that touched down on June 16, 1992. The whirlwind completely destroyed it.

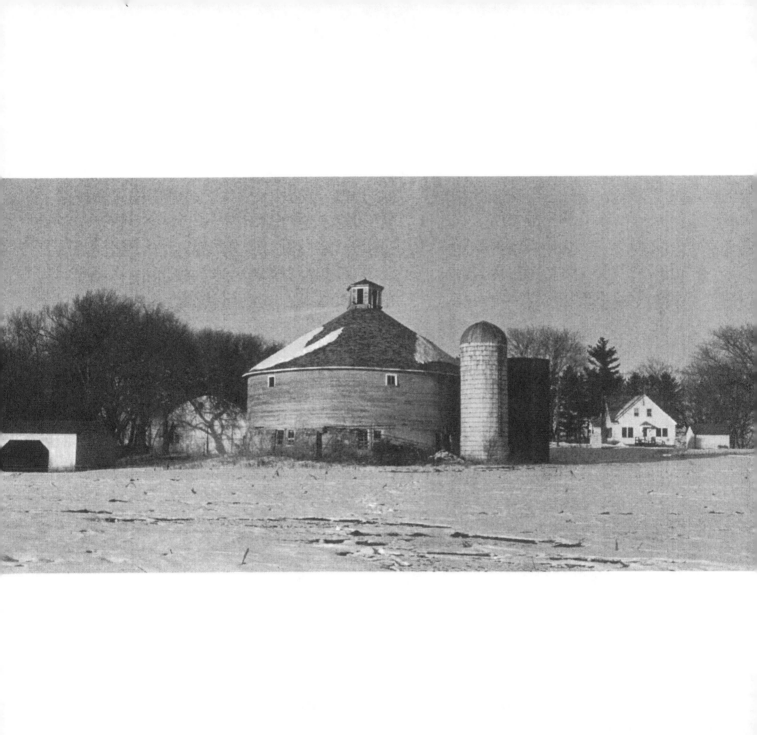

SOUTHERN MINNESOTA

Chicago, Milwaukee, St. Paul & Pacific Railroad Depot

400 Second Street, Farmington
1894–1984

FROM THE TIME THAT THE MINNESOTA CENTRAL RAILROAD built the first tracks to Farmington in 1855 until the middle of the 1860s, the town had no railway depot. The first station manager sold tickets from the top of a lumber heap. Finally, a proper depot was erected, but it burned down in a fire that destroyed much of Farmington in 1879. Fifteen years later, with the Chicago, Milwaukee, St. Paul & Pacific Railroad now owning the tracks, a new depot rose a block from the center of the town's commercial district.

Several features distinguished the building, which housed both passenger and freight operations. It was covered by a whopping hip roof—a Farmington landmark—with flared eaves supported by plainly designed brackets. On two sides the surrounding brick cobblestone bore an unusual circle and line pattern, and waiting passengers could pass the time by reading the names of a variety of brick-making companies stamped on the masonry. By the end of the nineteenth century, Farmington depended on the railroad as its lifeline to the Twin Cities, and this 100-foot-long depot symbolized the town's reliance on trains.

That reliance would grow in the early years of the new century. By 1909, trains were arriving in Farmington every half hour. The following year, Farmington opened its own terminal yard, allowing freight trains to avoid congested facilities in Minneapolis and St. Paul. The depot employed an agent, four operators, a warehouse worker, and a cashier.

But eventually the rail activity slowed. The terminal yard closed in 1921. The depot grew sleepy. By 1970, Farmington's daily rail traffic was down to six trains, none carrying passengers. The old building stood as the town's sole remaining connection with its past as a busy railroad stop. The depot's last owner, the Milwaukee Road, used it as a storehouse for track maintenance equipment until 1982.

In 1983, citing concerns about liability and public safety, the Milwaukee Road announced that the depot must be moved or torn down. Preservationists in Farmington formed a committee to save the depot, but they could not raise enough money to relocate or rehabilitate the building. Bulldozers flattened it in April 1984. A "pioneer village" in the Dakota County Fairgrounds acquired some of the paving bricks on which so many railroad customers had tread.

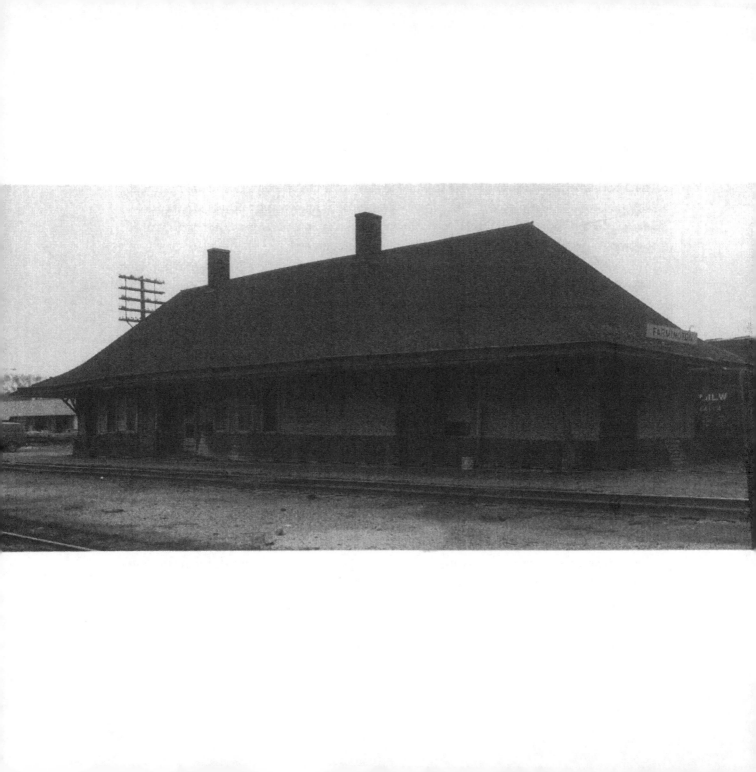

Close Brothers House

Faber Farm, Beaver Township, Rock County
Around 1883–1989

WILLIAM AND FRED CLOSE, IMMIGRANT ENGLISHMEN who opened much of southwestern Minnesota to white settlement, designed and built the simple house that stood for about 106 years on the Faber farm near Luverne. They also built hundreds of similar houses, each of them originally standing on a 160-acre parcel of land that the Close brothers acquired from railroad companies—made suitable for farming by breaking the prairie sod—and offered to buyers. Today, nearly all of these farmhouses have vanished or been altered beyond recognition.

Twenty-four feet long and sixteen deep, this house had two rooms on the first floor and another two on the second level. In virtually every way, it was typical of the houses that the Closes built, down to the L-shaped staircase, central stove chimney, wood siding, and plastered interior walls. A researcher for the Minnesota Historical Society came upon it in 1978 while surveying historic buildings.

The Close brothers, reportedly from a wealthy and high-ranking English family, arrived in the United States in the late 1870s and settled in Le Mars, Iowa. There they formed the Iowa Land Company, largely financed with capital from their homeland, and began purchasing and subdividing land acquired from railroads. In addition to raising a house and preparing the soil on each parcel, they built a barn and dug a well. For just over $1,000, buyers could have a ready-made farm.

By the end of the nineteenth century, the Close brothers had bought and sold at least 344,000 acres in thirteen Minnesota and Iowa counties, including nearly half of the land in Pipestone County and 25,000 acres in Rock County. They undoubtedly prospered. Fred Close died during a polo game in Sioux City in the 1890s, but William lasted until 1921.

At the time this house was rediscovered, its owner, Francis Faber, declared it a hindrance to his farming operation. During the 1980s, the Rock County Historical Society and city officials in Luverne tried to relocate and restore it. (It was in fair and unaltered condition.) Mrs. Leonard Hagen of Luverne, who was born in the house in 1905, lent her support to the effort. Even so, insufficient money was raised to protect it. In 1988 a fire damaged the house, and its owner demolished it the following year.

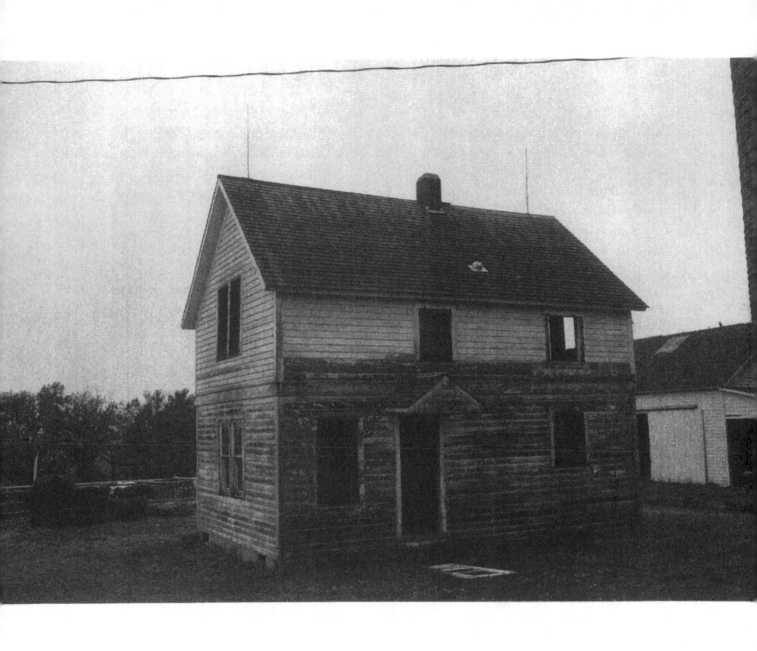

Constans Hotel

121–127 North Main Street, Blue Earth
1868–1988

THE LINEAGE OF THE CONSTANS HOTEL, which the city of Blue Earth demolished in 1988 to make way for a retail development, sprang from the town's earliest years. Its builder, Henry P. Constans, arrived in Faribault County in 1856 after a colorful youth spent in his native France, New Orleans, and St. Paul. With James Wakefield he platted Blue Earth and got to work making his fortune. He started the first lodging house in the fledgling town, a log building called the Metropolitan, and guided his establishment through months of housing troops during the U.S.-Dakota Conflict in 1862 to become the commercial hub of the community.

After twelve years in business, Constans decided he needed a bigger hotel. He tore down the Metropolitan and built on the same site—the southwest corner of Main and Fifth Streets—a three-story frame structure that he named, rather immodestly, the Constans Hotel. Little is known about the original appearance of this building because Constans had half of it pulled down in 1896; he faced the remaining segment with brick and added a taller three-story section that the Kinney & Orth architectural firm of Austin designed in the Renaissance Revival style. (This image was taken after these changes, in 1909.)

After this significant facelift, the Constans had forty guest rooms, a dining room full of gleaming quarter-sawed oak, steam heat, electric lights, a basement chamber in which salesmen could display samples of their wares, and an intercom system that connected the hotel office with every sleeping room. The *Blue Earth City Post* pronounced it the finest hotel in southern Minnesota.

For years, the Constans served Blue Earth's travelers. After its founder's death, the hotel passed to son Victor Constans, who managed it with his four sons during some thriving decades in which Sunday dinners at the Constans became a town institution. In 1950, however, the hotel was sold to a nonfamily member and manager, and it soon settled into a dreary life as a boarding house and apartment building.

Decrepitude was inevitable. In 1979, the fire marshal closed all the Constans apartments except those on the street level, and the owner claimed that it made no economic sense to repair the building.

By 1988, the Constans had lost nearly all of its splendor. Most of the interior woodwork was gone. The floors sagged and falling bricks threatened pedestrians. The city branded the building a safety hazard. In addition, the owner of the Constans owed $25,000 in back taxes.

That year the building went up for sale. The city of Blue Earth, the only interested buyer, picked it up for $5,000. The Constans Hotel, and some of Blue Earth's history, disappeared within weeks.

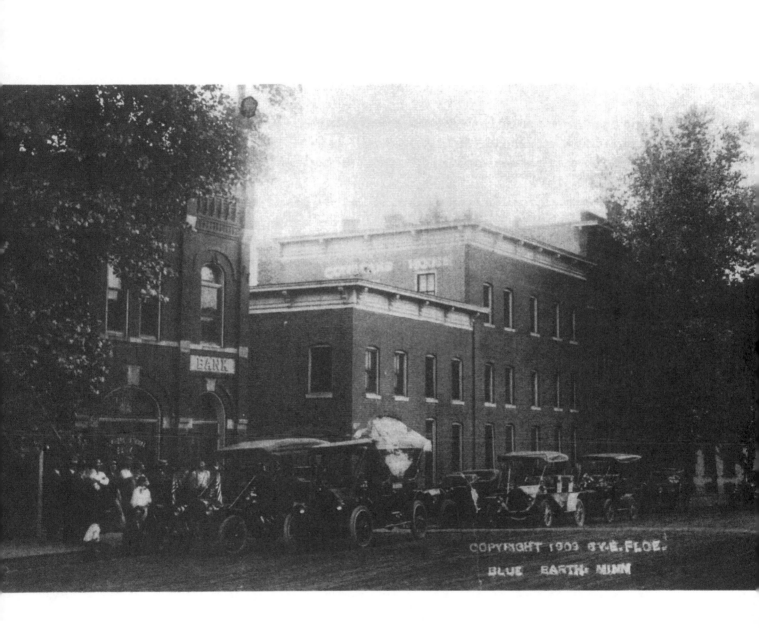

COPYRIGHT 1909 GY E. FLOE.
BLUE EARTH MINN

Lucius Cutting Barn

3210 Nineteenth Street Northwest, Rochester
1868–1982

DURING THE LAST THIRD of the nineteenth century, stagecoaches traveling Minnesota's old Mantorville Trail would sometimes stop at a farmstead in Cascade Township, west of Rochester. There the driver and passengers would spend the night in the farmhouse while the horses fed and rested in an unusual barn.

Built completely of random-coursed limestone quarried just a mile away, the 2,000-square-foot barn had a square cupola on the roof and a prominent stone arch over the main wooden doors. Inside, heavy timbers held up the roof. The barn, a symbol of the hard work farmers put in during the early years of agriculture in Olmsted County, was built to last—and it lasted for 114 years.

Its builder was Lucius Cutting, who had assembled and run a steam-powered sawmill for nine years in his home region of Chautauqua County, New York, before migrating to Cascade Township with his wife, Laura, in 1855. The Cuttings were among the region's first white settlers. Highly skilled in building with stone, Cutting raised his own house in 1867, the barn a year later, and a stone schoolhouse across the Mantorville Trail from his property.

By the 1880s, Cutting had increased his land holdings to 360 acres and enjoyed a reputation as an industrious grower as well as an accomplished builder. "If one inquires for a substantial, representative farm, Mr. Cutting's name is the first mentioned," observed the *History of Olmsted County* in 1883. The following year, however, Cutting, with his wife and son, moved to Louisiana and never returned to Olmsted County.

The stone schoolhouse burned down in 1925 and the farmhouse vanished into the mists of time, but the Cutting barn stood strong and unaltered. It sheltered countless generations of livestock.

The barn's end arrived unexpectedly. In the early morning hours of January 24, 1982, a fire started inside. By the time a fire crew arrived, only a single stone wall remained standing. The blaze claimed no human lives, but several calves were lost. With the destruction of the Cutting barn, our connection with Olmsted County's distant past grew weaker.

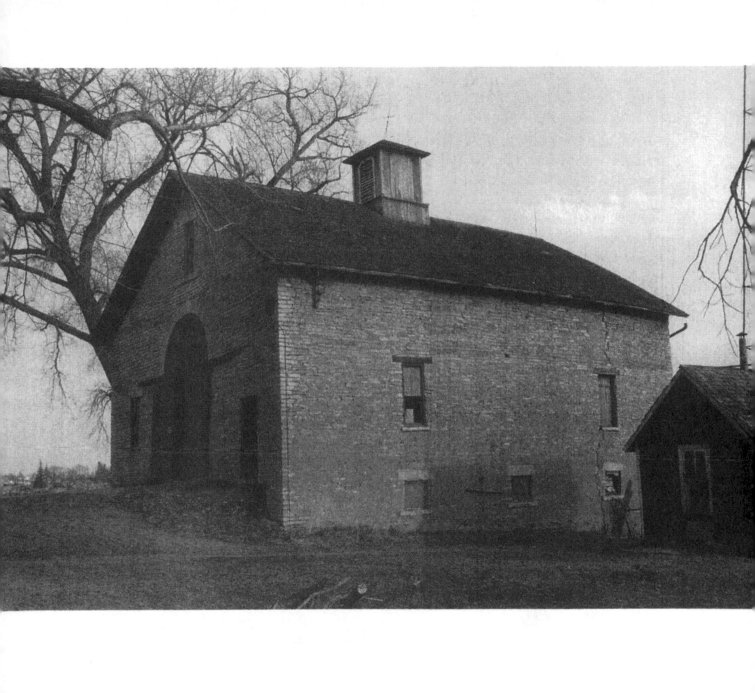

Elysian Water Tower

Fourth Street at Frank Street, Elysian
1895–1989

THROUGHOUT THE LATE NINETEENTH CENTURY, towns around Minnesota were developing municipal water systems. The most visible part of these public works projects was usually the water tower, often an area landmark that bore the name of the community.

In Elysian, a driller named S. Swanson bored down 287 feet to prepare a well for the town. The community's water tower was one of seven such structures that appeared in Le Sueur County between 1895 and 1900. Built by the U.S. Wind Engine and Pump Company of Batavia, Illinois, at a cost of $5,000, it sat atop a 75-foot-high trestle tower that overlooked the town. Its squat wooden tank held 50,000 gallons of water and had a conical roof. A wooden catwalk encircled the base of the tank.

For the first seven years of its operation, a windmill powered the pump that drew water out of the well. In 1902 a brick structure was built next to the tower to house a gas engine that replaced the windmill. Over the next several decades, as metal water tower tanks supplanted the wooden tanks in other towns, Elysian's old water tower continued to mark the skyline. By the 1980s, it was one of the few tanks of its kind still providing water to a Minnesota community.

Eventually, though, the Elysian Water Tower proved too antiquated to handle the town's needs adequately. It was razed in 1989 and replaced by a streamlined metal tank and tower.

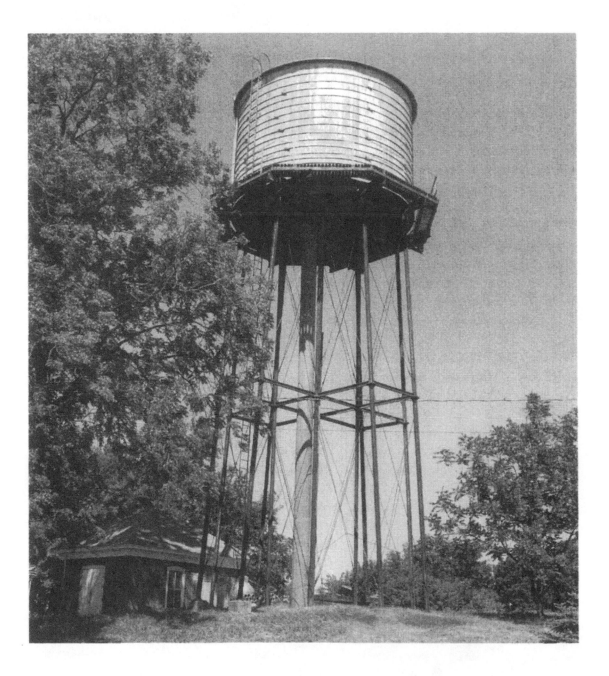

Hastings Spiral Bridge

Mississippi River, Hastings
1895–1951

IN ITS DAY ONE OF THE MOST FAMOUS RIVER CROSSINGS in America, the Hastings Spiral Bridge was renowned not for its length, method of construction, or longevity as a Mississippi River span. Instead, people loved the bridge for its strange, corkscrew approach on its Hastings end—a design conceived for the purely mercenary purpose of setting bridge traffic down right in the heart of Hastings's commercial district.

The first crossing built over the Mississippi River at Hastings was an 1854 rope ferry bridge. This bridge eventually proved inadequate for the needs of the growing community. In 1890 the U.S. Congress passed authorization for a new span, but Minnesota authorities did not act. Four years later, Congress gave Hastings another chance to build a new bridge, and this time citizens voted to issue the necessary bonds. The Wisconsin Bridge and Iron Works Company of Milwaukee came in with the low construction bid of $40,000.

Nobody knows the identity of the creator of the bridge's unusual design. John Geist, the chief engineer for Wisconsin Bridge and Iron Works, never claimed credit for it. The project's supervising engineer, Oscar Claussen, was experienced in bridge design and may have planned the spiral, but no surviving documentation names him as the designer. Local legends raise two other possibilities: a Hastings machinist named B. D. Caldwell, whose daughter swore that she saw him one day trace the spiral in some sand; and an anonymous but architecturally gifted inmate at Stillwater State Penitentiary.

Whoever designed it, the bridge was 1,987 feet long. The portion that crossed the river was of an unexceptional truss design employing oak joists. It had an 18-foot-wide roadway made of plank-covered steel and a sidewalk at one edge. On the Hastings end, the bridge rested on iron beams bolted onto a solid rock base. Concrete pedestals supported the beams on the other side, near Denmark Township, where the bridge approach was traditionally straight.

The spiral, constructed completely of steel, circled for 385 feet. Vehicles coming across from the east bank found themselves gently set on solid ground near Sibley Street, one of the main downtown avenues in Hastings.

Most of the town's thirty-eight hundred residents, as well as thousands of other folks from elsewhere in the region, attended the official opening of the bridge on April 27, 1895, at the Dakota

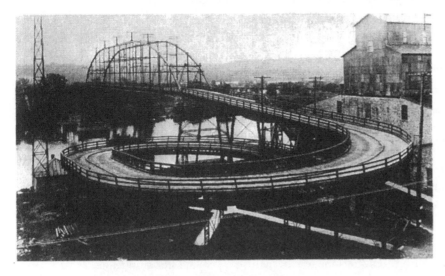

County Courthouse square. Canons roared, the regimental band from Fort Snelling played, militias staged mock battles on the river's east bank, and five thousand people feasted on a picnic lunch hosted by the community. (This photo dates from that same year.)

Hastings citizens quickly grew fond of the Spiral Bridge. On spring and summer evenings, they made a tradition of strolling up the twisting curve and across the span. In 1897, a composer named J. B. Lambert penned a lilting piano piece titled *The Spiral Bridge Waltz.* The following year, a women's organization in Hastings raised money to beautify the grounds beneath the spiral, naming the plot Meloy Park, after the donor of the land.

Over the years, the bridge received few repairs—mainly, the replacement of the planks on the roadway with a bituminous coat. Hastings, however, had trouble paying off its indebtedness for the bridge, and the state assumed the remaining financial obligation in 1935, forty years after the bridge had been built. By that time, the state had already taken ownership of it.

As early as 1928, residents began to lobby for a replacement bridge. Projecting spikes some times caused blowouts. Meanwhile, the load limit dropped from 10 tons to 4. On one memorable day, police cited three vehicles for exceeding the weight limit, including a school bus. Fire engines could not cross the span.

By the end of World War II, nobody could fix the Spiral Bridge's many structural problems. Rust had eaten away much of the steel. A new $2.5 million bridge was proposed as a replacement. Few disagreed that the Spiral Bridge had worn out for vehicular traffic, but preservationists wanted to save it for pedestrians or keep the spiral from destruction. Other local fund-raising drives during the late 1940s, though, fettered the preservationists' efforts.

Soon after the new crossing opened in 1951, the Okes Construction Company of St. Paul tore down the Spiral Bridge.

Heron Lake Public School

Sixth Avenue and Tenth Street, Heron Lake
1896–1986

THE END OF HERON LAKE PUBLIC SCHOOL could have come in the waning hours of 1901, when a fire gutted the interior of the five-year-old building. The fire, whose cause was never determined, disheartened the small town of Heron Lake, which had sprouted along the tracks of the Omaha-St. Paul Railroad just a few decades earlier. Public education was a high priority in this community of immigrants, brick makers, and farmers, and the damaged building had been a source of pride. No one less than N. W. Pendergast, the state superintendent of public instruction, had called it "quite a marvel. . . . the best school in southwestern Minnesota."

The school rose two and a half stories, built from Mankato brick and trimmed with Kasota stone. Four half-columns peaked with an arch strengthened the main entry, which stood under an open-belfried tower. A notable example of a school adaptation of the Romanesque style, the building was designed by Kinney & Orth of Austin, architects of the Constans Hotel in Blue Earth as well as schools and courthouses in Iowa.

The community, however, responded to the fire with a determination to rebuild. "It is believed—though not verified—that certain of the stones from the archway of the burned building were rebuilt back into the new school," the *Heron Lake News* reported years later. By all accounts the rebuilt school, completed in 1902, looked just like its singed predecessor.

And so life went on at Heron Lake School. A 1936 addition designed by Carl Buetow of St. Paul gave students a new gym, library, and classrooms.

Then, in the late 1970s, an economic crisis struck southwestern Minnesota, the population of children declined, and Heron Lake merged its school district with that of Okabena. The school closed in 1982. A preservation drive spearheaded by Minneapolis architect Ian Epley failed to inspire any practical reuse plans. "It has gotten to a point where the building is a liability to the district and the community," noted Dick Orcutt, the Lake Heron-Okabena school superintendent, in 1986. Wreckers demolished the school in March of that year. (This photo was taken a year before its demise.)

Photos taken just before the razing show desks neatly stacked against a wall, lessons still filling a blackboard, and a classroom clock stilled at 11:16.

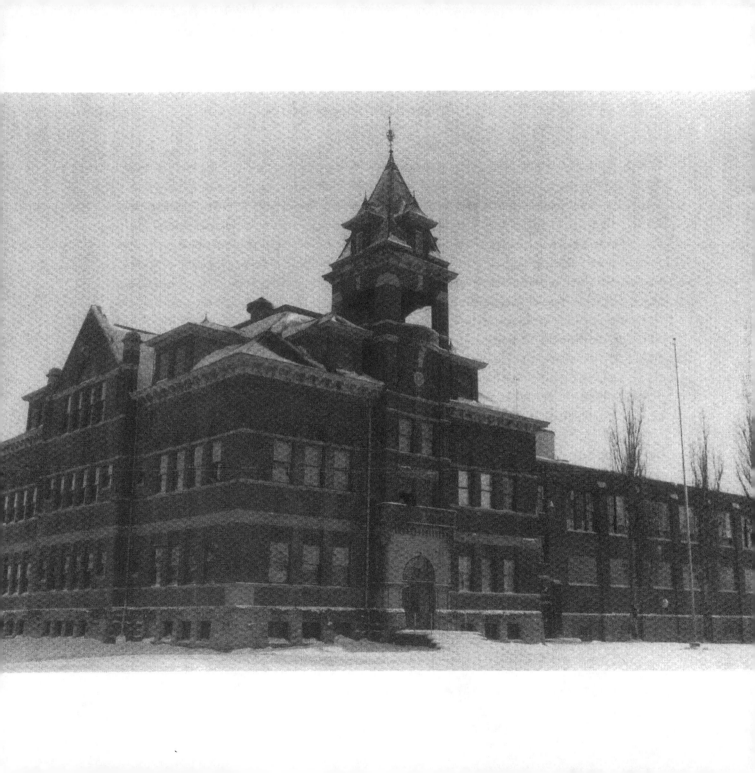

Horticulture Building

IN 1918, THE DAKOTA COUNTY AGRICULTURAL ASSOCIATION acquired a tract of land in Castle Rock Township, near Farmington, to use as permanent grounds for its annual county fair. By that time, the association had already been active for sixty years and had held fairs—events that provided an educational and social outlet for county residents—at several sites around Dakota County.

One of the first structures raised at the new fairgrounds was the Horticulture Building, whose octagonal dome greeted fairgoers as they arrived at the main entrance. The dome sat atop the octagonal central section of the building, which was made up of four 24-foot sides and four 12-foot sides. Flanking this central pavilion were two wings, 40 feet each in length. The entire Horticulture Building was constructed of wooden beams and red clay tiles, and the dome bore a coat of silver paint.

Inside, the building housed exhibits of farm produce. Clerestory windows at the base of the dome illuminated the display floor.

The Horticulture Building, designed and built by C. S. Lewis, was an excellent example of early twentieth-century fairgrounds architecture. A rural cousin of the big-city conservatory, it echoed the features of such urban park structures as the Como Park Conservatory in St. Paul.

Over the years, while thousands of fairgoers passed through its doors and admired its exhibits, the building began to weaken. By 1984, it had acquired a noticeable tilt. "The dome is leaning northeast, and it could topple in a strong wind," explained fair director Ernie Ahlberg. "We've done a number of studies on whether we could restore it properly, but it's just too expensive." Even if restoration were possible, the fair needed more space for its agricultural exhibits.

So the Horticulture Building was razed during the early summer of 1988. Its replacement, a new one-story horticulture building of industrial design, was ready to accept exhibits during the next fair.

Meanwhile, the dome of the old building had indeed landed on the ground. It is displayed, intact, in an open, park-like area of the fairgrounds.

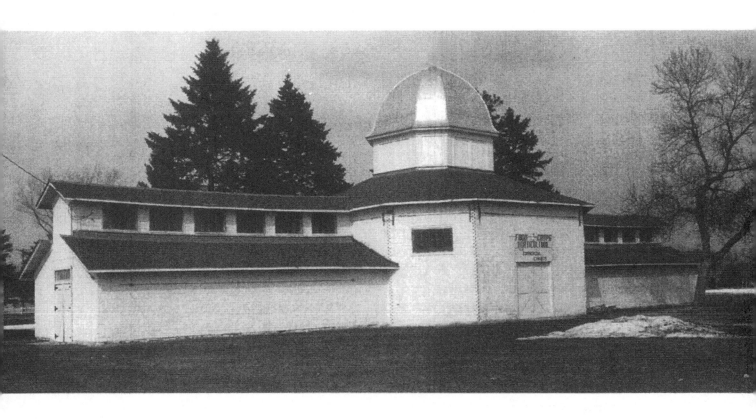

Hotel Zumbro

101 First Avenue Southwest, Rochester
1912–87

IT'S AN UNUSUAL HOTEL THAT IS DESIGNED to contain forty hospital rooms and a surgical chamber. The Zumbro, however, was in Rochester—a city whose growing recognition as a medical mecca inspired the erection of the hotel.

John H. Kahler raised the Hotel Zumbro in 1912, just as the Mayo Clinic was building its reputation as a medical center of national distinction. Sitting on a prominent block in Rochester's central business district, the hotel was the first component of a lodging empire that Kahler would eventually develop in order to capitalize on the growing number of Mayo patients and their families seeking overnight accommodations. Originally five stories high and configured in a U-shape, the building had red brick facing and a bracketed cornice on its north and east facades. Of the 125 guest rooms (including those adapted for hospital use), forty had private baths. Telephones and steam heat were other advertised conveniences. The hotel also offered sample rooms for the use of traveling salesmen, headquarters for the local Kiwanis Club, and nightly dinners, priced at $1, in the dining room. In 1922, the *Rochester Daily Bulletin* called the Zumbro "another of the ultra-metropolitan hotels for which Rochester is famous."

The growth of the Mayo Clinic made the Zumbro's expansion inevitable. Three years after the first clinic office building rose right next door in 1914, the Zumbro built an eight-story addition and an elevated bridge to the medical building, razing the tiny West Hotel in the process. In 1927, the clinic completed its state-of-the-art Plummer Building down the block, and the hotel provided guests with a comfortable pedestrian subway connecting to it.

In subsequent years the hotel changed little on the outside except for a residing project that altered the appearance of the street level. By 1980 it was known as the Kahler Zumbro Hotel and had 165 guest rooms.

In the 1980s, however, the Kahler Corporation, now Rochester's biggest hotelier, announced plans for a $20.5 million, 197-room Rochester Plaza Hotel complex that would replace the Zumbro. Wreckers razed the old hotel in the fall of 1987, and the new hotel opened its doors a year later. With the Zumbro vanished a part of the Mayo Clinic's early history.

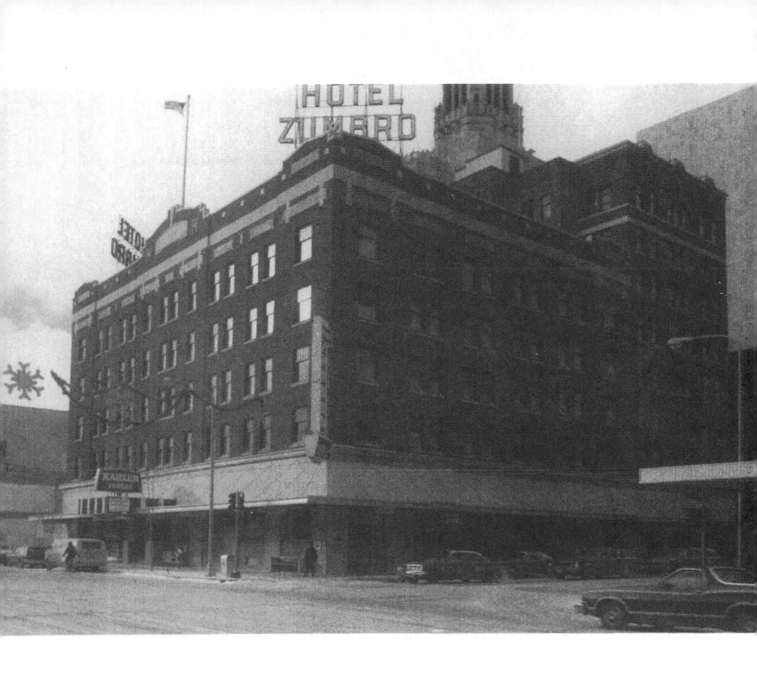

Lamberton-Wabasso Farmers Elevator

First Avenue at Douglas Street, Lamberton
1916–89

MINNESOTA HAS HAD PLENTY of wood-cribbed grain elevators, and more than its share of ones made of concrete. A brick grain elevator, however, is an exotic species.

Built in 1916 on the site of an earlier wood-cribbed elevator that burned down, the Lamberton-Wabasso Farmers Elevator sat at the north side of Lamberton, close to the railroad tracks. Bricks made up every part of its construction, from the sections that housed the elevator to the offices. The town depended on the elevator to prepare the grain that arrived from surrounding farms for transport to distant markets.

Although brick had advantages as a fire-resistant building material and a colossal 4.5-million-bushel brick elevator had been erected in Argentina in 1904, Americans generally disapproved of its expense. Wood and concrete were far cheaper. *The Book of Plans of Country Elevators* cited the Lamberton structure as unique in design.

The structure's anonymous designer used the masonry construction to great advantage, placing stepped and coped parapets all over: atop the main cupola, on the roofs of the side sheds, above the truck entrance, and on the office portion of the complex. The elevator had a capacity of 45,000 bushels of grain, divided among sixteen bins. Originally, the drive-up area was proportioned for horse-drawn wagon teams, but it was later expanded for trucks. Aside from that and some minor additions to the offices, the elevator complex changed little over the years.

In 1951 a concrete elevator rose alongside the brick structure, giving the site the distinction of having harbored all three major types of elevators: wood, brick, and concrete.

The Lamberton elevator served its community well. By 1983, though, it stood in disrepair and was no longer a safe place to store grain. The city of Lamberton feared that repair was impractical. One of the few brick elevators ever built in Minnesota, it was razed in 1989.

Little Rapids Village

Louisville Township, Scott County
Around 500–1851

WHEN THE 1851 TREATY of Traverse des Sioux gave the U.S. Government possession of much of the land of the Eastern Dakota Indians, including the grounds surrounding a place called Inyan Ceyaka Otonwe (Village of the Rapids), a chapter closed in the history of Native American life in Minnesota. For more than a thousand years, people of the Woodland and Eastern Dakota cultures had made their home in this settlement along the Minnesota River, which the whites later called Little Rapids.

Today a flat area within the Minnesota Valley Trail not far from the town of Jordan, the 20-acre site of Little Rapids is lush with grass and oak trees. The spot may have appealed to the Woodlanders and Wahpeton Dakota because of its convenience as a canoe portage circumventing a stretch of rough water in the river, now called Carver Rapids.

Eyewitness accounts from the 1830s and '40s, when about 325 Wahpeton Dakota lived there, described about fifteen rectangular wood and bark lodges in Little Rapids, each about 500 square feet in area, that during the summer sheltered a Dakota family in each corner. Pitched, watertight roofs covered the lodges. In the fall, the families would move away to harvest wild rice and hunt. When hunters sometimes came back to the area during the winter, they lived in cold-weather tipis and did not enter the summer lodges.

Whites began a presence in Little Rapids in 1802, when an American Fur Company trading post opened in the village. The post closed in 1851 after the Dakota, bound by the terms of the treaty, were relocated to the Upper Sioux Reservation in western Minnesota. Little Rapids sat unused and eventually disappeared. Mazomani (Iron Walker), the Wahpeton leader, was later killed while carrying a flag of truce during the U.S.-Dakota Conflict of 1862.

Although archaeological surveyors mapped the site during the 1880s, finding twenty-nine burial mounds and an earthen enclosure perhaps used for dances and other ceremonial rituals, the former village only became an archaeological mecca in the last half of the twentieth century. University of Minnesota archaeologists and students eventually turned up more than four thousand artifacts—some dating to the early Woodland Era—and located six hundred more in the hands of private collectors. The archaeologists also identified several distinct areas of the village site, including the location of the community lodges and places of food processing and storage.

Little Rapids no longer shelters people, but it continues to tell a story.

Charles H. Mayo House

419 Fourth Street Southwest, Rochester
1903–87

OF THE TWO BROTHERS who founded the Mayo Clinic, Dr. Charles Mayo (affectionately known as Dr. Charlie) was less obviously brilliant but warmer and more gregarious than Dr. William Mayo (Dr. Will). At the age of thirty-six, Charles and his wife, Edith Graham Mayo, decided to move out of their shared quarters with William's family in Rochester and build their own house. Tellingly, the site chosen for the new house was right next door. After construction was completed in 1903, Charles's house became known as the Red House and William's as the Yellow House. Recalled Charles's son: "Except for the color of their paint, the homes were similar. They had porte cocheres, city water, gas heat, and a special feature, a speaking tube connecting the houses to adjoining barns, where the carriages and drivers were." Charles's house was also notable for its projecting gable-roofed dormers and porches, octagonal tower, and elaborate exterior spindlework.

While Charles and Edith occupied the house, the brothers Mayo improved their clinic's facilities, publications, and quality as a medical research center. Already, however, Charles had purchased a large tract of land outside of town and was planning to move there. In 1919, his family adopted this estate, Mayowood, as its new home.

The Red House then served for many years as headquarters of the Rochester YWCA. (It's pictured here around 1935.) In 1944 it was converted to use as a dormitory for nurses. During the 1960s and '70s it changed hands many times, ending up as the Edith Mae Guest House, a temporary residence for Mayo Clinic patients. Although it now bore white aluminum siding and was described as "garishly decorated" in newspaper accounts, the house earned a listing on the National Register of Historic Places in 1980 because of its significance as part of the Mayo Clinic story.

The house's last owners, Rosie and Rex Savage, tried unsuccessfully for several years to sell the property. In 1987, the Mayo Clinic offered to buy the land on the condition that the house first be razed. The Savages accepted this offer and the house came down that March. They were later charged with a misdemeanor for failing to obtain a demolition permit, required under Minnesota law for the destruction of National Register properties.

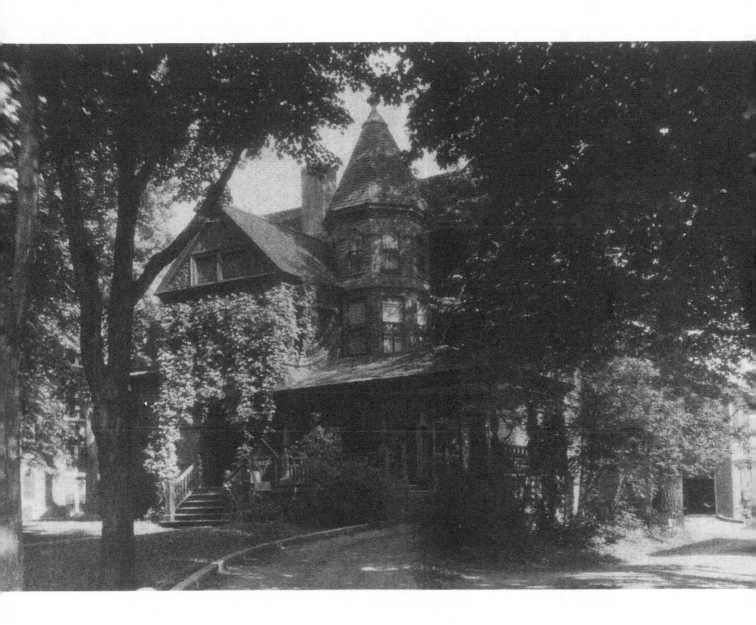

Murray County Courthouse

Main and Seventh Streets, Slayton
1892–1981

AROUND 1970, THE STORY GOES, a district judge adjourned the proceedings in his courtroom in the old Murray County Courthouse when he heard the building issuing alarming sounds—moaning and wheezing. He demanded a safety inspection of the building. But no immediate dangers were located. The courthouse was just responding as it sometimes did to a windy day.

By the end of its nine decades of existence, practically nobody had faith in the structural integrity of the Murray County Courthouse. Not its tenants, who suffered through the abysmal working conditions the courthouse afforded. Not its owner, Murray County, which in the building's final ten years invested little in maintenance or repair. And certainly not the folks who wanted the thing torn down and replaced by a new courthouse. In the end, though, the old building enjoyed a laugh at all of their expense.

Designed by Frank Thayer of Mankato, who received $380 for his architectural services, the Murray County Courthouse arose in 1892 in the wake of an intertown dispute that had ripped apart the county. Currie had been the county seat ever since Murray County's organization in 1872, but in 1887 proponents of moving the seat to Slayton won a bitterly contested election. Slayton's supporters abducted the county records within hours of the vote tally and refused to return them when courts declared the election invalid. In 1889 Slayton became the seat by action of the Minnesota legislature, and the new courthouse was built.

The courthouse was one of sixty-two erected in the state during the 1880s and '90s. Rising just two stories, it was built—maybe too sturdily—with yellow brick and Kasota limestone in the Romanesque Revival style. The main entry sat beneath a round arch supported by thick columns (see detail photo). The clock tower apparently never housed a clock.

Inside were county offices on the first floor and the courtroom and judges' chambers on the second. Later, the basement and attic would also house offices.

Overcrowding caused the addition of those offices, and the courthouse underwent its share of interior alteration. But by the 1970s the exterior was remarkable for its lack of changes. The Murray County Courthouse remained one of the few from its era to retain its original look.

The 1970s also marked the building's ruination as a working courthouse. Hoping for a new

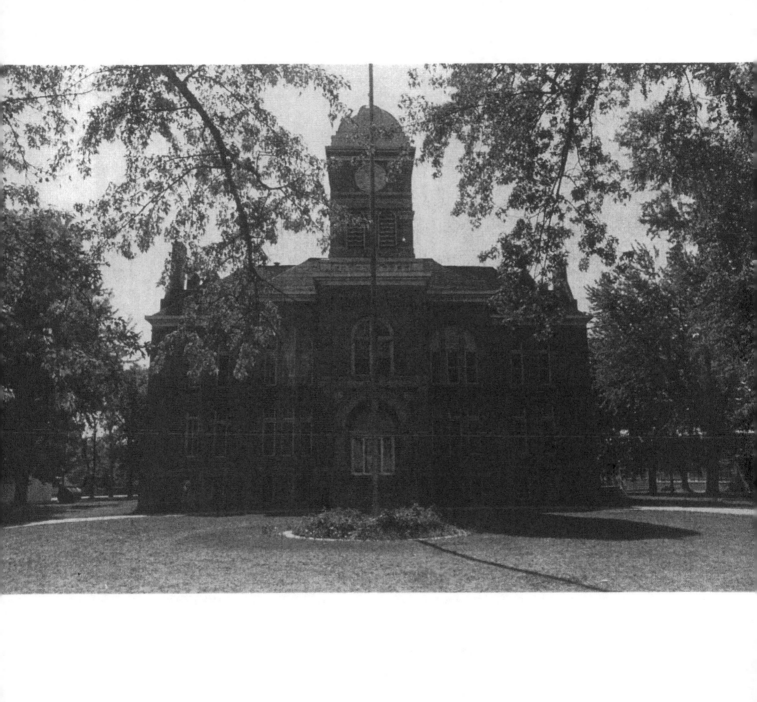

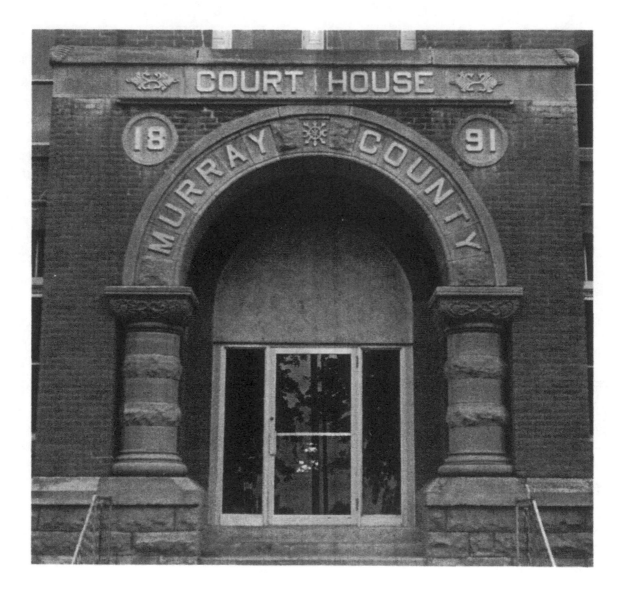

government building, Murray County's commissioners allowed the old building's plumbing and heating systems to deteriorate and let the roof leak. "The building is crumbling away," complained the county auditor in 1980. "The foundation is cracking, and you can see daylight around most of the doors and windows. Upstairs, you can see where the rafters have been pulling apart." By then, only the basement and first floor were fit for occupation.

In 1981 the commissioners voted to ignore a preservation campaign and fund a new courthouse. The preservationists ultimately ran out of money.

A demolition crew scheduled a quick end for the old courthouse in the early days of October 1981. When the time came to topple the clock tower with tractor-pulled cables, however, the building would not cooperate. For more than six hours, a crowd watched the steel cables break nine times. After the tower at last succumbed, hiding the building in a storm of dust for five minutes, a passerby picked up the tin ball that had once topped the courthouse. A bullet hole of uncertain vintage pierced it.

The rest of the courthouse came down in two days.

New Ulm Roller Mill Complex

222 First Street South, New Ulm
1910–82

ON A SATURDAY NIGHT IN MARCH 1910, a crowd gathered on the streets of New Ulm to watch a firestorm in progress. Flames streaked from the old New Ulm Roller Mill, a blaze "probably caused by spontaneous combustion," the *Brown County Journal* speculated. Soon the heat grew so intense that the crowd had to move back hundreds of feet. When the flames finally died down, the mill was a complete ruin.

New Ulm depended on grain milling in the early twentieth century, and the industry dated back to the 1850s in Brown County. So within a few months of the fire, a second New Ulm Roller Mill complex arose on the same site, a low stretch of land close to the Minnesota River. The complex included a three-story brick mill building humming with rolls, flour and bran packers, scourers, bran dusters, sifters, sieve purifiers, and dust collectors. Alongside it stood a thirteen-bin wood-cribbed grain elevator (increased to twenty-two bins in 1912) and a brick office building, whose lower walls may have been the lone survivors of the 1910 fire.

The mill worked long and hard, usually running day and night. Its output contributed to Brown County's stature as Minnesota's top outstate producer of flour during the early decades of the twentieth century.

As the New Ulm Roller Mill kept grinding, its neighboring milling businesses gradually closed down. By the 1970s, it remained the best-sustained milling complex in Brown County and was one of only four early merchant flour mills to stay in operation in Minnesota. Now owned by International Multifoods, the mill alternated between producing rye flour, blending custom-made bakery mixes, and grinding spring wheat and durum.

The continuing commercial viability of this old mill abruptly ended in November 1982. On a Saturday night reminiscent of the disastrous evening seventy-two years earlier, a fire spread through the mill building. A crowd emptied from two nearby bars onto the street. The onlookers watched flames once again reduce the New Ulm Roller Mill to rubble.

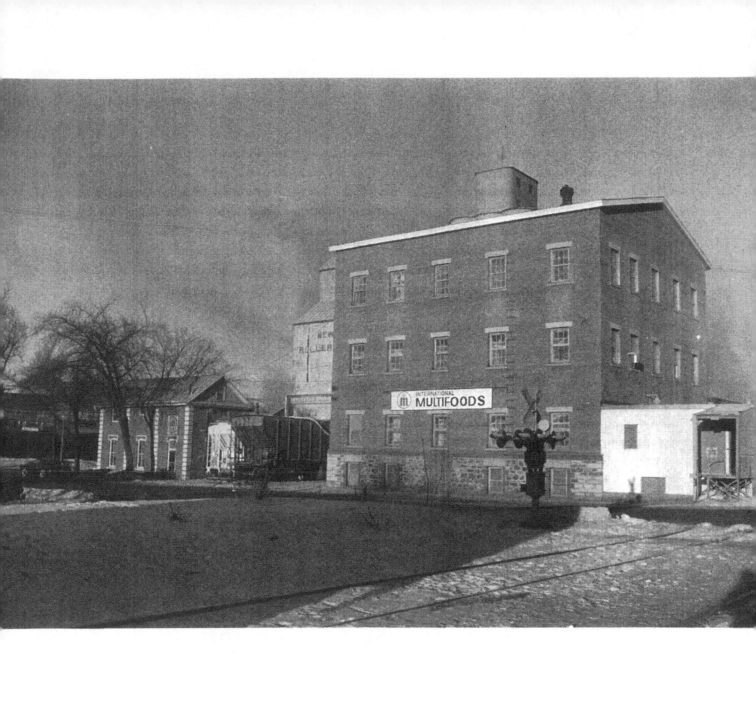

John Niebuhr Farmhouse

Mansfield Township, Freeborn County
1873–1997

A FREEBORN COUNTY LEGEND MAINTAINS that Jesse James, riding into or out of Northfield at the time of his gang's famous bank robbery of 1876, stayed overnight at the house of John Niebuhr, about a mile southwest of Mansfield. Whether or not the outlaw did that, there is no doubt that the Niebuhr farmhouse boasted another distinction nearly as historically important. Niebuhr, a fifty-year-old immigrant from Hanover, Germany, wanted his new home to look like the one he, his wife, Catharine, and their nine children had left behind in Europe. In 1873 he hired other recent immigrants from the large local German population to put their skills to work in building a house using solid-oak post-and-beam construction, all parts 8 inches square, with hand-carved wooden pegs holding together the skeleton. The post-and-beam system was visible in the walk-in attic, where the beam complexes each bore a marked Roman numeral left over from their assembly. None of the traditional American balloon-frame, pattern-book homes in the county looked like the Niebuhr house beneath their clapboard skins, and few residences in Minnesota were ever built with the same construction methods.

The Niebuhr house was notable in other respects. It had a 2-foot-thick granite fieldstone foundation to shore up the supporting timbers and an upstairs room that extended the width of the house, nearly 500 square feet, sometimes serving as a community party room and dance hall. There were fourteen rooms to house the dozen children the Niebuhrs eventually reared. A wraparound covered porch completed the picture.

Two later generations of Niebuhrs owned the house, although the family occupied it only until 1914 before renting it out. The farmhouse never served as a commercial hotel (contrary to another local legend), but it did often provide shelter to traveling peddlers. It underwent no significant structural changes during all the successive decades except for the removal of the porch, which was leaking, and the addition of a rear storm entrance around 1977.

This house had the structural durability to last well into the twenty-first century. Instead, its life ended suddenly and unexpectedly. In May 1997, just as owner Herb Niebuhr was readying the vacant house for new tenants, local fire companies were called to the farmstead and found the old home dancing with flames. Although thirty-one firefighters brought the blaze under control in less than an hour, only one corner still stood. The house and the German craftsmanship that filled it were gone. The cause of the fire remains unknown.

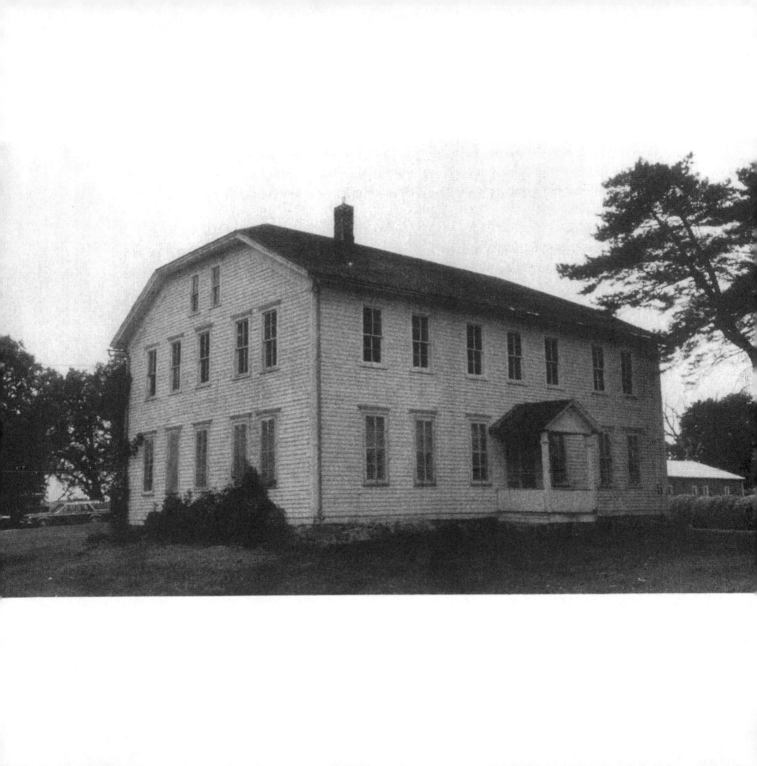

Owatonna Water Works Pumping Station

West School Street at Mosher Avenue, Owatonna
1890–1992

MANY PEOPLE WOULD NEVER HAVE GIVEN IT A SECOND LOOK. Built in 1890, the original Owatonna Water Works Pumping Station more closely resembled a country cottage than a machinery-filled facility that for about a century moved most of Owatonna's water supply from deep artesian wells to holding tanks.

An engineer named W. W. Curtis designed the pump house and its intricate network of pipes and mains. In its original configuration the pump house had steam-powered pumps that drew water from the ground, gathered the water in hand-dug cisterns, and stored it in a 100-foot-high, 125,000-gallon standpipe.

The pump house that sheltered all the necessary equipment was built of red brick, although it acquired a stucco facing sometime early in the twentieth century. The L-shaped building had arched windows and door portals, a cupola atop its gabled roof, and round windows at the ends of the gables. Inside, a concrete slab floor supported the equipment. A pressed metal ceiling looked down on the pumping activity.

The growth of Owatonna along with advances in pumping technology and a steady increase in the number of artesian wells feeding the system caused a continuous change of equipment inside and outside of the pumping station. Turbine pumps powered up in 1940 and 1945. An ambitious renovation of the machinery in 1959 doubled the station's water output, increased its storage capacity with the addition of an adjoining water tank connected by pipes, and put an end to the use of the original cisterns. Ten years later, the old standpipe came down.

By the 1980s, the pump house—now the last remaining vestige of Owatonna's first water works—seemed obsolete. For years the building ranked as one of the city's maintenance nightmares. The foundation, built on sinking ground, leaked. The walls were deeply cracked from the settling, and there was no easy way to reverse the damage.

After the city went ahead with plans to build a $1.1 million replacement pumping station, the old one was razed in 1992.

Rockledge

Winona
1911–87

GEORGE WASHINGTON MAHER LEFT his architectural mark throughout the Midwest. But after the 1987 razing of Rockledge, the house near Winona that Maher designed for E. L. King in 1911, Minnesota's collection of Maher's buildings suffered a serious reduction.

Maher, who worked alongside Frank Lloyd Wright in the Chicago office of Joseph Lyman Silsbee, developed his own style of Prairie School architecture, a commercial variety that spawned pockets of Maher-designed homes in affluent areas of Illinois. In 1897, Maher conceived the "motif-rhythm theory," a means to unify the surroundings of a house with its interior through liberal use of such design motifs as leaves, trees, and flowers.

Although the typical Maher house was a low, suburban structure, Rockledge was designed for no ordinary client and thus became an extraordinary Maher creation. The site was a bluff above the Mississippi River just outside Winona, the town where E. L. King had marched the J. R. Watkins Medical Products Company into the high-rolling world of international business. King demanded from Maher, and got, a house that any visitor would remember.

For Rockledge, Maher borrowed from the river-bluff surroundings a lily motif and the brown, green, and orange colors of the area's cliffs, plants, and flowers. Lilies appeared on the glass panels of lamps, drapes, and upholstery fabric, all of which Maher designed. He plotted the house like a bungalow, with a tile roof and a brawny oak staircase.

In 1931, five years after Maher's death, the King family redesigned the interior, adding a bowling alley, marble staircase, and chrome hardware. Maher's furniture was exiled to a barn, where it long remained. The Minneapolis Institute of Arts acquired one of the chairs.

For several years before its razing, Rockledge stood empty, an easy target for vandals and roosting pigeons. With the house now gone, only the Winton House at 1324 Mt. Curve Avenue in Minneapolis and the J. R. Watkins Building in Winona remain in Minnesota as examples of Maher's work.

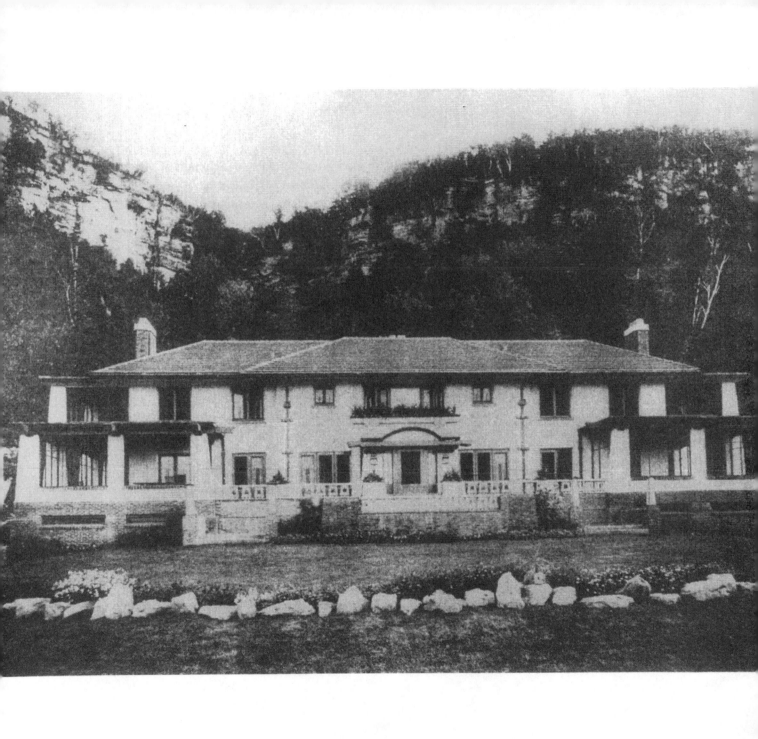

Oscar Schmidt House

111 Park Lane, Mankato
1925–88

BACK IN THE DAYS WHEN HORSES MOVED most everything in Minnesota, the Schmidts of Mankato ranked as the chief harness and saddle merchants in the southern part of the state. Gottleib Schmidt, a German immigrant, started the business in 1861, and a long succession of Schmidts kept it thriving by diversifying into the merchandising of other leather goods and camera equipment.

In 1925 Oscar W. Schmidt, Gottleib's son, engaged the architecture firm of Henry C. Gerlach to design a new house on the west end of downtown Mankato. Gerlach's son, Henry C. Gerlach Jr., a draftsman with the firm, executed the design. Probably led by the preferences of his client, Gerlach Jr. produced a house design in the Georgian Revival style—fifteen years after that residential style had faded from popularity.

The house had red brick construction and a two-story front portico held by Tuscan columns. An open porch wrapped around from the front to the east side, and stylistic echoes of the porch also appeared on the west side. Inside were fourteen rooms and a large gathering hall.

Many Schmidts grew up in this house, and it remained in the family until 1958, when the Mankato YMCA acquired it for office space. The Y long grappled with the home's many small rooms. In 1972 and 1976, however, it built additions to the house's back and east sides. Stylistically incompatible with Gerlach's design, these additions were hidden from view.

In time, the property grew more attractive to the Y for its hilltop location than for its house. The organization in 1986 proposed to raze the house and build a $1.2 million gymnasium in its place. The house, agreed the *Mankato Free Press,* "is in some disrepair and [is] costly to heat and maintain, and its collection of small rooms on three floors makes it virtually useless to the 'Y' or the community."

This assessment of the house angered many Mankato citizens who believed that the home's connection with the city's longest-operating business made it valuable. A group called Save the Schmidt House delivered a five-hundred-signature petition to the city council urging preservation of the building. The campaign received no support from Roger Schmidt, who grew up in the house. "Nothing's forever. . . . After they added on here and there, it can't be restored," he said. "I'd rather see it torn down."

The Y did tear it down in April 1988. The gym took its place.

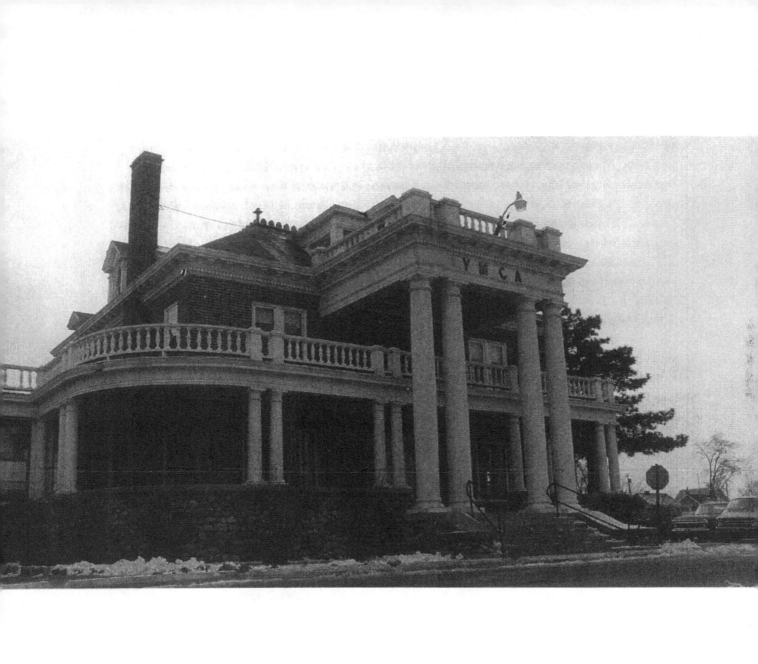

Twente Farm Elevator and Granary

Albin Township, Brown County
Around 1885–1986

RICHARD TWENTE WAS TALL AND HEAVY, a powerful man whose brute strength made neighbors fear him. He harnessed that strength during the 1880s to erect a group of buildings on his farm in Brown County that long resisted the effects of heavy use and scores of Minnesota winters. He raised a 100-foot-long barn that sat on a foundation of hand-cut stones, some of which weighed hundreds of pounds. He also cleared a small cemetery on his land, guarded by giant elm and ash trees, in which to lay to rest his six-year-old daughter Anna Mary, who died in 1886.

But Richard Twente's most impressive achievement was the granary that he built in the center of his property in about 1885. A frame-built structure with a tall gable-roofed tower to house the grain elevator, for decades it served area farmers as an unusually large and sophisticated center for the storage of grain and seeds.

At the south end of the building, wagons could drive through and unload grain into an underground elevating bin. The mechanical centerpiece of the facility, a massive Fairbanks flatbed scale manufactured in St. Paul, weighed the incoming produce. A network of chutes emptied seven grain bins fed from the elevator in the tower. Farmers from a large area surrounding the Twente farm in southwestern Minnesota used the granary to store their grain.

In the twentieth century, the formerly horse-powered granary equipment became motorized. Reroutings of the chutes and the creation of a new unloading area at the north end adapted the granary for use by gasoline-fueled trucks. By the late 1950s, the Fischer family had acquired the farm, raising buffalo and hogs, as well as keeping the old granary operating. The building seemed invincible. A New Ulm reporter who visited the farm in 1959 found that the Fischers "are of the opinion that the buildings will endure for another century."

The granary did not last that long. Small doors made entry by large trucks impossible, and the granary eventually fell into disuse and disrepair. The Fischer family tore it down during the summer of 1986. A large corrugated metal grain silo replaced it.

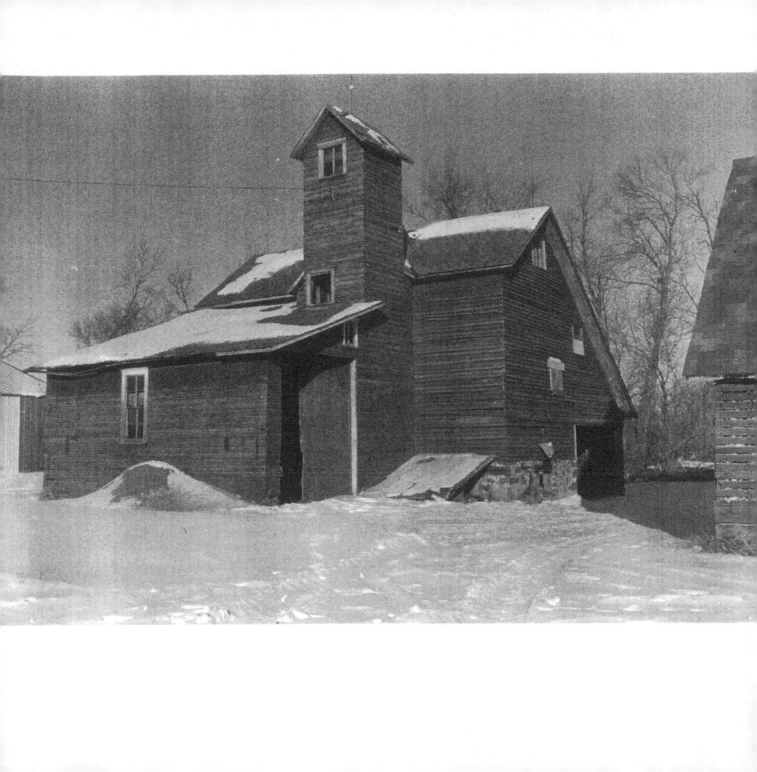

Winnebago Agency House

County Road 138, McPherson Township, Blue Earth County
1855–1986

THE SAD AND UNUSUAL HISTORY of the Winnebago Agency House begins in the 1840s, when the U.S. government forcibly relocated the Winnebago Indians from the area around Fond du Lac, Wisconsin, to 891,000 acres of land near Long Prairie, Minnesota. In 1855, however, the government once again moved the Winnebago, this time to a reservation one-quarter the size of the previous one, along the Blue Earth River. There a settlement grew that included log homes, a blacksmith's shop, a warehouse, and other buildings.

One of the busiest structures in the reservation village belonged to the Indian agent, a government employee charged with disbursing supplies and treaty payments to the Indians. Jonathan E. Fletcher first assumed these duties, and over the next eight years he was succeeded by Charles H. Mix and A. D. Balcome. These men lived in and worked from the agency house, a two-story brick building simply designed in the Federal style. It had unframed windows, two chimneys, and two fireplaces on each floor. Much of the house remained unheated, leaving it unprotected from Minnesota's winters. "The design would have stood well in Virginia or Georgia," a Minnesota Historical Society restoration specialist noted in 1985, "but it's not adequate for here."

The Winnebago Indians lived unhappily on this reservation, coping with unreliable payments from the government, poor fishing and hunting, and the agents' attempts to turn them into farmers, Christians, and followers of European American customs. Meanwhile, white settlers sought access to the reservation land and its plentiful water and acreage. In 1859 the Winnebago ceded half of the reservation in exchange for an increase in their government annuity. Three years later, though, the U.S.-Dakota Conflict alarmed the Winnebago into accepting a government proposal to relocate once again, this time to a Missouri River site in Dakota Territory. By 1863 the Winnebago were gone from Blue Earth County and the agency house closed.

That year the Truman family picked up reservation land for two dollars an acre and converted the agency house to a hotel. So many people entered the house during this time that the floor wore out in one room and the Trumans simply built another one on top of it, elevating the room by four inches. (An odd footnote to the Truman ownership of the house: a story is told about how several years after Mrs. Truman died and her body was buried on the old reservation grounds, the family decided to

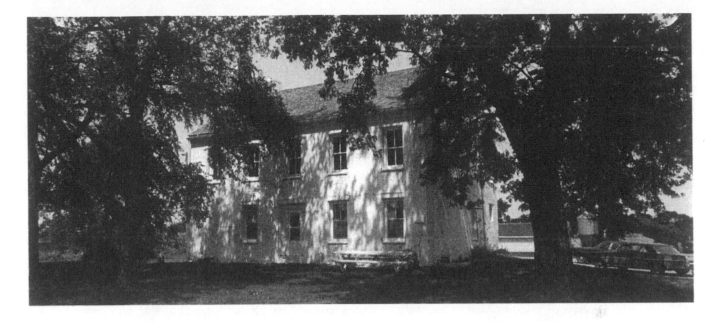

reinter the body elsewhere. Diggers, dismayed to find that the coffin weighed hundreds of pounds, opened the casket and discovered that the corpse had somehow petrified into a stone-like material.)

Four other families owned the property and the agency house during the next 120 years. These owners covered the fireplaces and removed the chimneys, divided the rooms, built a stucco addition to the rear, and installed plumbing and heating. Meanwhile, all of the other buildings of the reservation village disintegrated or were razed, although some of their foundations remained. By the 1970s, the Winnebago house was one of only two Indian agency houses still standing in Minnesota.

The house's last owner, Marvin Preston, battled shifting walls and, finally, the collapse of one section of the building. He refused to let his grandchildren venture anywhere nearby. Repairs would cost $200,000, and no government aid was available because Preston did not plan to open the house to the public.

In 1986 the house came to an ignominious end. The St. Clair Fire Department set it alight and watched the flames destroy it in a controlled burn.

Winter Hotel

111 Main Street, Lakefield
1895–1989

BUILT FOR PRACTICALITY AND NOT FOR ELEGANCE, the Winter Hotel served the Jackson County town of Lakefield as a temporary home for visiting business people, performers, politicians, and tourists. It sat by the railroad tracks at one end of Lakefield's business district for ninety-four years, a reminder of the town's historic link to the trains and the importance of small hotels to communities in southern Minnesota.

The building's first owner, Grant Winter, was a well driller as well as hotelier. The hotel grew in three sections: a plainly designed two-story brick structure that dated from 1895, and two additions that arrived in the early decades of the next century. There was a storefront on the southeast corner and guest rooms upstairs. Apparently, the original design included limited indoor plumbing; workers had to descend through a basement trapdoor in order to wash at sinks.

Besides the additions, the hotel underwent other changes over the years. Stairs and balconies were added to the south and east sides, and new windows and doors replaced some original ones. During the 1930s or '40s the building finally received full plumbing. As a result, according to one historical surveyor, the owner "took all the pitchers and bowls in the back yard and broke all of them."

The establishment—eventually renamed the Lakefield Hotel—fell into decline after World War II, when the automobile eclipsed the railroad as the dominant form of transportation in the region. Now in competition with highway motels, the hotel changed hands several times. The Hutzler family acquired it in 1975, remodeling it to create larger apartments. Even so, taxes, insurance, and a lack of customers made the hotel unprofitable, and it closed in 1988. Water seepage from the roof damaged the upper floor.

Now an infirm building with no foreseeable use, the hotel attracted the neighboring Farmers Co-op Elevator, which wanted the land it occupied. Wreckers tore it down in 1989.

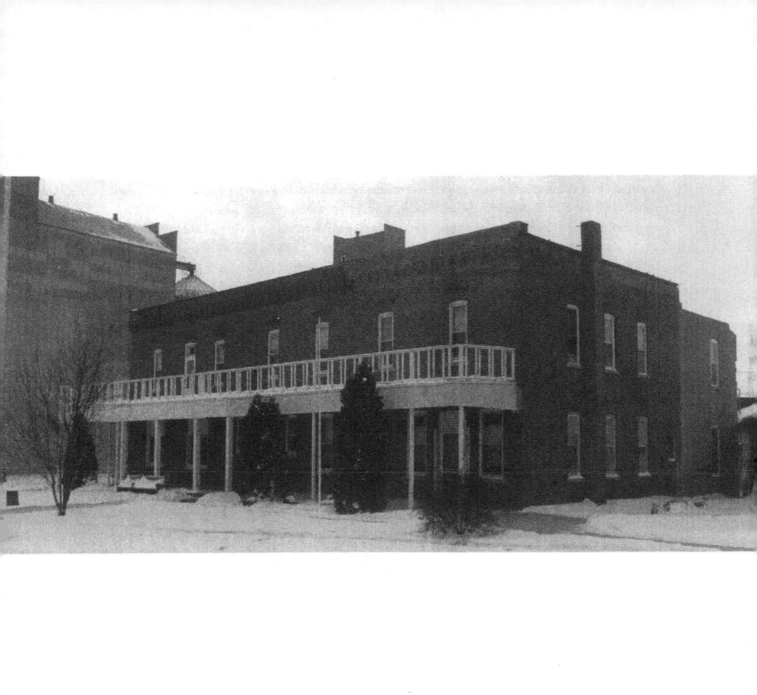

Worthington and Sioux Falls Railroad Depot

106 East Fletcher Street, Luverne
1876–1992

WHEN RAILROADS BEGAN CONNECTING TOWNS across Minnesota during the last third of the nineteenth century, communities cheered the end of their social and commercial isolation. It happened in Luverne, Rock County, in the fall of 1876. "The railroad grade including side-tracks, etc., is now complete," the *Rock County Herald* reported, "and in a few more days our people may expect to see the smoke of a locomotive tower up on the eastern horizon, and hear the angry snort of the fiery monster."

That smoke-belching beast, operated by the Worthington and Sioux Falls Railroad, made its first stop for Luverne actually a half mile east of town, at the bank of the Rock River. Soon, however, trains were able to pull up in Luverne at the town's first depot, a facility that handled both passengers and freight. Built just the summer before, it was a single-story wood-frame building with curved brackets and king posts supporting the wide eaves and gables. There were big freight doors on three sides. The depot contained 1,300 square feet of open, undivided space. It had no heat, lights, or plumbing, and its designer is unknown.

Luverne worked this depot hard. Within eighteen months, it was receiving 1.7 million pounds of freight in a week. For Luverne's citizens, the building represented the importance of the rail link. The 1913 construction of a second depot nearby led to the dedication of the older building to freight operations. In later years, as the building was further demoted to a storage capacity, it lost its windows and several doors.

In 1978 the depot, miraculously still standing, was owned by the Chicago and Northwest Railway Company of St. Paul and leased to the Luverne Farmers' Co-op Elevator, which used it for storage. By then, few living people recalled its use as a passenger depot.

The next fourteen years were not kind to the aging building. Pieces of one door lay disintegrating on the ground. The depot leaned to the south on a crumbling foundation. Parts of the flooring had moldered and collapsed.

In 1992 the city of Luverne judged the depot a fire risk and hazard to public safety. It acquired the building with the intention of demolishing it. The razing took place that summer.

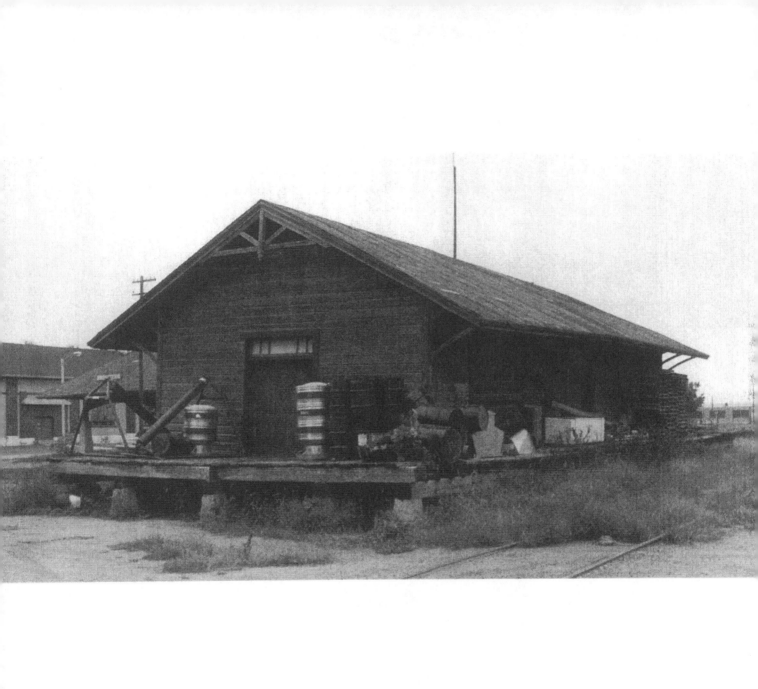

Sources

INFORMATION ON MINNESOTA'S LOST PROPERTIES awaits researchers in many different places, from newspaper archives to family memoirs. During the past ten years I have plumbed a variety of libraries and research centers.

For information on lost properties in Minneapolis, I have made extensive use of the clipping and photo files of the Minneapolis Collection of the Minneapolis Public Library. The collection's staff maintains clipping files on both buildings and people, and there is nothing quite like opening one of these files for the first time, catching a whiff of antique newsprint, and unfolding a pile of articles full of the immediacy of daily newspaper reporting.

I also relied heavily on the Research Center at the Minnesota Historical Society's History Center in St. Paul, which offers a wealth of articles, manuscripts, books, and photographs relating to lost properties throughout the state. More than a hundred thousand images from the society's photo collection are now available online at the organization's Web site (www.mnhs.org). The society's priceless archive of Minnesota newspapers on microfilm often provided good information on lost properties, especially their demolition.

Within the same building resides the State Historic Preservation Office (SHPO), which keeps files on every property in Minnesota that has ever been awarded a listing on the National Register of Historic Places. These files include properties that have been removed from the National Register, often because the property has been destroyed. Many of this book's essays on properties outside (and a few inside) the Twin Cities are based on SHPO's files, which include National Register nomination forms, surveyor's reports, newspaper clippings, photographs, and other documentation of a property's life. I am grateful for the opportunity to make use of these files.

When possible, I have also interviewed people who lived in, worked in, or owned the properties profiled in this book. If you think tracing lost buildings must be hard, try tracking down lost people. When I've found them, these folks have been generous with their time and unfailingly helpful.

Permissions

THE UNIVERSITY OF MINNESOTA PRESS is grateful to the following institutions for permission to reproduce the photographs on the pages indicated. The name of the photographer, if known, is listed in parentheses following the page number.

Minneapolis Public Library: 7, 9, 13, 19, 21, 29, 31, 33, 34, 35, 41, 43, 45, 47, 55, 57, 59, 61, 63, 101.

Minnesota Historical Society: 3, 5, 11, 15, 16 (Jack Renshaw), 23 (C. P. Gibson), 27, 37, 39, 49 (C. J. Hibbard), 51, 53 (C. P. Gibson), 63, 67 (Norton & Peel), 69, 71, 73, 75, 77 (Lawrence Rylander), 79 (W. H. Illingworth), 81, 83, 85 (C. P. Gibson), 86, 87, 88 (Haas & Wright), 91 (Fredric Quivik), 93 (C. P. Gibson), 94, 99, 103, 105, 107 top (*Minneapolis Star Tribune*), 107 bottom (Gillis), 109, 113 (M. H. Reynolds), 115 (Robert M. Frame), 119 (Barbara Hightower), 121 top (C. W. Nelson), 121 bottom, 125 (Dennis Gimmestad), 129 (James A. Sazevich), 131, 133 top and bottom (Tom Jenkinson), 135, 137 (Liza Nagle), 139, 141 (Rolf T. Anderson), 143, 145 (Elroy Quenroe), 147 (Mark Haidet), 149, 151 (John J. Hackett), 155 (Susan Pommering Reynolds), 157, 159 (E. Floe), 161 (R. Frame), 163 (B. Bloomberg), 165, 167 (S. Granger), 169, 171 (R. Frame), 173 (Dennis Gimmestad), 175, 177, 179, 180 (Thomas Landvik), 183 (Dennis Gimmestad), 185, 187 (Noreen Roberts), 191 (Dennis Gimmestad), 193, 195, 197 (S. Granger), 199.

Northeast Minnesota Historical Center: 117, 123.

Walker Art Center: 25.

Winona County Historical Society: 189.

JACK EL-HAI is the author of six books, including *Minnesota Collects* and *The Insider's Guide to the Twin Cities*. His writing has also appeared in *American Heritage, American Health, Minnesota Monthly, Twin Cities Business Monthly, Minnesota Law & Politics,* the *Minneapolis Star Tribune,* and the *St. Paul Pioneer Press.* He has written the "Lost Minnesota" column in *Architecture Minnesota* since 1990.